THE DESIGN ART OF NICOS ZOGRAPHOS

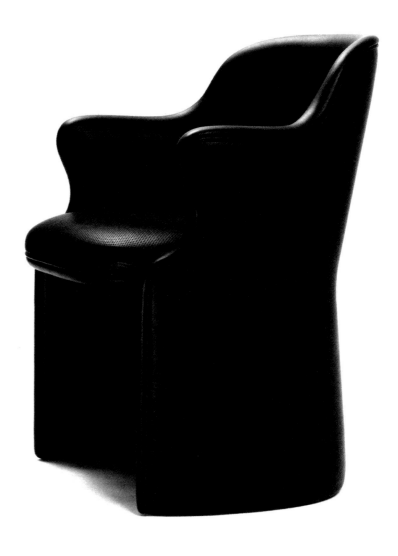

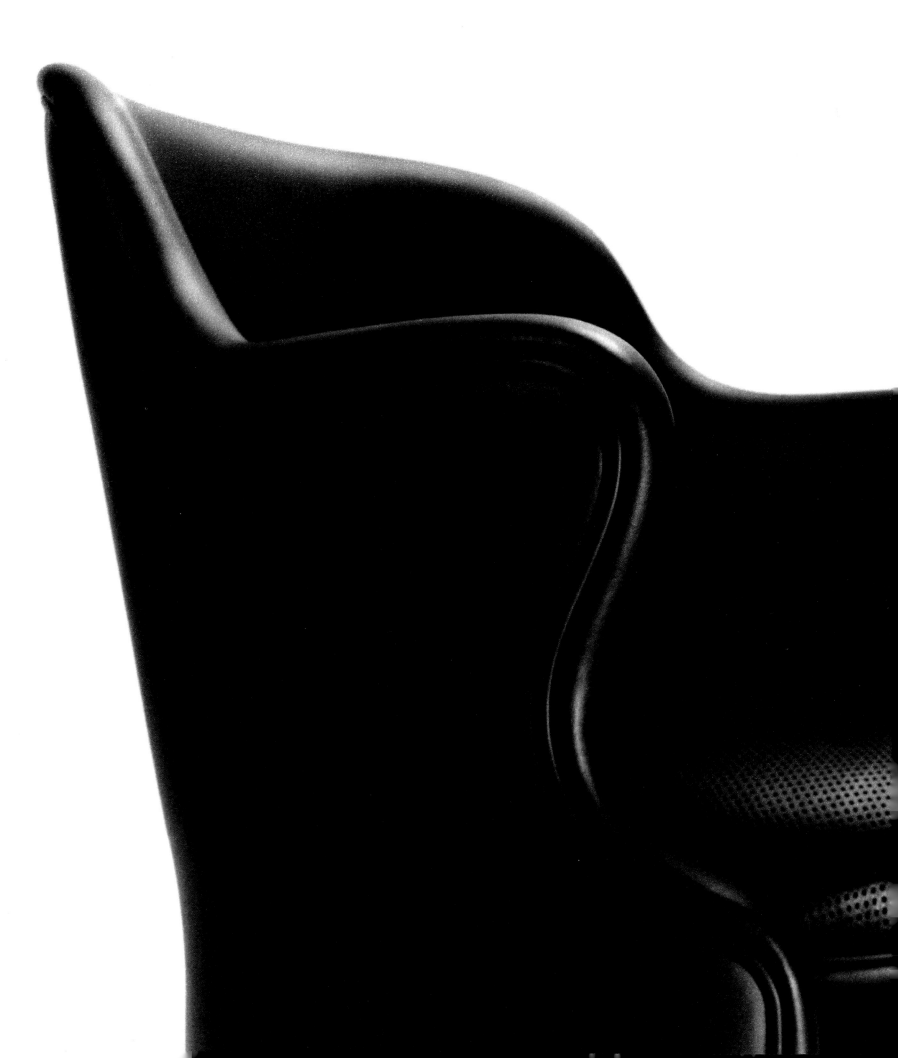

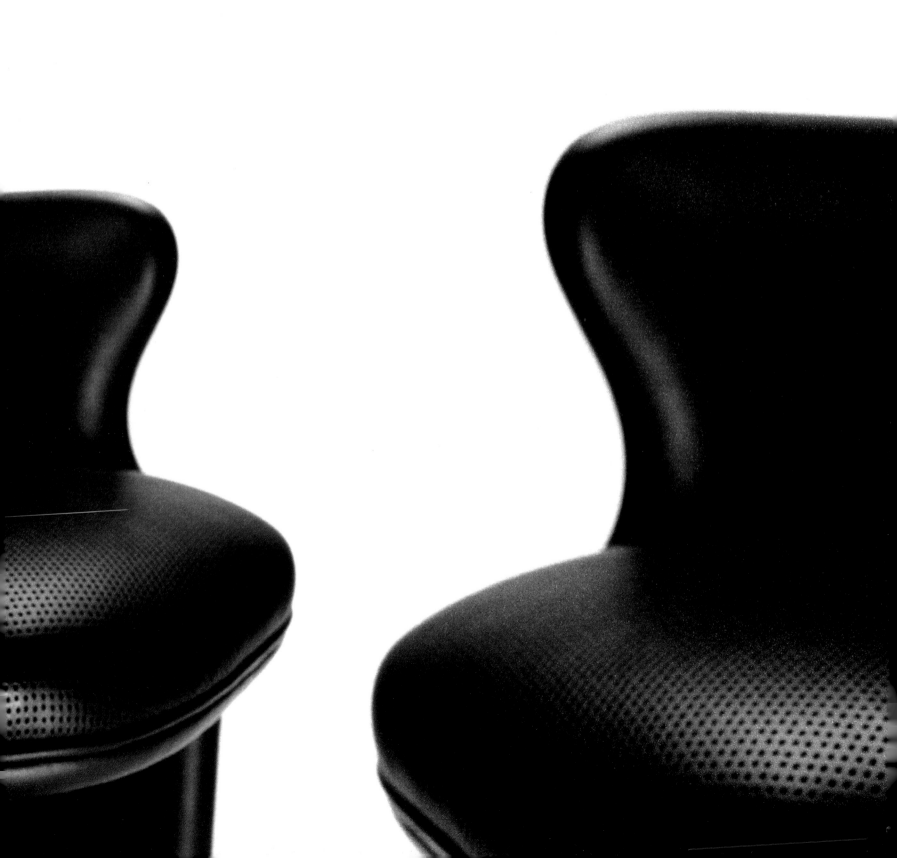

NICOS

APHOS

TEXT BY PETER BRADFORD

WITH INTRODUCTIONS BY HARRY WOLF,
GEORGE LOIS, AND PETER BLAKE

THE MONACELLI PRESS

DEDICATED TO ALIKI, FOTINI, AND ATHENA

First published in the United States of America in 2000 by
The Monacelli Press, Inc.
10 East 92nd Street, New York, New York 10128.

Copyright © 2000 Nicos Zographos

Library of Congress Cataloging-in-Publication Data
Bradford, Peter, date.
The design art of Nicos Zographos / by Peter Bradford ; introductions by Harry Wolf,
George Lois, and Peter Blake.
p. cm.
ISBN 1-58093-066-2
1. Zographos, Nicos, 1931- —Criticism and interpretation. 2. Architect-designed
furniture—United States. 3. Interior architecture—United States. 4. Furniture—
United States—History—20th century. I. Zographos, Nicos, 1931- . II. Title.
NK2439.Z64B73 2000
749.213—dc21 00-023794

Printed and bound in the United States

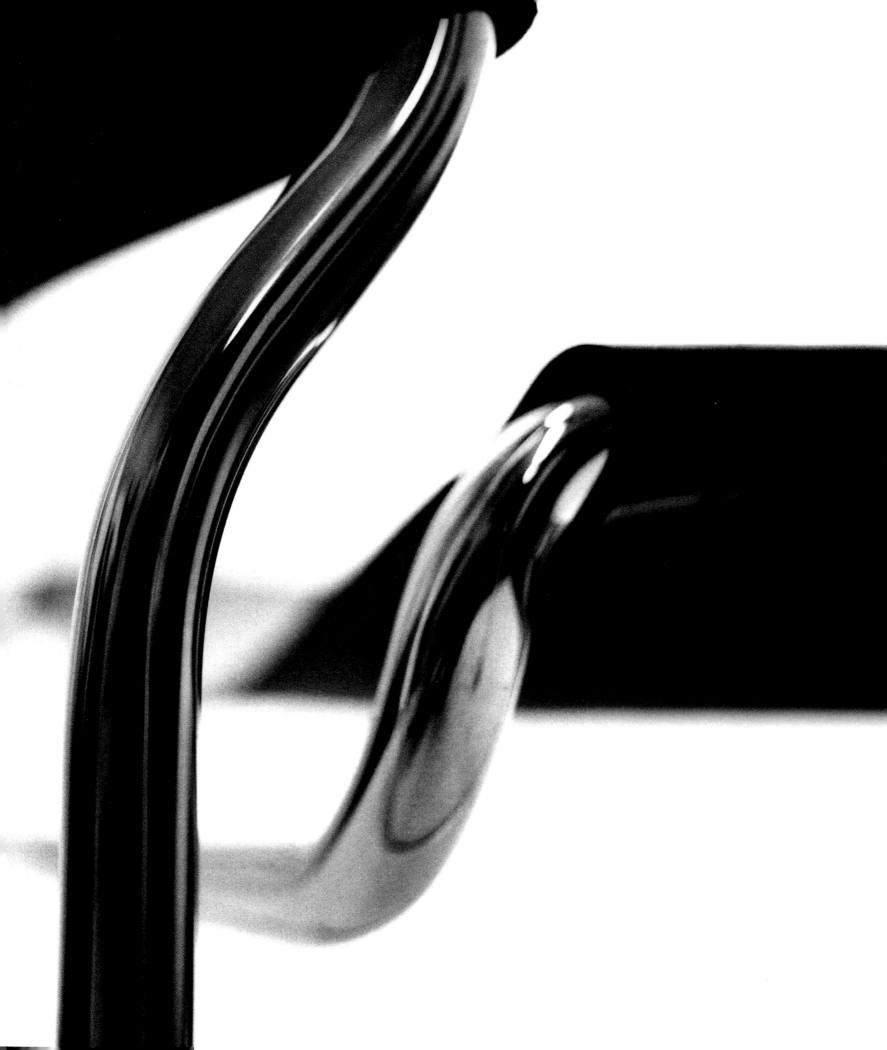

In art, the best is good enough. —Goethe

enry Moore! Sticks, Rocks, and Stones! These images come immediately to mind as I see again the fluid volumes of the chairs, and the end detail of the remarkably shaped frame on the Alpha bench. Where, from what primordial recess, does the piece that holds the straps get its exceptional form? Just as Moore's work was seen to combine the sensory, the conceptual, and the psychological, so too does that expressive chunk of stainless steel communicate its great strength, seemingly straining against the taut leather. Again like Moore, the forms are organic even when they are pure and abstract. They seem to touch on some archaic model.

Who is this man Zographos? Sculptor? Yes, and Architect and Craftsman. The man who has focused these attributes on the making of furniture. In a time when modern furniture design has moved from classical to pop to funk to high-tech, Nicos Zographos has maintained his focus and stayed true to his roots, indeed, true to roots whose origins are classical, Greece.

That amazing and archetypal chair—the original bucket— that is more than a chair, indeed, a throne. Its shape is unexpected: those arms, thin, sharply defined edges fading away into soft curves—so elegantly proportioned. Those coffee tables whose tops seem to levitate a hairsbreadth above their frames, and everywhere only the most rarefied palette to select from.

Here is an attitudinal presence at once rational and expressionistic. His Alpha base is completely different from everything else in its time: the subtle reveal making the transition from round shaft to petal base that gently, gracefully kisses the surface of the floor with its elegant reverse curve. Base as ballet, "these tiny precisions," to paraphrase Martin Amis, are the atoms that constitute Nicos's universe.

In this book, you will meet my friend of long standing, thirty-six years to be exact. You will learn of his education, his influences, and his evolution. You will see in his furniture evidence of a keen and critical eye, of an obsession for detail, of the constant refinement of both design and material. You will read of his Zen-like work methods—not simply preparing himself but reflecting respect for his art, his craft; homage through order. The drawings, sketches and studies, yes the working drawings too, are all so unselfconsciously beautiful because they represent a clear and scrupulous thought process.

Once, a number of years ago, I visited Nicos and his wife, Aliki, in their house in the Hamptons, and at one moment we had to run an errand, taking his car. As we got in the car, I noted what I thought was a dark leather case, and when I remarked on it, Nicos said, "Oh, this is a pillow that shields my hip from the transmission." So saying, he sheepishly held up the piece, not larger than a book. Here was wonderfully buttery leather stitched almost invisibly and containing just the right amount of padding to round out perfectly its irregular form. A soft, wrapped stone.

Who else would lavish on such an ordinary object such marvelous, refining energy? Who else but an artist for whom the best applies to all of life and for whom the best means not excess but the pure and the perfect.

Pay attention, for in all the noise, here is powerful silence.

uripides must have seen
Nicos Zographos in the future
when he stated: "The Greeks
are a people born into the world
to take no rest for themselves . . .
nor allow any to others."
He remains, resolutely,
one man against the world.
Compulsive, impatient, altruistic, demanding, pessimistic,
perfectionist, aesthetic, ascetic, worrier, visionary,
doom and gloomer, control freak (and ecstatically Greek!).
My kind of guy.

The Zographos oeuvre, the rock on which he stands,
is an unabashed continuation of the heroic period
of modern architecture: Le Corbusier, Breuer, Gropius, Mies.
But despite that design ethos, a Zographos space,
a Zographos object, is pure Zographos.

Original, thoughtful, with an intensely private vision and
extraordinary talent, he is a man of unwavering integrity.
His passionate belief in himself has never allowed
his elegant personality to blow his own horn.
But this book will be his Gabriel.

Nicos Zographos grew up amid the classicism of
the glory that was Greece,
the smoky ambience of Byzantine mysticism,
the spectacular vernacular of Cycladic architecture,
and the Bauhaus-inspired crispness
of pre-war Athenian housing as his family struggled
to survive the horror of Nazi occupation.

An American citizen he may have become,
but he spends much of his life on Greek soil,
continuing to drink in the art created by
generations of artists who have been the antennae
of human sensibility.

Nicos and I became fast friends when we discovered
in our twenties that we both worshiped
the Cycladic artists of five thousand years ago.
The pristine Aegean idols, exquisitely simple abstractions

of the human form, seemed magical to us, with
the spiritual intensity of form
that makes true connoisseurs genuflect.

When I acquired a stunning piece in 1962,
Nicos designed a marble and stainless steel vitrine.
(And it has contained its divine power for almost forty years!)
To ensure its perfect classicism, Nicos warned me
that his vitrine would be difficult to maintain,
but I happily regard the procedure of cleaning it
as a penance that must be performed . . .
a visit to my exquisite Zographos chapel each Sunday.

Nicos also designed two ad agencies for me:
one the epitome of Miesian sensibility,
the other his vision of a modern Manhattan monastery.
And of course, he created unique furniture for each,
including a spectacular oval director's table,
a dining-room table, stunning artist's taborets,
a marble drafting table springing out of a slate floor,
miraculously held up by a single, gleaming, sunken post,
and a wooden bar that would drive lesser talents to drink.

I learned when we were still youngsters
how to get the best out of him:
I let him do exactly as he pleased.
Along the way, other believers, architects,
interior designers, graphic artists, discovered him.
Zographos is the designer designers turn to.

Despite his demanding cultural sensibilities,
he has an unexpected respect for American popular culture.
I have always seen Zographos as
a Greek Gary Cooper in *High Noon*. A man who is right,
against his whole town, his whole world.

Nicos Zographos remains, to his bones, a Greek mystic.
He bears a striking resemblance to an iconic,
ethereal being, escaped from an El Greco painting,
viewing the ugliness of the man-made world below him,
and ascending to Mount Olympus where
he surely intends to redesign the house of Zeus
and everything in it.

he past hundred years or so have seen more innovative furniture design than any similar period in recorded history. Most of us are familiar with the extraordinary work done by (in no particular order) Marcel Breuer, Alvar Aalto, Le Corbusier, Charlotte Perriand, Mies van der Rohe, Charles Eames, Eero Saarinen, and a dozen more. Their work reflected several obvious facts of life: never have there been so many technological advances in so short a period of time, and never has there been such an enormous increase in population, with the resulting need for rapid mass production of virtually all things that people need to live and work and generally function—including tables, benches, chairs, and all the rest.

The opportunities for innovation were never greater—and not only for the reasons listed above: the basic principles advanced by the pioneers of modern design were more easily (and less expensively) translated from theory into reality if you were making simple objects like chairs and tables, rather than skyscrapers and cities. More easily, more inexpensively, and more directly—yet the basic principle turned out to be pretty much the same: the structural frame of a chair and the structural frame of a skyscraper are shaped by very similar factors, technical as well as aesthetic; and so we find that architects, whose principal interests were clearly in buildings and cities, spent years exploring the structure of chairs and tables instead. It was a lot easier to find clients for the manufacture of chairs than for the design and construction of Seagram Buildings.

Among those who have played a significant role in the design of chairs, tables, and related items, the Greek designer Nicos Zographos may be the least well-known. One reason is that he is a somewhat reticent person, unwilling to promote himself. But the real reason has to do with the rather special character and quality of his work—and with the ideas that motivate it.

Unlike most of the modern designers whose work shaped the new furniture, Zographos was and is not especially interested in social or technological issues; he is, above all, an artist interested in the perfection of minimalist form. His work, although clearly made for sitting or working on, is much closer to the minimalist sculpture of Constantin Brancusi than it is to the practical "equipment" designed by Breuer. In fact, although Zographos is a modern technologist in every detail of his work, he is really much more interested in the precisions and craftsmanship of steel and leather and glass and all the rest. His exemplar, in twentieth-century de-

sign, is Mies van der Rohe—and in fact, much of Zographos's furniture design clearly owes a great deal to the perfectionism and the detail found in Mies van der Rohe's Barcelona and Tugendhat furniture. And like Mies, Zographos is not especially concerned with mass production; he is interested in pure detail and form, in the quality of materials and in less is more.

And so he is really not a "modern designer" in the traditional, functionalist sense. His work has the flawlessness of Brancusi's polished marble and metal *Birds*, and the sharp edge of a Modigliani head. If it is also good to sit on, so much the better—but it may be even better to look at. He is not a technologist or an advocate of Social Betterment. Zographos is—pardon the word—an artist.

He is not alone in that regard, of course: I have mentioned Mies van der Rohe's furniture, which is probably better to sleep on than to sit or work on; and one might mention some of the chairs by Le Corbusier and Charlotte Perriand in 1928—dazzling works of constructivist sculpture rather than "machines for sitting on."

In short, this book is not really about chairs and tables, but about minimalist, perfectionist art. It's about the work of a sculptor who says that his exquisite objects have some functional purpose, which is almost as convincing a claim as pretending that Brancusi's marble fish will teach you how to refine your breaststroke. Like all sculptors, Zographos has looked at all kinds of forms—natural as well as man-made; and like many modern sculptors, he has been greatly influenced by the geometric forms of machines.

Some of his most elegant works are, in fact, exercises in Machine Art. The details of his leather sofa for the Alpha Credit Bank are much closer to forms found in Léger's cubist paintings than to organic forms that might be found in nature; and the details in some of his tables, where stone slabs meet stainless steel supports, almost but not quite—those are exercises in hairsbreadth precision, like oscillations performed in a magnetic encounter.

Are some of his details more perfect than others? Of course. But as in the work of all first-rate artists, there is a consistency that pervades everything: even the leather-covered pieces, some of which I find less persuasive than his stainless steel-framed chairs and tables, have an inner consistency of detail and of form that would be very difficult to improve upon. Are all his pieces equally comfortable? Certainly not—they are just equally delicious to observe and to enjoy. Are they the best ones done in our time? Well, there was always Mies and Le Corbusier and there was Charlotte Perriand. But Nicos Zographos certainly comes closer than anyone else has come in the past seventy years or so.

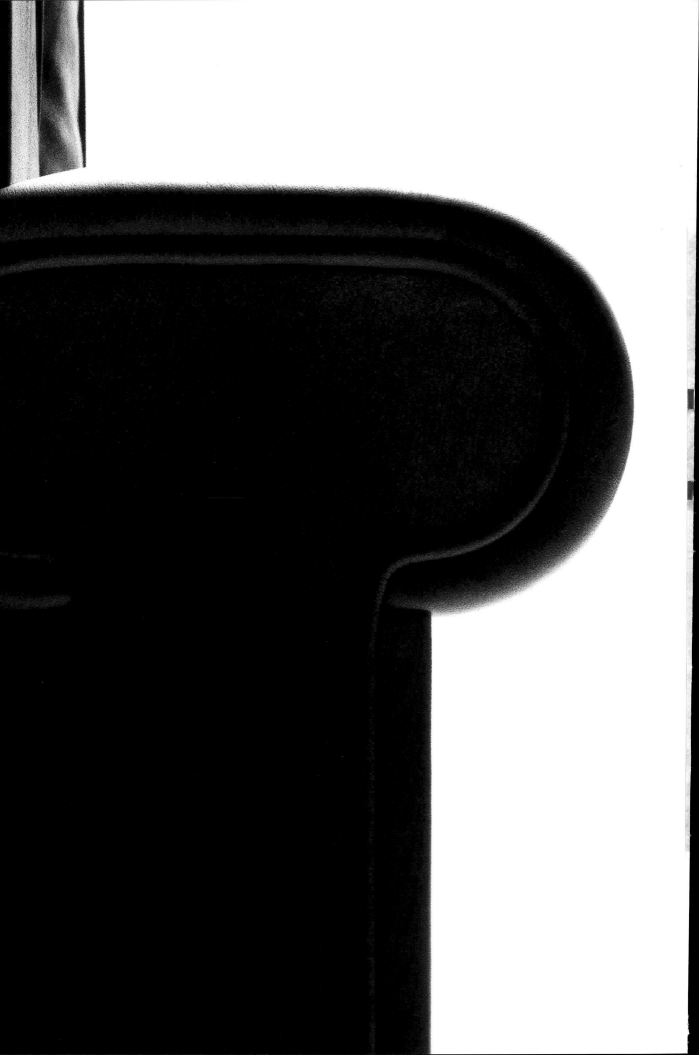

A few miles north of the isle of Rhodes, within sight of the coast of Asia Minor, lies the tiny Greek island of Symi. By the middle of the nineteenth century, Symi, along with its neighbors Chalki and Kalymnos, had grown from agrarian communities into thriving urban centers. The wealth that brought this transformation was created by a prosperous trade in the gathering, processing, and exporting of natural sea sponges to Europe and beyond.

The little neoclassical city that sprang up on Symi during that time filled the natural amphitheater overlooking what has been called the most beautiful harbor in Greece. Built over a span of only two generations, then frozen in time and almost abandoned when the sponge business declined, the architecture of Symi remains uniquely harmonic, with orderly rows of pedimented houses rising from the water's edge.

Nicos Zographos, the creative source of much of America's most urbane corporate furniture, descends from the people of Symi. His parents were born on the island, his father, Dimitrios, in 1900 and his mother, Fotini Petrides, in 1905. Both families had lived off the sea. Nicos's paternal grandfather was a deep-sea diver, sailing his own boat and collecting sponges throughout the Mediterranean and Aegean Seas, while the Petrides family traded sponges through their many business interests in Europe. After early schooling on Symi, Dimitrios Zographos left to study law at the University of Athens. Shortly before he finished, he joined the main office of the Credit Bank in Athens, where he was to stay throughout his career and ultimately become managing director. When Fotini Petrides came to Athens to enter finishing school, she renewed her friendship with Dimitrios and in time they were married. Their son Nicos was born in Athens on October 26, 1931, and a second son, Panayotis, was born in 1937.

The Zographos family began life in a decade of uncertainties: poverty, perverse politics, and war threatened all of Europe. But even closer to home, an old conflict continued to plague Greece. In 1922, immediately after Greece lost the battle over Asia Minor, the local Greeks were forced to flee, or left later when Turkey and Greece agreed to exchange ethnic populations to resolve the issue.

Greece was suddenly flooded by thousands of refugees, most of whom came directly to Athens. As the ancient city grew to accommodate them, its complexion was slowly transformed. Much of the new construction was designed by young Greek architects stirred by the principles of the German Bauhaus school. New structures based on the fresh ideas of European modernism rose beside old buildings based on classical principles. But remarkably, the city's modern and classical architecture did not clash; both had harmonies of logic that were surprisingly compatible.

In 1939 the Zographos family moved into one of the modern structures. Nicos was eight years old. Many years later, after creating hundreds of contemporary furniture forms, it seems that his work echoes his early surroundings. Sometimes it appears intuitively simple and shapely, at other times it appears distinctly rational and reductive. When he first took his wife, Aliki, to see the building of his childhood, she laughed and said, "Well, *no wonder*."

In late 1940 Greece was plunged into world war. Italy invaded the country through Albania and the Greeks successfully resisted, but German reinforcements overpowered them and drove south to Athens. The city was declared a white city to protect its irreplaceable monuments, but the rest of the country was ravaged. Wrote Dmitri Kessel: "From the beginning the Germans seemed to pursue a cold-blooded plan to exterminate the Greeks—through starvation or wanton murder. In the winter of 1941-42 alone almost half a million Greeks died of hunger."

When the Germans confiscated nearly all of the country's food supplies for themselves, Greece endured a ruinous famine. "It was really grim," Zographos remembers. "People would stand in line for hours for a bit of bread or a few beans from the Red Cross. I remember them starving and dying on the streets, and being carried away in little hand carts." But his father always managed to find ways to sustain his family. "He was a smart man," says Nicos. "He was dedicated, serious, very fair, and *very* honest. He did everything he could to isolate us. Somehow, from somewhere, he found a great number of cans filled with Argentinian corned beef. Our cupboards were full of it and we handed it out for years." Zographos laughs. "That damn stuff lasted a *lot* longer than the war did."

From ammunition they found on the streets, Nicos and his

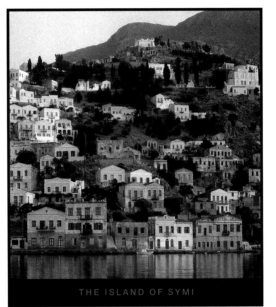

THE ISLAND OF SYMI

friends took gun powder and nitroglycerin to burn, or make deadly contraptions to explode against stone walls: "The stuff we did was crazy, *crazy*." But the Italian hand grenade he found was a delight. "It was a wonderful thing, shaped like a drinking cup and very pleasant to hold. It was *friendly*, not black and ugly like that German mallet thing. Made of aluminum I think, with each piece painted a bright color, like red, yellow, and light blue. I must have taken it apart, oiled the pieces, and put it back together a thousand times."

In 1942 the occupation grew even more harsh and dangerous, and Nicos's father decided that his family must stay at home. That meant tutoring for his son—not a thrilling prospect for an active young boy. "She was a stern old lady, very severe and very, *very* serious," he says with feeling, then a laugh. "But I guess I learned as much as anybody at the time, history, French, some ancient Greek, but not much math or science, and not a single art subject at all." After one sheltered year, he was allowed to go to public school: "It was really awful, with hundreds of kids stuffed in huge classrooms and nobody learning anything. Some kids were members of the Greek resistance. They brought loaded guns into school and put them right on top of their desks. That I *distinctly* remember."

Nicos was thirteen years old when the Allied armies defeated the German forces in Italy in late 1944. Germany withdrew to defend its own borders, Greek and British troops entered the city, and the occupation ended. Four years of abuse had systematically destroyed the country's health and economy. But still more trouble was in store for Greece. The German retreat had left a vacuum in government control and two groups rushed to fill it: the Greek resistance army, now leaning to the political left, and the troops of the pre-war Royalist government. The two groups clashed and five years of civil war followed. "And this time the war was *real* to us, with people shooting at each other all around our house," says Zographos. In early 1945 the resistance group was driven north into the mountains, where the fighting continued for four more years. The national trauma was complete. Athens was a desolate place, but in time, with British and American help, the old city gradually calmed and its natural rhythms were restored.

In 1946 Nicos entered a private lyceum noted for its excellent teachers. He had grown tall and thin, and his manner was pa-

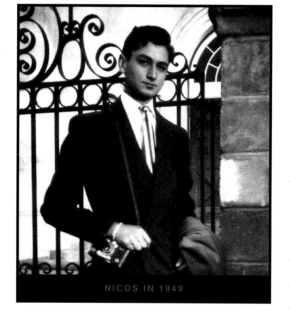

NICOS IN 1949

tient and subdued. "We hardly ever heard his voice," says his friend Xenophon Colazas. "Maybe because he knew the teachers called on the noisy ones. He had a terrific sense of humor in a very quiet and *sneaky* way." School life was steady and undisturbed for Nicos; there were no hints of things to come. Apart from liking to work with his hands, he was unaware of any creative urges. Enjoying his friends and quietly tolerating his education like everybody else, his future appeared to be safely predictable. By now, after years of watching his city and family overcome difficult times, his own reserve and cautious nature had become indelible traits.

But then a fresh gale of free spirits blew into town—the Americans. The war's last army to enter Athens, the Americans galvanized the old city and a whole generation of young Greeks with their leather jackets, MacArthur sunglasses, and lively sounds of jazz. "Well, we loved America for its help in the war. We wore American and we talked American. The impact they had was just tremendous," Zographos remembers. The vigor he saw was seductive, the music they brought hypnotic. "Every Sunday morning we went to listen to live jazz. Faithfully, like going to church."

In 1949 graduation from high school approached. The university in Athens had not fully recovered from the war, and if their families had the means, Greek students were advised to advance their education abroad. Again, Nicos's father managed to find the means. Just weeks before he had to leave for the fall semester, it was decided that Nicos would go to America to study a profession, something respectable like electrical engineering.

However, American universities were still crowded with war veterans. Nicos's school record was only average, his English was not impressive, and he had no clear goal. But good fortune brought forward a family friend, Marietta Isidoridis, and she helped him find a place at the State University of Iowa. Not too big, not too small, the school seemed just right for a not-too-sure foreign student.

And so, in August 1949, Nicos bought a dark blue suit and white shoes, packed one suitcase, boarded the ship *Nea Hellas* with his friend Colazas, and sailed off to America. Only one month before the end of the long civil war in Greece, the two young students set off on their American adventures and left the climate of war that had governed more than half their lives.

They landed in a very strange, outlandish place. Young and pulsing with energies, America was far removed from the battered and war-weary city of Athens. All the old boundaries in the post-war world had collapsed, intellectual and creative lives were on the move, and New York City had become the place to be. Eyes were shifting from the European standards of what the word *modern* meant, revolutions in all the arts were in the air, and restless minds were roaring and pummeling the establishment with outrageous thoughts. Architect Peter Blake writes of the time, "Eero Saarinen and Charles Eames, at almost the same moment, shifted the center of gravity of modern design from Western Europe to North America."

Design? What on earth was design? Upon arriving in New York, Nicos was stirred by other brighter, more tangible sights. The same American spirits he had watched racing through the streets of Athens were magnified and boundless in the big city. Cars and taxicabs were packed from curb to curb, neon lights spangled the stores, and construction bloomed on every block. Radios spewed endless noise on all sides, store windows flickered blue with the lights of tiny television sets, and jazz played all night every night in a row of clubs on West Fifty-second Street. Everything was "overwhelming, just overwhelming."

He began his travels west by train to Iowa. Now alone for the first time in his life, Nicos watched the country roll by: "So many cars, so many big buildings, big highways, big everything. The *scale*

of everything was just incredible." Even the flat plains around the school in Iowa City looked impossibly broad. But the town was small, blessedly quiet, and the local chapter of supportive countrymen, every Greek's family-away-from-family, quickly swooped down to greet him. Far from home, writing constantly to family and friends to relieve his isolation, Nicos settled down in this "institutional sort of place" and began his second life.

For over a year nothing much happened. He liked the school

NEW YORK IN 1949

and his language skills slowly improved, but he could not put his heart into engineering: "Physics, algebra, chemistry—I *never* figured out what was going on in chemistry—they were all a loss. I just was not interested in these things. I began to think it was a miracle I got out of high school." So did his adviser. "He said I was wasting my father's money; he said I should quit and go back home to Greece. But I didn't want to go back home. I promised I would do much better and talked him into letting me stay another semester. Then I raced to the catalog to find courses that looked easy enough to help me stay in school." He found something called industrial design. "I thought it was engineering design. I knew about drafting and I liked to draw, so I signed up. But on the first day, when I walked into my first class, I found myself in the *art department*. But from that moment on, everything, *everything* was different. Suddenly, I was getting straight *A*s, suddenly my world opened up. But most of all, it was *me* who was opening up."

Zographos speaks slowly and carefully. "Look, you have to understand. This design stuff I was hearing about was totally unlike the world I knew. I was a very rigid kid from a very rigid society. I was brought up and I lived in a very regimented way—'you have to do this, you have to do that.' Then suddenly, I found that I was completely *free*. I found myself in a place where nobody bothered me, where I could imagine anything I wanted, create anything I wanted, and do anything I wanted. And my teachers were for me and with me. The work wasn't something I had to do, it was something I *wanted* to do. For the first time I was inventing things that were *my* things, without following the ideas or dogmas of other people. It all began that first day in that first class. It's hard to explain. The class just made me feel really free and that felt very important."

It was 1951. In a few classes in a few short days, the young student was stripped clean, revealing many wants he sensed he had and many more wants he hadn't sensed at all. As vague as they were, new ideas and inclinations began to appear, and all at once, without needing to know why he had these thoughts or where they came from, he felt pressed to see where they led. Art students in their first year often have such revelations, but in pursuing them, this student had some distinctly uncommon advantages.

Zographos was heir to a celebrated culture of ideals from the

start. His youth had been laced with the spirits of classical beauty, Mediterranean warmth *(left)*, and modern rationality. In ancient times, the Greeks expressed the world's first principles of personal freedom, believing they would protect and enhance every individual's moral, intellectual, aesthetic, and practical life. The ancient Greeks revered knowledge for its own sake. As H. D. F. Kitto wrote, they were a people "not very numerous, not very powerful, not very well organized, who had a totally new conception of what human life was for and showed for the first time what the human mind was for." The Greek ideals, a balance of moderate living and discipline, were profoundly aesthetic and produced great art. "The extraordinary flowering of the human spirit which resulted in Greek art shows the spiritual power there was in Greece . . . Beauty and rationality were both manifested in it," Edith Hamilton wrote. As Pericles said, "We love beauty without extravagance."

THE PARTHENON

But that was long ago, before many centuries of cultural blending made the heritage of Greek descendants difficult to trace. Very few Greeks today can trace their roots directly back to those ancient times and beliefs. But as C. M. Woodhouse suggests, it doesn't really matter too much: all the glories of ancient times and ideals are still alive in Greek minds, and a Greek today is simply one who *thinks* he is Greek. Will Durant wrote, "The feeling for form and rhythm, for precision and clarity, for proportion and order is the central fact in Greek culture."

Zographos had another uncommon advantage: his successful leap from one culture to another had bolstered his flexibility and self-reliance: "For someone transplanted from his native soil, the ability to adapt is more than a knack that can come in handy. If one is to achieve any kind of security and stature in a place where one is destined always to be an outsider, it is essential." Writing about the Russian Alexey Brodovitch, an earlier immigrant to America's design world, Andy Grundberg also noted that "forced to invent his own identity, he became a master of the art of assimilating a variety of influences and forging from them a style of his own."

Nicos's first class was conducted by John Schulze, professor of design. "Right off the bat he told us to design a house. 'Go to your drafting tables and design a house on a hilly site,' he said. 'And while you're at it, design a fiberglass chair too.' That was my first semester," Nicos says. "Now, I didn't know anything about designing houses, let alone chairs. So I went to the library and began to look at everything that was being done by anybody, *anybody*. For the first time, I was reading a lot of stuff without being told to read it." He stops. "I mean, I was suddenly very *hungry*. I needed to learn all I could all at once, quickly. I didn't think I was getting enough in class, I felt I needed to get moving."

His awareness broadened. He learned about Frank Lloyd Wright, the American hero among hero architects. He learned about the two designers, Charles Eames and Eero Saarinen, who made molded plywood chairs and won a competition at the Museum of Modern Art in New York. The new process was provocative, like the fiberglass he was beginning to use in class. Although his first designs showed the influence of Richard Neutra and Wright, Nicos felt himself pulled again and again to the European Bauhaus school. The work of the architects Mies van der Rohe, Walter Gropius, and of course, Le Corbusier drew him like a magnet.

But especially Mies van der Rohe. Mies most clearly articulated the ideas of modern architecture and practiced them with phenomenal style *(below)*. He was, as Werner Blaser wrote, "the father of the new ubiquitous skyscraper, director of the seminal Bauhaus School, evangelist of the International Style in architecture—in short . . . probably the single most influential architect of this century." The presence of Mies was so large in the minds of admirers that it created some ambivalence, even in those who were most committed to his work. Zographos says, "I was very, *very* influenced by Mies," gently stressing his debt to the architect and the weight of it. But Peter Blake scotched the notion of owing too much to a mythic figure: "Understanding and following a valid rationale of aesthetics is not only historically logical, it's honorable. In Europe they would say that Nicos is continuing a very long and noble design tradition."

The Bauhaus was founded in Germany by Henry Van de Velde before World War I. In 1919 Walter Gropius became its director and defined the school as a research center for architects, designers, and artists. Emphasizing a commitment to technology, economics, and social change, the school created a comprehensive aesthetic of design and structure that was distinguished by simple geometries and efficient construction. The aesthetic was inspired by the work of Frank Lloyd Wright in America and Peter Behrens in Germany, and it was energized by the intellectually violent resistance to fussy and excessive art and design in Europe in the early 1900s. Its deeper roots may be drawn in a number of ways, but historians agree that what is known as modern architecture dates from the Bauhaus statements of belief in technological and social relevance.

Mies was appointed director of the Bauhaus in 1930. "The Bauhaus was not an institution with a clear program—it was an idea," Mies said in 1953. "The fact that it was an idea, I think, is the cause of [the] enormous influence the Bauhaus had on every progressive school around the globe." The idea was explicit: to respond to the growing needs of society and to exploit new technologies, the applied arts and industrial production would be reconciled for the good of all. Architecture, design, and manufacturing would work together to produce "the composite but inseparable work of art, the great building, in which the old dividing line

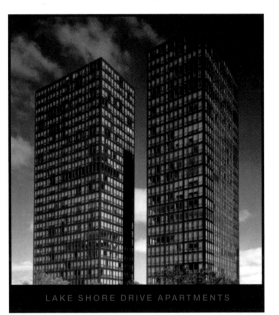

LAKE SHORE DRIVE APARTMENTS

between monumental and decorative elements would have disappeared forever," as Gropius wrote. Spaces would be *communities* of walls and furnishings that vastly stimulate the human spirit. Mies felt that "the shaping of space with structure is the true task of architecture. The building is not the work of art—the space is."

As Mies introduced his logical and practical alternatives to the dusty architectural traditions of the time, he was proclaiming the fundamental virtue of all design called modern: a discipline of thoughtful economy. His message resonated throughout the profession, stirred up the world's design schools, and spawned large collectives of young believers. Architecture had a larger role in society, he said; the role was spiritual and the way to achieve it was through *balance*. A space and its furnishings should be a landscape of harmony and balance, with the resulting beauty in the marriage of forms rather than in any one form itself.

Such thoughts were not unlike those of William Morris and the Arts and Crafts movement many years earlier. As H. W. Janson wrote, Morris too was "an apostle of simplicity," believing in total environments of architecture and furniture "designed in accordance with the nature of their materials and working processes." But Morris rejected the machine aesthetic and favored the hand-crafts of the past. In contrast, the Bauhaus revered machines and painted a glowing picture of fruitful partnerships between designers and manufacturers who could learn how to use machines properly.

The Bauhaus idea was timely and irresistibly rational—but sadly utopian. It was conceived by designers, proposed and practiced by designers, and cast designers (of course) in a prominent partnership role. Not surprisingly, industry had a problem with that.

After all, "industry" is the machinery of business, business usually means money, and money almost always means control. But feasible or not, the idea challenged the traditional establishment—an industrial society was obligated to make the most rational use of all its resources, was it not? This was the idea that Mies brought to America, to the design of his apartment buildings and the Farnsworth House *(below)* in Chicago, and to his students at the Armour (now Illinois) Institute of Technology.

The newest, most provocative design philosophy in the world had come within arm's reach, right into Zographos's backyard. When he looked at the buildings that Mies was producing, his intuitive attraction to the Bauhaus rationale was deeply confirmed.

Mies was not only a welcome prophet of the modern design aesthetic, he was extraordinarily good at practicing what he preached. "His towering faith in an architecture founded on logic and reason never swerved throughout his long lifetime," wrote C. Ray Smith. "Yet his use of space was undeniably romantic—

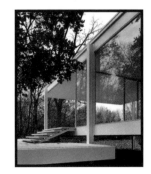

open and sculptural in its fluidity." Creating exhilarating spaces and wonderful objects to place in them, Mies realized the Bauhaus intent with more grace and eloquence than anyone before or after.

Dr. Lester Longman, a remarkable and prescient organizer of art schools, introduced the Bauhaus idea to the design curricu-

lum at the State University of Iowa. He added heavy doses of art and design history "until it came out of our ears." Within a year of his first art and design revelations, Zographos had buried himself in work. He completed his first foundation year, then took smaller, more focused seminar classes for three straight years: the same studio sessions in architecture, industrial design, and graphics with the same three practitioner-teachers. "None of them were specialists in what they taught," Nicos says, "they were artists. We ran our own classes and chose our own problems. The teachers were there to help us, guide us, and push us on."

In three years of design projects, he created buildings, interior spaces, sculpture, graphics, fabric patterns, and many kinds of consumer products. He built cabinets and tables out of wood, and he hand-formed chairs out of fiberglass, plastic, and bent plywood. When there was time on weekends and between school semesters, he traveled to see the products of the theories he was learning. He walked through structures by Wright and Mies in Chicago and he admired Mies's buildings at the Illinois Institute of Technology. In 1954, after four years of study, he received his degree in fine arts. The rude shocks of his awakening to art in that first class had grown into a lifelong commitment to design.

But the four years at the university weren't enough for him: "I didn't think I knew what I needed yet and I really wasn't ready to leave. I loved the school and I wanted to stay as long as I could. Besides, it's always been hard for me to leave a comfortable place no matter where it is, home or school or work." A vast understatement. Years later his life would be described by a friend in New York as a series of time capsules, each carefully fashioned for long periods of serenity and continuous work. The school had become his hermitage, a place of isolation he thoroughly enjoyed and obviously meant to squeeze dry. "By the time I got my degree, I had a one-track mind. I was a fanatic about design and modern architecture. In my slow and gradual way, I had come to believe that my principles could be pure, and I just about killed myself all day and all night making sure that the principles were right."

NICOS AND JOHN SCHULZE

John Schulze recognized the value of such extreme diligence and proposed that Zographos be offered a teaching fellowship for the next two years. That was great news for Nicos. His time capsule could remain undisturbed for a little while longer, he could stay in school and continue to work, and he could earn a master's degree too. The fellowship money was necessary, of course, but the gesture of support from his professor meant a lot more: "I just can't tell you how good it felt. This man was my teacher. I liked working with him and I liked the students in his class. He told me not to worry about the future, I would be fine no matter what I did.

At the time I really needed to hear that." But most of all, the fellowship grant brought reprieve: it was a welcome means to delay change. As much as he enjoyed the teaching, he would never do it again, nor would he express his design ideas in public more than once in the next forty years.

During the next two years, Zographos enjoyed the satisfactions he found in hard work, growing more focused and, if possible, even more intense. But he also found that having a lively mind around could distract him from his overly serious ways, like the mind of his new friend Donn Moulton. "We met the day he arrived for graduate school, and I talked him into taking design instead of painting. He still says he will never forgive me for that," Zographos laughs. "But Donn became my closest friend. I was so serious and he was so *alive*. I have always needed people like him, people who aren't at all like me, like my friend Colazas in Greece. So to survive the work and to keep me company, I listened to jazz on the radio twenty-four hours a day, and I listened to Donn Moulton."

In the years ahead, finding lively minds to balance his own would become as natural as drawing a pleasing curve or detail. "If we didn't make him laugh," says Donn Moulton, "he was a lot less than happy with us." In New York, his friend George Lois would provide seamless laughs, as would designers Bill Katavolos and Gary Fujiwara. Eventually, Nicos's wife, Aliki, would lift him through dark times. "Well, you could say he's a fanatic, he's crazy, and he's neurotic," says Aliki, "or you could say he's a focused and serious

artist—it all depends on how you see him. But whatever you decide he is, he can be a really funny guy to watch. I laugh a lot. I think he needs to hear me laugh, he needs me to be a clown for him, just like he needs Gary and George and Donn. And for us, he's perfect: he's got a great sense of humor."

While the design courses at the university were collectively called industrial design, they were developed like most design programs: to cultivate the imaginative mind, not the practical one. The schoolroom became a creative cloister in which students were asked to specify the projects they wanted to solve, then solve them with their own ideas. Nobody worried too much about commercial markets, costs, or manufacturing limitations. Eventually, however, some realities must invade such a cloister; students must learn to move from the safety of their own self-invented perspectives to the more pragmatic views of working professionals. Usually they manage their conversions by needing to respond to a real-world problem, one that tests their ability to work successfully within a number of tight constraints. Zographos was tested when he received his first commission, a request from the engineering department of the university to design the interior spaces and furniture for a new student lounge.

The results were prophetic, to say the least. Not only did his solution for the lounge satisfy the problem, it included a detail that reached far into his future. Hanging from the walls, looking like nothing he had produced before, was a cantilevered seat with tightly welted cushions *(below)*. Three years later, given a new base made of steel bars, the seat would be transformed

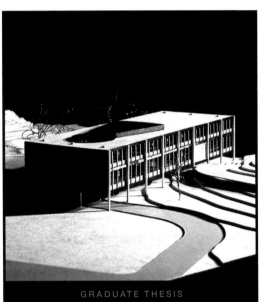

GRADUATE THESIS

into a freestanding lounge chair and win a national furniture competition. Two years after that, the chair would become the Zographos chair, the first product he built through his own company and sold to the American furniture market. Today, more than forty years later, Zographos Designs Limited continues to manufacture the same chair—a remarkably long life span for the results of a young student's first professional commission.

Zographos earned his graduate degree in 1956. The master's thesis he wrote expressed his beliefs in the training he had experienced at the university and promoted the values of three consecutive years of problem solving. It concluded with plans for a new teaching facility. Essentially, he described what should happen at a school of design and showed the kind of place in which it could happen. The building he visualized was a cool, two-story structure, a clear sign of his prevailing preference for the Miesian idiom. But within it he designed another prophetic detail—a graceful spiral staircase that softened the rigidly square geometries of the building. He would later use the same kind of staircase to mute the severity of several corporate interiors and residences. The cantilevered seat made a second appearance, and a post-and-beam steel and glass table whispered of similar furniture products to come. All in all, the Zographos thesis was a tidy piece of foreshadowing.

With his portfolio of interior and furniture projects in hand, Nicos finally left the comforts of the university and Iowa City. He had submerged himself in the little town for seven years without interruption, without a single trip back to Greece. He had come for an engineering education and he left with a creative education. Veils had been lifted. Certainly he was a novice professional, but his views and methods were unusually advanced for a design graduate and it was time to go. Within a year, good fortune was going to place him in another right place at the right time. *Love Athena*, the Greeks say, *but move your hand*; God helps those who help themselves. Finally ending his long journey from home, he left the safeties of school and returned to Greece.

Soon after arriving and settling in Athens, Zographos met Aliki Sourrapas, the woman he would later marry. But his search for design work was frustrating and unproductive. The few interior projects he found were not interesting enough or sustaining, and his eyes kept straying back to America. He followed what was happening in New York by reading architectural trade magazines, but all of it seemed so very far away. Soon his isolation became too much to bear, and he decided to return. He contacted the Athens office of an American contemporary furniture company and through it sent a letter of introduction and his portfolio of work to the interior designer Florence Knoll. Shortly afterward, far more confident this time but just as blind to his prospects as when he first left Greece, he followed his portfolio to the big city.

ew York City, still humming in 1957 with post-war energy, was flush with intellect, art, and entrepreneurs. Full grown and well fed now, the flames of expression flared up even brighter than before, whether abstract, pop, or otherwise; jazz was playing at Carnegie Hall; poetry was howling in downtown coffee shops; and the Seagram Building was rising on Park Avenue. "I don't believe New York," Dylan Thomas said. "It's obvious to anyone why. All the same, I believe in New Yorkers. Whether they've ever questioned the dream in which they live, I wouldn't know . . ." Bulging with purpose, the city chased the heady scent of profit. "Only the poets remain pure," said Larry Rivers as art and design became big-market commodities and creative products filled the streets.

Into this hopping place walked a man who wouldn't hop if you jabbed him. Now twenty-six, tall and erect, with near courtly grace, Zographos moved in slow time as if assessing and approving each step before he took it. He placed himself *precisely* in life, in conversation and in front of his drawing board, just as he placed his drawing tools precisely before him. He spoke distinctly, with bursts of emphasis and conviction—"It was the way things were *done* then, there *was* no other way"—as if he thought you too slow to understand his meaning. The effect was oddly compelling. He talked to you darkly but directly, and his saying "*Look*, let me make this really *simple* for you" was magnetic and binding. The intensity belied his humor; to tease him about it, to plead for some lightening up please, only made him laugh. His point-blank manner seemed to amuse him as much as anyone.

Not that it made much of an impression on Florence Knoll. Zographos went to the company to pick up his work, received his polite "Thanks, but no thanks," and left with no job and no idea where to go next. "I knew very little about how things were done in those days, I was really naive. All I knew about architecture and design came from reading magazines. I knew which buildings were extraordinary and who the good architects were, but I didn't think I had the qualifications for big firms. I didn't know how I could reach them anyway, I had no connections." So he did the most rational,

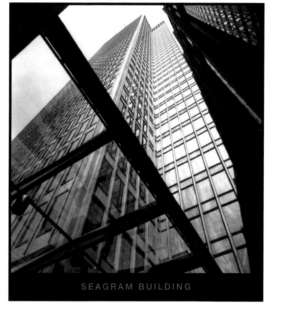

SEAGRAM BUILDING

most unheard-of thing: he looked in the Yellow Pages. Under architects. Under architects who appeared to be Greek. "Well, they're not too hard to spot, you know. I made a list and I began to visit one after another—in alphabetical order. Some of them were really awful, some almost laughed me out of their offices. I got really discouraged." But in time, he reached the *M*s and Paul Mitarachi. Mitarachi, who would work with Zographos on two houses much later, liked what he saw and promptly threw him to the wolves and winds of a big-time, big-thinking hurricane: the architectural firm of Skidmore, Owings & Merrill (SOM). Roy Allen, an associate of the firm, took a look at the young designer's work and hired him on the spot.

In one quick serendipitous stroke, he had been drafted by the most aggressive architectural firm of the day, a firm that had just organized the profession's first full-scale, in-house interior design department, a firm whose furniture designer had just resigned. For the next five years Zographos would be soothed, shaped, and smacked by the passions of architects using the ideologies of European modernism to redefine corporate architecture in America. "I couldn't believe it," he said of falling into his bed of roses. For a while he would subordinate himself to the principles of others, but after all, those principles were not very far from his own. In his first (and only) salaried job, his thoughts would not be undermined—they would be enlarged and reinforced.

Anybody with an ounce of imagination relished New York in those days. So much was happening in so many other design hurricanes, like the graphics at CBS, the advertising at Doyle Dane Bernbach, and the product design at George Nelson. It was a prime time for clever minds. Pushing them along, nursing every profit-promising idea they had, was the enormous patronage of Big Business. Since the end of the war, and the end of the demand for war products, the machinery of corporate America was hungry to find other markets with even greater demands. It found everything it wanted in the innocent, dollar-rich, product-hungry consumer public. To tempt and cultivate these new customers, business needed lots of things to sell and powerful ways to sell them. For the next two decades, for better or worse, business would use its money to hire the arts, design, and architecture to serve its purpose—which was nothing less than the reshaping of the American economy. To

be sure, all sorts of things were possible when the arts of design were allied with the crafts of industry, just as the people of the Bauhaus had dreamed. But the setting was not at all what the modernists had hoped; within the scope of the American corporate umbrella, the alliance could not be a marriage of rational ideals, it had to be a collaboration of commercial expedience.

For architects the prospects were promising, but after the first surge of corporate money came some second thoughts. As Peter Blake wrote in 1964, "Just about the *only* factor that determines the shape of the American city today is unregulated private profit: profit from speculation from land, profit from manipulating land and buildings, and profit from the actual construction and subsequent lease or sale of buildings. With very, very few exceptions, the buildings constructed in our cities are built without the slightest regard to matters of urban design. They are built, solely, for the purpose of making a fast buck faster."

The SOM brand of architecture perfectly suited a fundamental goal of the new corporate scheme: profit through persuasion. While some architects took the low road and cookie-cut one speculative building after another, and other architects took the middle road and elevated the values of land with one city complex after another, SOM took the high road and produced one building-as-impressive-corporate-icon after another. Within the immense, column-free

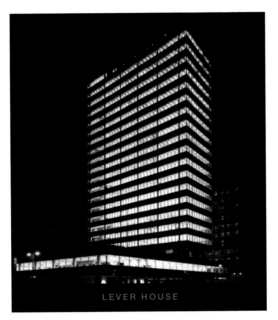

LEVER HOUSE

spaces that war technologies had made possible, the firm brokered the Bauhaus idea and applied its visions of spare economy to every building it built. The International Style was the practical and tactical heir to the principles of the Bauhaus, and SOM succeeded in establishing it as the preferred corporate image. In the midst of whirling profit hunts, tightly corseted by unsympathetic zoning and tax regulations, the architects developed the SOM agenda: "a commitment to the inventions and abstract formal constructs of modernism; a will to serve, unstintingly, the large corporate institutions through rationalized and often innovative planning; and an unswerving pursuit of available technology," Stanford Anderson said. "These were accomplished technocrats."

SOM had offices in six American cities. Leading the charge in the New York office was Gordon Bunshaft, certainly one of America's most under-credited architects. In 1952 Bunshaft finally realized the early Bauhaus goal of a skyscraper sheathed entirely in glass when he designed Lever House in New York. The building is still called a key pronouncement in the evolution of the International Style and is generally considered a landmark in the use of architecture to dramatically advance a corporate presence. Anderson wrote that Gordon Bunshaft, "more than any other designer, shaped the production of the great architectural firm . . . which in turn set the standards of corporate architecture."

Bunshaft was a design autocrat: an implacable hard-hat hardliner, who wrote his own bible as he went along. He was a perfect model for an equally certain young designer. Zographos understood authority, and he respected Bunshaft's version of modernism. Bunshaft often excited him and just as often frustrated him, but he was deeply impressed by the man's force and his stubborn, relentless consistency.

In 1957, shortly before Nicos joined the firm, Bunshaft finished the suburban headquarters building for the Connecticut General Life Insurance Company. The project was widely admired for its innovative plan and details, but Bunshaft had clashed with the building's interior designer and he wasn't happy at all. Henceforth, he decreed, the firm would create its own interiors, and furthermore, it would do the job differently. He hired people with widely disparate, and not necessarily architectural, backgrounds and blended them to form SOM design teams. To Bunshaft, it followed that more interesting interior spaces would be produced by diverse and interesting people, spaces that would be consistent with the ideas he had for SOM's architecture.

It was a set piece of Bunshaft tyranny and it was a bold move. Controlled interior architecture had been explored "by a few major firms like McKim, Mead and White, but not at all on the scale that Bunshaft intended," says Davis B. Allen, who had left Knoll Associates and come to SOM for a job in 1955. "At first, Bunshaft was cool to the idea of hiring me, that is, he was cool until I offered to work six months for nothing." Allen brought charm and natural taste to the work, soon becoming the most visible point man for interior design produced by the SOM teams, and the first true prototype of the American corporate interior architect.

In 1956 Allen was designing the interiors for the Hilton hotel in Istanbul. When the SOM clients for the Inland Steel Building in

Chicago visited the city, Allen invited them to tour the hotel interiors. As George Larson wrote in his book *Chicago Architecture and Design*, "Allen had done what would become increasingly impor-

tant in modern architecture. He gave otherwise plain modernist buildings distinct and memorable touches." The Inland clients, Leigh and Mary Block, decided they wanted Allen to apply his talents to their building in Chicago *(left)*. So began the first concentrated effort by SOM to stretch its rationale for a glass-wall building wide enough to encompass all its interior spaces.

Given the luxuries of a handsome building exterior, a clear-span space on each floor, and the Blocks' interest in purchasing a collection of large-scale modern art for the offices, Allen had all the ingredients he needed to create a thoroughly contemporary corporate environment. Utilizing Inland Steel's raw material throughout the building, Allen designed lounge chairs made of steel-mesh, upholstered chairs on steel legs, and an office desk that "was quickly adopted by the furniture company that manufactured it, Steelcase, as one of its trademark products," says Larson. "Inland's was one of the first interiors to be integrated so completely with modernist architecture on such a large

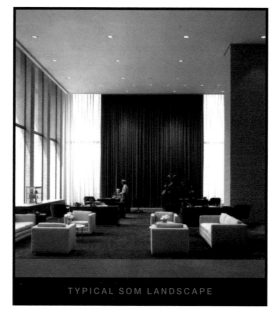

TYPICAL SOM LANDSCAPE

scale. What was a handsome piece of architecture inside and out, also became a convincing blend of technology and corporate image-making. Other corporations, including Chase Manhattan Bank in New York City, would follow with SOM designing equally distinctive urban monuments for them." In 1958, shortly after Nicos joined SOM, the Inland building was completed. In the two years that Bunshaft and Allen developed the project, they set most of the exacting standards to which the firm's interior designers would work.

Bunshaft built three teams on the Allen model, with Allen directing one team and Alan Denenberg and Jack Dunbar hired to direct the others. Eventually there were sixteen people on the three teams, almost always working on separate buildings but sharing space, facilities, and their growing experience. "Some of us came from oddball, strange places and we were all still learning," says Dunbar, who had come from the design staff directed by Alexey

Brodovitch at *Harper's Bazaar* magazine. Davis Allen recalled the team mix as rich and nourishing: "The office becomes like a design studio. You are inspired. People become prolific. Designers are not given these kinds of opportunities often enough. They all just blossom when they have more responsibility."

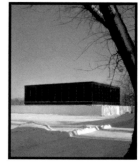

On his first day, Zographos was assigned to Dunbar's team and promptly immersed in the first of three projects that would last his entire tenure at the firm: the Reynolds Metals building in Virginia, the Union Carbide building in New York City, and the Albright-Knox Art Gallery in Buffalo *(above)*. While team member Gary Fujiwara was struck by his quiet austerity and obsession with making perfect drawings, Dunbar remembers his intensity most vividly: "It wasn't his style or language, he just seemed to be in a different *place* than the rest of us. When he came to me there was no question in my mind, to any of us, that he was somebody special. I remember watching him sitting down to work, dusting off his perfectly clean desk, moving a piece of paper, polishing a triangle, slowly arranging his tools around him, nudging them parallel or perpendicular, whatever seemed right—it took him some time before he was ready to work. After a while I realized he wasn't procrastinating, he was meditating. He wasn't arranging his things, he was arranging *himself*." With his radio at hand playing jazz and the monologues of Jean Shepherd ("I have hours and hours of his tapes reminiscing about the Midwest—the people, the landscape, the train whistles at night"), Zographos settled into his apartment on East Tenth Street and began life number three.

The job to be done was elementary. Whatever the SOM project, the interior teams were asked to bring the spirit of the architecture inside the building. They were to *landscape* the interior with color, fabric, and furniture to enhance every space and its use. By the 1950s, the technology of load-bearing skeletal structures had vastly opened the breadth of a building's interior spaces, and the design opportunities were nearly limitless. As Werner Blaser wrote, Mies himself exploited the same open landscape when he "designed special furniture in keeping with his interior spaces, and with

prophetic intuition, created the unity of building and furniture."

However, designing virtuous products for SOM spaces meant viewing the spaces through the SOM telescope—and that telescope was cubic. The flat grid and the constraints of partitioned volumes pervaded every building SOM did. If it wasn't a five-foot module (Lever House) or a six-foot module (Connecticut General), it was some other module. "The Union Carbide building was modular right down to the ashtrays," says Peter Blake. "From the design point of view, the five-foot module created pleasantly open corridors and reception spaces; anything smaller seemed compressed. But the point wasn't design or pleasant spaces anyway, the point was consistency. Consistent spacing meant cheap building."

The economies of building within the available construction sizes, standards, and materials could not be denied. Like Blake, George Larson felt that "modular building of the time had very little to do with the people who occupied the space or their needs, and everything to do with the economic return for a building's developer." And modules were so satisfying; everything came out so damn *even*. One almost could hear the parts of an SOM building fitting snugly together: click, click.

In order to save construction dollars, SOM used spatial grids to marry the ideas of modern architecture to standard building components. No other firm applied the marriage more energetically or produced more significant modular buildings. Led by Bunshaft's "ready endorsement of visual simplicity as central to the art of architecture" and his use of standardized construction systems to achieve it, SOM made some truly grand spaces.

Still, one wonders if the constraints of modules eventually infect the lively minds that apply them. George Larson describes the "fraternities of wounded people" that he remembers at SOM. Industrial designer and social advocate Victor Papanek referred to studies showing how "shaping our surroundings sets up a closed feedback loop that ultimately shapes us." About the same time, similar fears about the consequences of modular thinking in other more removed fields were being expressed: Marshall McLuhan was calling sentence structures idea-repressive, and Alexey Brodovitch was calling page grids image-repressive.

Regardless, straight was straight at SOM and corners were

ROUNDING THE SQUARE

square. Curved was, unfortunately, curved. "They hated round legs and shapes in furniture," Zographos says. "I think they saw furniture as little post-and-beam structures with planes and edges just like their buildings. They wanted little buildings to put inside their big buildings. It was very hard to get them to soften anything." When the visually compressed look of cubes is mentioned, Zographos points a finger in the air, says, "Ah, *entasis*," and then laughs. But entasis, the Greek word for altering lines and shapes to make them *appear* to be straight and perfectly geometric, was a realm of illusion, a kind of manipulation that could not exist within the SOM allegiance to standard modules and building systems. All the same, this reign of organized precision at SOM served to embed the discipline that already marked every Zographos design.

Even more valuable was the developing sense of space in which his design could be disciplined. Niels Diffrient, designer of many of America's most advanced ergonomic products, recalls the architect Eliel Saarinen saying, "Always think of the next largest thing." SOM gave Zographos his next largest thing: a series of empty volumes in which to visualize his work. "I always, *always* think of the things I do as part of a landscape," he says. "I probably always will. At SOM I learned that almost nothing except cabinetry was placed next to walls, everything had to stand in clusters away from the walls or stand alone. I began to see a mental picture of this landscape, and carefully place objects in it. Every object was an island, like the furniture by Mies *(below)*. Each object was separated, each was sculpturally beautiful from all sides.

"I began thinking of my design as an act of art in open space, like a David Smith or Calder sculpture in the middle of an open field. But everything had its precise place—everything was designed to fit that place and it was not to be moved." He laughs. "I mean, we deliberately made furniture so heavy it took four men to move it a half inch. Placement, object, and function, that was the proper order of things. Just as Mies meant his furniture to flourish in the Farnsworth House, I tried, I still try to create forms that can flourish in these landscapes."

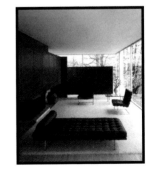

He hesitates. "SOM also gave me some really strong urges to react *against* these spaces, to escape their rigidities." He clearly remembers the first time he rounded a corner joint in the steel frame of a small glass table where the vertical leg post joined the horizontal cross beam. For no functional reason at all, he softened the stark skeleton—so much like the cage of an SOM building—with a sympathetic turn. SOM purists could call that turn fussy and probably did. But Zographos, always (and forever) inclined to squaring detail, was beginning to make rounds where he sensed rounds ought to be. "Then I started to soften cushions in sofas. At first I held the outside planes of the sofa cube, then I began to round the cushion edges a little, then I broke the cube by raising the backs and arms a little. I remember how *liberating* that felt." The small freedoms, the few subtle curves, warned of a sea change coming—tiny notes of warmth were beginning to color the cool shapes.

As for SOM's response to the table, Zographos only sighs and laughs: "A major, *major* breakthrough." When told of it, Peter Blake also laughs: "You know, that little rounding is no small thing. To talk architects into liking a filled corner was a nice little victory, but to make it—that's a real pain in the neck." Blake takes up a pencil and draws the legs of Mies van der Rohe's Barcelona chair *(below)*. "You see this roundness where the two legs cross? A little separate curved piece of steel had to be carefully cut, inserted, and welded to fill that joint. Then the gaps had to be filled, ground smooth, then buffed—it was really, really tedious.

"As far as designing the table corner goes, well, you need the mind of a watchmaker to do that," Blake says. "In that sense, Zographos is very reminiscent of earlier designers like Mies. Their furniture was handmade in a painstaking, aristocratic, almost baronial manner. The Barcelona chair, for example, has come to be a

model of design and manufacturing economy, but it was actually the opposite—a very expensive undertaking. Of course, that made it just the sort of thing that Bunshaft would want to have in his palaces for the new rich, the corporations." Thanks to big budgets and the corporate passion for supremely refined

executive spaces, price almost never mattered at SOM—full speed ahead, make the place *look* grand, and damn the cost. So removed was the firm from cost restraints, it could generate spectacular concerts of interior design, leaving nothing untouched, refining every detail right down to the smallest cabinet hinge.

In this context, design was supreme. As long as SOM got the SOM effect, Zographos was free to design as he wished—a freedom that likely had a more lasting effect on him than the constraints of the SOM modules. "For the first time in my life, I found people who really cared about the little things. Like table frames made of miniature T-beams and hinges that worked like Swiss watches. And Allen-head bolts—they *loved* Allen-head bolts. Well, I loved them too, the things were so precise, so much like precious jewels."

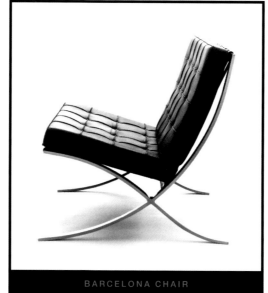

In such a robustly extravagant place, with design latitudes so wide (within the modules) that they nearly vanished, it was hard to sustain a grip on practical values. But Zographos had his shell of caution to protect him. "I thought him very balanced," says Davis Allen. "Whatever you asked him, he thought first and then gave an honest and direct answer. I considered him very Greek in his attitude—by that I mean the best of the Greek thinkers—and of course, he was one of the best designers I've ever known." Still, wide latitudes or not, Zographos's ideas had started to roam beyond the confines of SOM to his own kind of chairs.

Speaking of chairs as artifacts of culture, design critic Ralph Caplan says, "There probably are few more powerful symbols in contemporary life. Stemming from the times when only the powerful had chairs, the chair may be the first status symbol." He and other observers feel the shapes of chairs reflect attitudes and values that are much more complex than simply creating a good place to sit. When a chair captures those values in a special way, when it gains a greater societal meaning than its practical function, the chair becomes an icon of the society that produces it. The Egyptian throne is an icon of power from the ancient world, the Shaker ladder-back chair an icon of restraint and self-denial from the nineteenth century, and the bucket seat an icon of business power today.

In fact, chairs can be found that fairly represent the world's major cultural changes in the last two centuries. The nineteenth-century chairs of Michael Thonet, made of swoopy mass-produced

parts that were uncommonly simple for the Victorian age, represent early attempts to bring the crafts of the time into the industrial age. The rigid planar chairs of Gerrit Rietveld in the de Stijl period represent the twentieth century's use of product design to dramatize artistic expression and rejection. The chairs of Charlotte Perriand, Le Corbusier, Mies, and Marcel Breuer represent the modern emphasis on utility, and the molded chairs of Alvar Aalto, Eames, and Saarinen represent the opportunities that can arise from a war's explosion of industrial techniques. Today, ready to represent a new emphasis on worker health and efficiency are the articulated chairs of Niels Diffrient and Bill Stumpf—chair icons in waiting. Of course, any brief survey is bound to neglect some significant symbols, but if we think of chairs as memorable portraits of their time, not many others can be so quickly brought to mind.

The most readily imagined modern design icon, the one that rises above every other in the last hundred years, is the Barcelona chair. It has become the world's most admired industrial art object. The chair is a royal statement by Mies, and royal is just what he wanted it to be: "I knew that King Alfonso XIII was going to visit us at the International Exposition in Barcelona during the opening in 1929. I therefore designed the Barcelona chair for a king. When I went back to my pavilion shortly before the king's arrival, to my surprise I found a wanderer sitting in the chair. I ordered him out with the following words: *For you I made a bench outside by the pool*."

Perhaps the Barcelona succeeds because it is so much like Miesian space itself, an architecture "characterized by poetic clarity, homogeneity, and restraint yet unparalleled elegance." In the simplest sense, a Mies building is a steel frame with filled openings. As Werner Blaser wrote, a Mies chair is not dissimilar—a steel frame that, "joined simply and cleanly, forms the skeleton of his furniture, while the filling elements—the 'skin'—lie freely on the steel frame." Sitting in open space, the Barcelona chair seems to wait, patient and serene. Always in tandem with another, always the ceremonial pair (well, have you ever seen a group of three?), the chair rests precisely, as if welded to the floor yet poised on its toes and ready for flight: a portrait of delicate balance and harmony.

In 1958, just a year after joining SOM, Zographos added a bent-bar base to the cantilevered bench he had designed at school

ZOGRAPHOS LOUNGE CHAIR

and produced a freestanding steel and leather lounge chair—his first independent furniture product *(below)*. He entered drawings and a seven-inch-high model of the chair in a competition sponsored by the National Cotton Batting Institute, a trade organization encouraging the use of cotton in product design. Like the Barcelona chair, the transformed Zographos bench had a clear separation of frame and seating surface, a tight skin of welted leather, and cubelike dimensions—all conforming to the SOM way.

But unlike the Barcelona, the back and seat of Zographos's lounge chair formed one continuous bending pad instead of two flat and somewhat rigid pads meeting at an angle. Also, the Zographos frame followed the lines of its pad instead of touching it delicately at crucial spots. The most distinct difference was the design of the Zographos base: instead of crossing to rest on the tips of four legs, the bars of the frame joined in vertical spines below the seat, then split into floor sleds. Regardless, apart from the details the two chairs were essentially alike. Both had been architecturally perceived, and both were distinguished by profiles that were minimal and starkly linear.

Like all the SOM furniture Zographos designed, the lounge chair was drawn in full-size side elevation. A metal craftsman built a miniature model from the drawing using thin bent aluminum bars for the base. The same drawing-model sequence was repeated when Zographos made miniatures for other chair competitions and repeated again later when the models became full-size prototypes of products for his own company. Apart from making sculptural shapes, which he found impossible to draw, the full-size elevation drawing method became his most common way to realize furniture ideas.

The regenerated lounge chair won the NCBI competition in 1959, and small measures of publicity began to arrive. When he was approached by a company interested in manufacturing the chair, Zographos was given an opportunity to test the Bauhaus dream— his first chance to see if a partnership with industry could succeed. His partner would be Albano, a traditional furniture company represented by an aggressive sales entrepreneur, Jack Creveling.

For some time, Creveling and Albano had cultivated a commercial alliance with SOM. Creveling brought new technologies to the firm, such as the honeycomb aluminum mesh that Albano had used to strengthen helicopter floors during the Korean War. SOM was just beginning to design the headquarters building for Reynolds Aluminum in Virginia, and the architects had been asked to incorporate aluminum into building products as often as they could. So with the help of Joe Bscheider, a gifted craftsman at the Albano factory, Zographos adapted Albano's honeycomb material to make stronger, lightweight cores for the tops of boardroom tables. The experience was a healthy one. Zographos liked the aluminum technology and the close factory involvement, and he liked the Albano company: "Bscheider was much more of a perfectionist than I have ever been. I also found that I liked to watch my things being built a lot more than I liked sitting at a drafting board."

Creveling proposed that Albano manufacture and sell the lounge chair. A contract for a limited period would be signed, the lounge would be properly built and advertised to the contract market, and Zographos would retain all design rights. Best of all, it would be called the *Zographos* chair. (Later it would be called the Twenty-Eight, then the Ribbon chair.) The arrangement seemed perfect. Zographos was given a small space in the corner of the Albano showroom in New York to display the new chair and several other pieces he had designed *(below)*. So was created a new design association, the Zographos and Creveling "industrial alliance." It was a perfectly logical, perfectly symbiotic, and perfectly tyrannical marriage of a creative mind and a commercial one, as both would soon come to know very well.

Zographos the design commodity had met Creveling the design broker. Then Donn Moulton, his old friend from school, introduced Zographos to the advertiser George Lois; through Lois he met the photographer Carl Fischer. Both were cast in prominent roles that would have lasting effects on Zographos and his work. The stage was set. Zographos would continue to add tables and lounge seating to the Albano collection while still at SOM, and Albano and

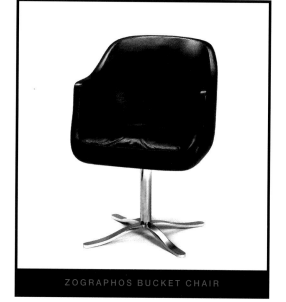

ZOGRAPHOS BUCKET CHAIR

Creveling would strive to ensure their success in the market.

It was 1960. The contract furniture market was dominated by the doctrines and designs of much larger companies like Herman Miller and Knoll Associates—the Albano collection was far too small to compete. Many products were needed to join the race. But what was really necessary was a fresh and unique design, one that would surprise everybody and grasp their attention.

SOM and other corporate architects were making some impressive spatial statements in those days, but for the most part the furniture they used was relatively archaic. More sympathetic designs were needed to harmonize with the scale and finesse of the changing office environment. "The office is becoming a kind of stage, from which one projects both a personal and a corporate image," said the *New York Times*. New chairs were needed to *exalt* these stages and all the people who had to perform on them—chairs that would contribute to the whole corporate production as the seats in a classic car contribute to the style of the driver and his whole vehicle. Those seats were the world's first bucket chairs, and their proprietary airs were uplifting: "A man at the wheel of an Alpha Romeo appears charming, refined, elegant, fond of speed, and sure of himself, and thus gifted with many of the qualities most admired and sought after by women—in their heart of hearts," said champion racer Prince Francesco Caravita di Sirignano about his "mechanical jewel." The corporate executives of the 1960s, trying to drive their organizations with comparable flair and confidence, wanted their bodies enthroned in elegant seats too.

The problem was finding them. In the words of Davis Allen, it was the age of "colonial baloney in furnishing offices," and the architects at SOM were still populating power sanctums with hybrid buckets, taking the legs off the best four-legged chairs they could find and attaching their own pedestal bases. For the office of David Rockefeller in the new Chase Manhattan Building, a cruciform base was made to be tacked under a conventional bucket seat from the Lehigh Company. The attempt was less than ideal, but the architects knew of nothing better. "We all knew what they wanted," Zographos says, "we all saw the opportunity." By now, with his sights raised well beyond the gates of SOM, the problem presented a good chance to make his strongest product statement so far.

Of course, his experience at the firm helped him understand exactly how good this bucket chair had to be. But creating it was another matter. It couldn't be drawn in simple lines in profile: it was too sculptural and form-fitting a shape. It had to be crafted by hand in the round. At the Albano factory, he was given an old wood chair frame with its upholstery and four legs removed. Zographos placed it on a table, sat inside, and began to reshape it around his body with rasps and files. Working blindly, he gradually altered the empty frame to achieve a final shape he could only picture in his mind. The process was long, painstaking, and intuitive, full of trials and errors, the designer never knowing the seat was right until the frame was upholstered. But finally, after weeks of rasping, filling, and covering the frame, and then stripping the frame down again and repeating the process, he finally found the shape he liked and covered it with black leather.

Strangely, in contrast to the bucket seat, the pedestal support was produced overnight. "Well, the base had to be done right away—too much time had already been spent," Zographos says. "So I went home, took a T-square and drafting curve, made a full-size elevation drawing in two hours, took it in the next day, and a day later the base was made and bolted to the seat." In those few words, Zographos describes the detail that solved his problem, established his signature design, and became his most popular and enduring market product.

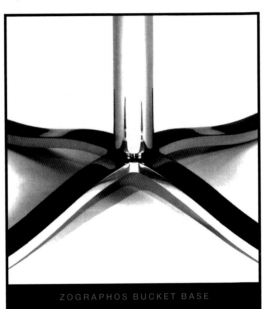

ZOGRAPHOS BUCKET BASE

The base was an elegant blend of geometries that ran counter to every square-frame reflex he had learned at SOM. With its solid round column raised slightly above its crossing flat bars, he had built an unusually cohesive unit using contrasting cross-sectional shapes. In fact, the whole bucket chair was a harmonic unit of contrasts, in shapes and materials. In a business that saw few truly new things, it was a dramatic advance. Most of all, the bucket did what Zographos needed most: it set him apart from other designers, it nudged him closer to independence, and it nearly guaranteed his commercial success. The base (later called the Alpha) was the key: as it was applied to all kinds of new tables and chairs, it easily surpassed the eloquence and grace of any other pedestal of the time. It was also the one Zographos design that was never revised.

Zographos believes the bucket chair (first called the Two chair, then the Alpha) was his first clear separation of the two sys-

tems of support in a chair—the sculpted support, which embraces the body of the sitter, and the structural support, which braces the chair itself. He describes the pedestal base as "neutral, a mutation of Mies's X-shaped glass table base and X-shaped Barcelona chair side supports." When he speaks about adapting the base

to other furniture products he is not much more animated. "Structurally, it is universal enough to be made in all sizes—as table bases for example—and in materials like stainless steel, bronze, and aluminum." Then almost parenthetically he adds, "The curves suggest tension and at the same time resiliency and repose."

Actually, the profile lines of the base owed less to a Mies-like X-base than they did to the curving, bouncy contours in the spring legs of a low bench he modeled early in the same year (above), a design that won his second NCBI furniture competition award. Now, almost forty years later, many architects still refer to the Alpha pedestal base as the best in the business. The delicacy of its bars are quickly singled out by Davis Allen as his favorite Zographos detail, "curving and rising slightly as they do, just a few inches off the floor."

The prototype of the bucket chair was taken to the SOM office and left in the most visible place that could be found. The effect was curious. Jack Dunbar says the response was quick and positive, but Zographos remembers it as being slow and muted—after all, SOM loved to make cubes and the chair was bound to bend a few of its principles. But Allen says the response was never in doubt—when Gordon Bunshaft spotted the chair, he committed the firm to buying "hundreds, no thousands of these things" for his buildings, then bought two of them for his own home. A few months later, Industrial Design magazine called the bucket chair one of the country's best-designed products in its Annual Design Review.

The empathy Zographos has for sculpted forms had surfaced in the first free-form chair he created. The mass of the bucket had modern appeal, yet it was neutral enough to place in any kind of interior space, corporate or residential, contemporary or traditional. But make no mistake, this chair was a paradox in appearance: its

look of utility and economy was created with painstaking labor and expense. Much like the mythical designer-architects of earlier days, Zographos had chosen to court his visual concerns—his designs were meant to enliven space, and the quality of the form came well before use. "I furnish our visual environment rather than our functional one," he once said. "I see the challenge of designing a chair in terms of form first, as a sitting device second."

While comfort in a chair was always a nagging consideration, Zographos could be ambivalent about protecting the sitter: "I am by now convinced that a chair is always the result of a number of compromises; they have to do with such realities as budgets, available technologies, materials, and distribution, as well as other limitations. But the biggest frustration is that a chair is supposed to accommodate the body in the *unnatural* position of sitting, which in itself is the worst compromise." All sorts of caster, swivel, and tilt mechanisms were added to Zographos chair designs to give his buyers the options they wanted and to provide mobility for them to shift and oscillate, "the movements that keep the body from becoming tired. With these chairs and their moving bases, body and chair work together." Still, these many mechanisms for body movement and comfort notwithstanding, it would be safe to say that in his work Zographos was sailing a primarily aesthetic course.

By late 1961, his success with his first two chairs had moved Zographos to a zone midway between his work at SOM and complete freedom. As always, the transition was slow—the cautious way was the only way for him to make a significant change. The Albano contract division published its first trade catalog in 1962: the Zographos lounge and bucket chairs were now endowed with product numbers, and the chairs were photographed in island groupings beside new tables with glass and marble tops—the bent-bar bases had begun to migrate from the chairs to make families of companion products.

But Creveling and Zographos were not content. They felt the chairs had more than proved their commercial worth, they wanted Albano to make a greater commitment to modern contract design, and they wanted to expand the collection at a much faster rate. To them, the votes of commercial confidence made life outside SOM look much more promising. The time felt right to move on. For the

interiors of a hotel in Ireland designed by Lydia dePolo, a friend from SOM, Zographos created the Ireland chair in early 1962. The first wood chair frame he built, it was a simple post-and-beam cage with a carved back and inset leather seat. Again, where the round legs met the square arms, he used a slight separation, or pinched reveal, to accommodate the contrasting shapes. Albano built large quantities of the Ireland chair, and the market liked and bought this design too; the Zographos rate of success was now three chairs out of three—a rate far too high to ignore.

Zographos left Skidmore, Owings & Merrill in September of 1962. He was thirty-one. For five years he had been a willing square peg in a tight square hole, but as Jack Dunbar says, "It was good that Nicos left when he did. He had been exposed to a fantastic place and fantastic resources, but it was best that he got out before he was gobbled up." Within the context of principles he understood, working with architects he would always admire, he helped develop the interior spaces that C. Ray Smith described as climbing "to an airy peak of classical aesthetic refinement." Zographos had been charged with providing the proper crowning touches. He was very good at it and he relished the responsibility. "We came to expect him to deliver the bright notes, the elegant and subtle details that excited us, the things we could *exclaim*," says Dunbar.

The SOM experience had cemented what George Lois would later call the "Zographos Primal Duty"— the need to master the conditions of a problem and to transcend every one of its limitations. But he had to cut himself free and he did—once more with timing that was much better than good. When he entered the larger world of free enterprise in 1962, the winds of a new hurricane were rising, sweeping waves of rebellion and social change throughout American culture. "The sheer excitement and energy of the physical changes transforming New York in this era fascinated the world," said the *New York Times*. "The city itself seemed to become a giant media star." Once more, the creative arts took wing and flew with the winds, just as they had after the war, and everybody seemed busily involved.

Zographos continued to add products to the Albano collection, but he felt the company was not showing much interest in the contemporary market. His faith in Albano declined and he decided

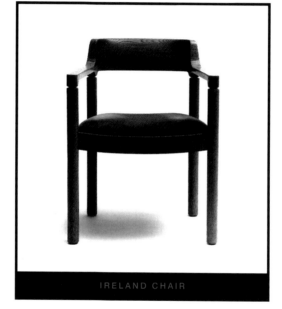

IRELAND CHAIR

not to renew his contract. Ironically, that lifted his prospects immeasurably—Creveling had lost his own faith in Albano. He sensed the market appetite for Zographos designs and outlined a rosy new vision: "Let's create a company of our own," he said, "a company that would do what we think it should do." The logic and challenge of independence appealed to Zographos, but when months and months of tedious negotiations produced nothing but frustrations, the vision dimmed and he flew back to Greece.

This time, returning once more from an odyssey to America, his visit was long and much more pleasant—he met Aliki Sourrapas for the second time. Aliki was a vibrant young artist who had studied abstract painting in Boston and Paris. She owned an art gallery with friends in Athens, but she says, "Nobody, *nobody* talked much about contemporary art and design in the city. When I met Nicos I was really impressed with what he had to say. *This guy is fabulous*, I thought, *and the things he does are spectacular*. I hated all those antiquities I grew up with, and I liked modern design so much I felt we could really understand each other. Of course, he's much more interested in design than art and he didn't like my work that much anyway—he really prefers white walls to paintings." Others saw the two as a combination of the bridled and unbridled. "Aliki is his exact opposite," a friend says. "The two of them are a perfect package."

In early May of 1963, Aliki and Nicos were married in Athens. They returned to New York and moved into Kips Bay Plaza, an apartment complex designed by I. M. Pei. "Well, Nicos wanted to keep his apartment on Tenth Street," Aliki says, "but I wanted a different place. Kips Bay was filled with fanatics about minimal living, just like my friends in Paris." First built as a combination of low- and middle-income housing, the two staggered buildings with their huge window modules proved irresistible to many New York architects and designers. Over the next thirty-five years, the Zographos family would occupy a succession of three different spaces in the same Kips Bay building.

The struggle to properly define a partnership with Creveling labored on and on. In his little apartment, Zographos compressed his drafting board and working life so tightly in a six-foot closet that it was photographed for the cover of *Progressive Architecture*. He added some bucket chair variations and a small table called the

SARONIS CHAIR

Aliki to his collection, and he built his first product with components, the Saronis chair—an open cage of mechanically connected wood posts, with leather straps supporting the cushions. Then he created his first bench for a friend, the architect Tasso Katselas—a simpler version of the spring suspension that won his second NCBI award. It also had leather straps supporting the cushions and a base that recalled his bucket base *(pages 82-83)*. The variety of designs produced in this one year show the designer comfortably juggling the two perspectives he had found when solving his first bucket: design in the round and design in profile. Each was evolving its own rationale; each was producing its own series of new products.

In 1964 Zographos was asked to design his first independent interiors project—the interior spaces of Carl Fischer's carriage house on Eighty-third Street. "Somebody else had begun the project and we had insurmountable problems," says Fischer. "Nicos made some ingenious suggestions, so we stopped in midstream, revised the drawings, and started all over again." Eunice Greenblatt, who was working for Fischer, was impressed by what she saw and asked Zographos to design a house—his first residential structure—for her family on Fire Island *(below)*. Then, coming around full circle, Fischer was impressed with what *he* saw, and asked the designer for a house in Connecticut: "Lying in bed when I visited the Greenblatt house, I looked around. This is exactly what I want, I thought, I want a place that feels just like this."

Two years had passed since Zographos had left SOM. The future was far from certain, but the immediate past had been amazingly productive. The furniture collection had grown to a competitive size, new kinds of products suggested the breadth of work that lay ahead, and he had begun his first space and structure designs. Even better, the Zographos family itself was growing—a daughter, Fotini, was born in 1964 and a second daughter, Athena, would be born in 1966. The family settled into its annual rhythms of work and school in New York, relieved by summers of regeneration in Greece. Despite all the uncertainty, Zographos had reached his last, most comfortable time capsule.

ographos Designs Limited opened for business in October 1964. The lengthy negotiations had finally produced an agreement that adequately defined the Creveling and Zographos partnership roles: Zographos would design and develop the company's products; Creveling would develop the business and its markets. It seems that the designer got what he needed most: complete control of the direction and quality of his work, plus the support of an energetic sales professional. Still, ever cautious, he was skeptical. Keeping his options open, he continued to respond to requests for special products from the architects who asked, a practice that became a lasting way to relieve his tendency toward creative isolation.

The company sublet its first office, "a tiny, *tiny* little place" next to the offices of Charles Koulbanis and Charles Brandreth, the architects who had helped Zographos with the Fire Island house. Shortly afterward, the firm rented a second, slightly larger room next door to display a few products. As he would do in every Zographos showroom, Creveling moved his desk to the middle of the space and conducted business in his typically brusque manner. Zographos chose to work in a much quieter place at home and did so for the next twenty years.

The little company chose a ripe moment to appear on the scene, perhaps the only moment that such a forthrightly principled design company with costly products could survive. The corporate splurge in new office building was still spiraling up, and the supply of like-minded furnishings had fallen well behind. At the same time, after thirty years of convulsive change in architecture, design, and production technologies, a climate of risk and innovation was spreading throughout the furniture business; any thought that seemed reasonable and feasible was quickly turned into a marketable product. The great big carrot of profit dangled in front of all eyes—but the carrot was growing so fat it was reinventing the whole contract industry. In general, six kinds of opportunities were pulling the business in divergent directions:

Technologic design. The war's revolutions in materials and manufacturing techniques had shattered traditions and invaded nearly every industry process. There were subtle innovations like the use of synthetic upholstery fabrics and aluminum chair structures, and there were very noticeable innovations like the molded-plywood and the fiberglass-reinforced polyester chairs designed by Charles Eames and Eero Saarinen.

Systemic design. Supported by studies of office and working behavior, encouraged by the economies of standard production methods, and liberated by the wide open spaces within free-span architecture, flexible office arrangements were developed using modular components, such as the storage walls designed by George Nelson and the office clusters by Robert Probst.

Architectonic design. The ideas of the Bauhaus and International Style architecture lived on in furniture designed to complement the rational making of buildings and spaces. Consciously shaping products to unify buildings with their interiors, designers strived to reach the spatial harmonies pioneered by architects Mies van der Rohe, Marcel Breuer, and Le Corbusier.

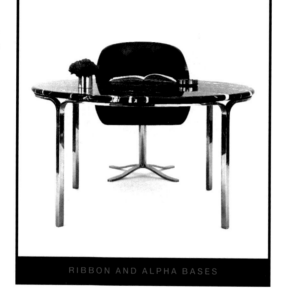

RIBBON AND ALPHA BASES

Ergonomic design. For the first time, the health and efficiency of the human body became a serious concern in furniture design. Products were developed that measurably countered the stress of office work. When the furniture worked well, it made people happier, less tired, and more productive. Thus a new kind of profit incentive appeared: when "healthy" furniture made a company more efficient, it obviously made good business sense. Moreover, the new incentive introduced a new aesthetic. Because designers specializing in ergonomics believed that form should always follow function in the most literal sense, they made chair-machines with multiple provisions for anatomical comfort. These machines looked friendly and seductive—like they sincerely *cared*.

Market design. Approaching the problem as a strictly commercial proposition, entrepreneurs produced furniture in great quantities to satisfy existing demands, or any demands that could be made to exist. Bulk sales were the measure of success, mindless fads and knock-off designs were second nature, nothing was expected to excel or endure. But when the entrepreneurs showed regard for designers as well as for buyers, as Alexander Girard did with textiles and Charles Stendig with his racy imported Italian furniture, their choices could divert the taste of the whole industry.

Art furniture design. The opportunity to use furniture to make a personal statement usually begets not much more than a personal statement. This trend could claim some honest roots in the angry revolutions of art in the early 1900s, but when it reared up again as a child of postmodernism in the 1970s it was clear that whimsy had replaced the rage. The self-conscious, self-indulgent results contradicted almost every meaningful spatial relationship that a piece of furniture could have, but obviously, that's just what the makers of art furniture wanted to do: resist all conventions and contexts with as much attitude as they could bring to bear. Even when good designers expressed their attitudes in art furniture, as architect Frank Gehry did in his chairs made of bent wood ribbons, they made products that were not more than momentarily significant.

Six different directions, six different trains of thought. The first four were led by singular individuals, all seeking answers to personal questions, solving problems they thought needed to be solved, then finding companies willing to invest in their solutions. These stubborn and persistent and clever explorers chased their visions and logic— and rang bells of adventure in the young designers who watched them.

Conversely, the producers of market and art furniture chased their own kinds of commercial or self-promotional profit, and merely used furniture as a means to chase it. While concentrating on profits is close to the soul of American business, profit motives also tend to produce the ephemeral in our lives—the things we buy one day but don't value much the next, like the consumer commodities that George Nelson had in mind when he talked about the American "Kleenex economy." Dwelling on maximum gains, unhobbled by the disciplines needed to advance the performance of furniture products, these two groups made the most dispensable (and no doubt some of the most cost-effective) stuff of the day.

Ironically, as the contract furniture business grew and was pulled in so many different directions, surprisingly few designers were attracted to practicing it full-time. Creating at least one chair has always seemed obligatory, even a rite of passage for designers, but after that the field appears to many as modest and limited. In fact, in 1964 it was possible to say that most designers could not sustain their interest in furniture design long enough to help it fully develop as a profession at all. As a result, the business remained a world of spontaneous contributions from disparate sources. The best architectonic furniture continued to come from architects who wanted to equip spaces with products to suit their buildings, the best technologic furniture came from designers who wanted to exploit the newest materials, machines, and office plan innovations, and the best ergonomic furniture was coming from designers who were determined to apply every factor of human engineering. For most people designing furniture in the 1960s, it was just one element of a much larger pattern they were developing.

Except for a few. After twelve years of school and work, Nicos Zographos had views of design that were indelibly architectonic. But he wasn't making pieces for a larger architectural pattern. He thought of himself as a furniture designer, first and last; his commitment was total and universal. Any helpful idea or technology interested him, as the honeycomb aluminum mesh had at SOM, and as molded urethane and component systems would later. Most definitely, his work would not be random or spontaneous. He would follow a consciously planned course, as he clearly showed in a sequence of new designs that appeared in the first year of business.

Not surprisingly, the Zographos design rhythm seemed to mirror the man himself: his movements were cautious and his products evolved slowly, one shading into the next. If viewed as a film, the work would appear to dissolve and change smoothly—no jumps and no quirks. Moving deliberately, he took the bases from the bucket and lounge chairs and carried them to a series of companion products *(right)*, just as Mies had carried his cross supports from the Barcelona chair to a glass table and low stool. Families of products were axiomatic in the contract furniture business: buyers wanted to marry chairs, sofas, tables, and desks in cohesive office arrangements. The carrying process was vastly satisfying to Zographos; while both chair bases had been created without thought of extended use, each one proved to be extremely adaptable when applied to other products.

In March 1965 the company published the first Zographos

ALPHA TABLE

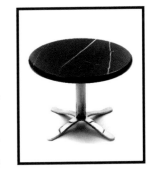

Designs catalog. Eight designs were shown in all, including the lounge, bucket, and carved wood chairs from the Albano collection, the glass table, and a new, very plump (and very short-lived) lounge bucket. With little nips and tucks and subtle turns, the chair bases had been added to new tables and desks, creating the first two Zographos design families. That was good: the stuff was necessary to compete in the market. But something more was happening, something more profound than family propagation—as each new product sprang successfully from its seminal source, Zographos began to feel that a good chair was likely to be a good propagator. In these first months, chairs became central to design evolutions at Zographos, and central to the company's success.

Because the first two chairs, the lounge and the bucket, had different structures, they bred entirely different product families. The lounge chair, now called the Ribbon chair and base, was supported by an external skeletal frame, and it generated a modest group of companions, all side-supported *(below)*. The bucket, now called the Alpha chair and base, was supported by a central pedestal column, and it generated a flood of its own companions on pedestals—eventually it would become the largest related family of desks, tables, and bucket chairs produced by one designer. Continuously and cautiously expanded for two decades, the Ribbon and Alpha families never produced a wild departure; each grew and flourished like a tree from a single seed. Moreover, with one mind controlling the growth of both trees, using similar materials and bent-bar structures, products from both trees were surprisingly compatible and easily combined.

The Ribbon and Alpha chairs had another common thread: an explicit separation of structure and sitting surface. Given his architectonic leanings, it was not surprising that Zographos gave

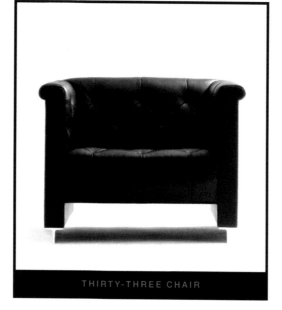

THIRTY-THREE CHAIR

these chairs (and all his future chairs) an outer structure to hold up the chair and an inner structure to accommodate the body. As he saw it, outer structure and inner accommodation amounted to two interdependent but different support systems, and he used different methods to solve them. For the outer structure, he would draw the frame that supported the chair in flat elevation, like an architect would. But for the inner accommodation, which had free-form compound curves he couldn't draw, he would "conjure" the shape he needed in his mind's eye, then build it like a sculptor would. These two perceptions prompted their separate methods when Zographos had to divide the two systems of support in a chair for the first time—not in the Ribbon lounge chair, which was conceived in a elevation drawing, but in the Alpha bucket, the conjured, hand-made shape sitting on top of the flatly drawn cylinder.

Hopping from one method to the other, he brought a healthy mix of flat planes and sculpted rounds to products. He used a compass in elevation and plan drawings to give the Ribbon frame more symmetry when it supported round tabletops. Similarly, when the Alpha pedestal base was carried to heavy tables, the sizes and proportions of the steel bars were changed in elevation drawings. The elevation drawing method even had a few conceptual benefits: its lack of depth often suggested a totally new design, such as using the profile half of the four-legged Alpha base to support the sides of a small desk or a low bench *(page 82)*.

On the other hand, when Zographos worked with a conjured shape, when he needed to revise the contours of a bucket volume, he preferred to slowly nudge the factory to make the changes he wanted with verbal descriptions and many prototypes. The process was tedious but healthy in its own way: because he never relied on a drawing of a free-form volume, and therefore had to describe what he had in mind, he soon refined his own language to express the nature of his chair-sculptures.

Of course, some ideas could go astray if the method he used was not appropriate. In 1965 he used the elevation method to draw the Thirty-Three club chair, a heavy and flattish mass with little sympathy for the sitting body. Essentially a bench with upright sides, the boxy cube of thick welted slabs was a commanding affair, with base details that nicely complemented the delicacies in the first bucket and lounge chairs. All three were used in a series of advertisements by George Lois—the first time the company announced its presence in magazines sent to the trade.

In 1966, serene in his tiny office at Kips Bay, Zographos continued to design variations on his bucket shapes, tried his hand at

designing a stacking chair, and produced a swivel stool. The work showed the three demands that usually prompted him to try a new design: necessity (the company needed more buckets to sell), curiosity (a stacking chair was both a design and an engineering challenge), and personal request (the Alpha stool was for a friend). But regardless of the prompting, nearly every design problem Zographos solved to his own satisfaction was quickly adopted and manufactured as part of the Zographos company collection.

In the same year, working with tubular steel and the cantilever principle for the first time, Zographos created a side chair known as the Sixty-Six. The chair became his second signature product, the one design now most readily identified with his name, and in retrospect, the one chair in the collection that *should* be called the Zographos chair. Exquisitely slender and open, it was the most appealing frame-cage he built, and it was built with only four pieces: two pairs of two different bent tubes.

He sees the resilient metal frame of the Sixty-Six as a return to the ideas pioneered in the early 1920s by Breuer, Mies, and Le Corbusier: "Obviously I find it legitimate to borrow old principles. I believe this chair to be a development from the Bauhaus classics in its use of the double cantilever, which frees the seat and the back to move independently. Tooling for the bends is kept to a minimum. The assembly is mechanical, eliminating the costlier welding method, and the parts can be knocked down. The leather seat and back are held in tension by springs, a direct debt to Corbu's early models. The exposed bolts in the back hold the frame together and keep the leather back from sliding down the frame *(left)*. The chair is resilient, elastic, and so light it doesn't encumber space with its mass. It was the closest I came to a pure and precise kind of chair."

In every sense a sophisticated construct of components, the Sixty-Six was a relatively inexpensive manufacturing job compared to the crafting of his other chairs, and it was a gratifying smash. Nominated for the permanent collection of the Museum of Modern Art by Philip Johnson, it was accepted and resides there today, just as it continues to reside in the offices of many architects and designers. Four of them are crammed into a corner of Ivan Chermayeff's office, and a scarred and battered set surrounds a table beside the desk of architect John Schiff. Will they ever get rid of the things? Separately, but in much the same tone, looking at their chairs like doting parents, they both ask, "Are you *serious*?"

The Sixty-Six chair thrust its designer into the front rank of the furniture design profession. Five Zographos designs were chosen by Davis Allen for the "Art of Living" exhibition at the Art Institute of Chicago, along with furniture from Knoll Associates, Charles Stendig, and others. Although not yet two years old, the company had become a recognizable presence in the industry. Also, it was clear that Zographos had made some fundamental professional choices: he preferred to work by himself, he avoided fashions and publicity, and he always placed manufacturing quality before profits. He approached a chair as if he were making a tiny precision tool. He made endless revisions, he was rarely satisfied with a design, and he would seldom consider one complete. "I always stop working on the goddamnit principle," he once said. "I stop agonizing when I think, goddamnit, I can't do any better, the thing doesn't *deserve* any more." But that really wasn't true at all: impatience was not enough to stop his relentless revising. Whenever a better detail seemed remotely possible, his nature demanded he try it.

All this was quite odd. Creating furniture according to some sort of personal ethic was not common in the business. When it became clear that principles were deeply invested in Zographos products, the designer was set apart. He became an anomaly. As more and more buyers were drawn to the qualities of his work, they were drawn to him—in any proposition that involves purchasing design, one should never underestimate the respect that buyers want to feel for the source. The cachet of a special identity is magical in design, and the silent image of Nicos Zographos began to appear in his furniture, just as images of other good designers appear in their products, just as the cachet of Michael Thonet appears in chairs he made more than one hundred years ago.

SIXTY-SIX CHAIR

In the twenty years between 1965 and 1985, the Zographos company moved three times, first in 1968 to a much larger space on East Fifty-sixth Street. Again, Jack Creveling surrounded himself with chaos and mismatched furniture in the center of the space, and his partner burrowed into a "sliver of a space" on one side. "When I closed the door, as I always did, it was quiet and tranquil. I was near, but I was far away too," Zographos says. "I did a lot of exploring in that room, and I made final drawings of every Alpha base I was using. I had reached the point where I felt all the sizes and curves were just right—*that's it*, I wanted to say, *don't touch them*. Being alone in that space helped me make those decisions." Yet every one of those "final" drawings was made in pencil.

In 1974, in its tenth year of business, Zographos Designs Limited moved to the thirty-fourth floor of the Architects and Designers building on East Fifty-eighth Street—its first formal showroom. Or at least, almost formal. Once more Creveling sat in the epicenter of the place and Zographos sat in a narrow room off to the side. But in comparison to past showrooms, the place was very large and bright, with huge windows and tremendous views. *New York* magazine called it a "hot" showroom, displaying furniture that was "the Rolls-Royce of classic modern." Five years later, in 1979, Creveling became seriously ill and it was necessary to change the terms of their contract. Again, the discussions were endlessly difficult and Zographos was brought close to leaving the company and very close to selling designs to other companies that approached him. But after two years, new rights of ownership were resolved and Zographos gained effective control of the company.

In 1983 the firm moved to a new showroom downstairs in the same building—the first space Zographos chose and designed himself, the first time he placed his furniture in the formal manner he liked *(left)*. He now had a real, rather than conceptual, landscape in which to work, a space in which he could isolate his prototypes of chairs and look at them for weeks, just as a sculptor might use the expanse of a studio. Stepping into the place, said *Greek Accent* magazine, "You become aware of a quiet serenity. The objects waiting for their human occupants invite calm. They promise relaxation . . ." The luxury of the place was a grand reward, but again Zographos sat to the side in a tiny cloister, well removed from the sounds of company commerce.

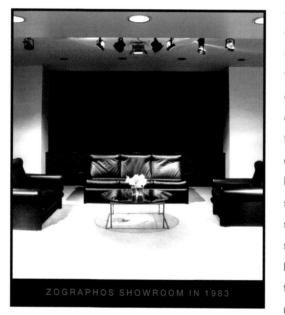

ZOGRAPHOS SHOWROOM IN 1983

Over the course of the next two decades, he added countless variations to his designs, multiplying the number of company products from twenty to over one hundred. He also slowly transformed the nature of his work. After creating much of the most surgically exact furniture the contract market had ever seen, he began to warm it up with streaks and elements of informality. Pushing his structures and volumes along, carrying innovations from one to the next, his work grew less rigid and more adventurous.

And very deliberate. Beneath all his work, providing purpose and direction, was a conscious scheme of design strategies. In 1971 alone, Zographos used three strategies, or themes, to produce three completely different designs: a wood chair, a bent steel suspension chair, and a component lounge chair. The three appeared to have nothing in common. Managing their contrasting styles at the same time must have been difficult, but one link is plain to see: from the side, in profile, all three outer structures hold the same inner core, the same accommodation for the sitter. Because he thought he had found a satisfactory sitting surface, and because he consistently maintained it, Zographos felt free to support that surface with any kind of outer structure he wanted; the only real differences between the three chairs are architectural.

In the same twenty years, detail continued to migrate from new chair designs to make families of companion tables and desks. The direction of the migration could be reversed, as it was in 1980 when Zographos used details in the new CTD table to create the Executive lounge chair and the Alpha Credit Bank sofa. But whatever way the migration went, one could always find his passion for controlled detail and craft in every design. Stand on tiptoe and see the minute convolution of glass and metal in his Amphora vitrine *(pages 112-113)*, or kneel way down and see the jewel-like bolts in his Metron table *(pages 118-121)*. Fastidious design is a rare and special skill, and whether he was understating a pedestal column or bringing pure geometry to the edge of a unique table, Zographos relished every chance he found to use it.

Three years after the founding of the company, George Lois designed and produced its first bound catalog. Nineteen products were shown in an essay of photographs by Carl Fischer, the last time the Zographos collection appeared without being gathered into generic furniture categories. But the price list that came with the catalog was organized differently. With simple line drawings, it clearly illustrated the network of conceptual themes that lay behind the work. After only three years of independent practice, Zographos was steaming along four different yet parallel tracks, each blending to some degree in every design he produced:

Bucket sculptures. The Alpha chair created the company's identity, its first big market, and its primary focus on chair families. In the next few years, when twenty other bucket designs were added and then multiplied by dozens of variations, eight different bases, and countless fabrics, leathers, and finishes, the group ballooned into the largest collection of its kind.

Early refinements to the Alpha chair thickened the padding, slightly increased the front curve of the arms, and varied the height of the back. Then, in 1962 the basic Zographos bucket leaped to a more integrated form: a bucket "cup" was created by softening the flat face and corners of the Alpha seat and carrying the shape's edge around in one long rim—a continuous contour of padded leather. Zographos built the first prototype of the design in Greece after leaving SOM and called it the Four chair *(below)*.

He liked the integrity of the unbroken contour and promptly endowed his new buckets with the same rim, reaching his happiest amalgam of cup shape and size in the Nine lounge bucket in 1965.

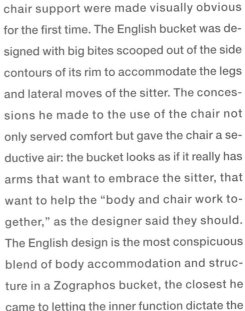

ENGLISH CLUB BUCKET

Seven years later, he carried the volume of the Nine bucket all the way down to the floor to produce the first Zographos club bucket. In time, with the addition of a love seat, the Nine series became his most popular family of soft leather chubbies *(pages 90-91)*. The Nine series is perhaps the most explicit expression of

Zographos buckets as sculpted volumes. As Zographos said, his work descended from the ideas of European modernism "with perhaps this difference: my designs are more concerned with defining solid volumes." Carl Fischer reinforced the Zographos view of volume by developing a technique of back-lighting the chairs when photographing them, making them look "like one piece, whole and solid like massive blocks." These pictures became the iconic views of the chairs, sometimes the only view that people saw before they bought them. "Boy, did he suffer over the contact sheets after every session," Fischer says of the struggle to find a signature picture to represent each design in ads and printed promotions.

Earlier in 1972, the same year the Nine club bucket was introduced, the dual concerns the designer had for body support and chair support were made visually obvious for the first time. The English bucket was designed with big bites scooped out of the side contours of its rim to accommodate the legs and lateral moves of the sitter. The concessions he made to the use of the chair not only served comfort but gave the chair a seductive air: the bucket looks as if it really has arms that want to embrace the sitter, that want to help the "body and chair work together," as the designer said they should. The English design is the most conspicuous blend of body accommodation and structure in a Zographos bucket, the closest he came to letting the inner function dictate the outer form. He stretched the sides of this bucket to the floor to make a club version, just as he had with the Nine chair. Then, in 1980 he slightly flattened and thinned the padded enclosure and its contours to create a cousin of the English, the relatively simple and un-scooped American club bucket *(right)*. These two chairs are the most expressive free-standing volumes he made. Conceived as islands sitting in a room's open space, both look more chiseled than constructed, more sanded down than built up.

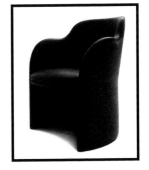

Carved wood sculptures. Zographos also conceived the wood chairs in his collection as one-piece, freestanding floor sculptures. "The material itself is ideal for carving into subtly formed surfaces where it comes in contact with the human back, and it is ideal for

constructing the frame needed to support the chair as a whole." Again, he solved the problems of chair support and body support separately as outer and inner layers of design, but here he had to provide both kinds of support with the same piece of wood. He shaped the outer surface of the back piece to conform to the chair's architectonics, while carving the inner surface to conform to the sitter's body: architecture enclosing comfort. But unfortunately, "there are no magic formulas to get the right combination for the curve of the back and the pitch of the seat." Just like building a bucket chair, carving wood to achieve comfort was a trial-and-error process, a slow evolution of each piece toward its proper shape.

Zographos Designs produced five carved wood chairs, each with its outer and inner layers more consciously integrated than the last. The Ireland chair of 1962 is an upright affair with flat arms and pinched joints where the arms meet the legs *(pages 136-139)*, and the White chair of 1971 is even straighter and cleaner—an utterly pristine frame with no obvious joints and slightly curved planes in the legs *(pages 140-141)*. The third carved seat was a bench done in 1974. Called the Museum bench after the Whitney Museum included it in its exhibition "High Styles: 20th Century American Design," the design borrowed many details from the Saronis table designed in 1970. The same thick, dome-footed round legs smoothly fuse with a curving, slightly concave top *(pages 160-161)*, suggesting the continuous contour of a bucket cup. The fourth carved seat was the armless Ten chair in 1976, a gently bowed frame of beams and posts that swept into a low carved back.

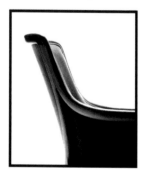

Then Zographos revived details from an early wood-rimmed bucket chair and created an even more sinuous carving in 1983. The Cinnamon chair *(left)* was produced as a dining seat for the new interiors in the Sea Grill Restaurant in Rockefeller Center designed by Phil George. "The chairs are key elements in restaurant design, and I wanted a hallmark design," says George. "I went to Nicos because he's a spartan guy like me, because he knows what I need, and because I love the grace in the *backs* of his chairs—the only part of a restaurant chair you ever really see." The

Cinnamon, with its curves of shaped wood supporting and framing a soft upholstered seat *(pages 144-147)*, achieves a more harmonic balance of chair structure and comfort than any other Zographos wood carving. Again suggesting the continuous rim of a bucket cup, the arms of the Cinnamon flare in one smooth line around the back and down the legs, showing the desire to surround, the same urge to converge that all of his chairs were showing in the 1980s. Later in the same year, an open-arm version of the Cinnamon design was produced and called the Saffron chair. For the sake of strength, the flaring of the arms was more sharply turned, but the fluid continuity of the surround remained intact.

As Werner Blaser wrote in 1980, "Pieces of furniture made of boards and posts are essentially constructions and skeletons. Mies attempted to return wood and wooden furniture to the logic of elemental union." In 1982, after slowly integrating the elements of carved chairs on one hand and padded buckets on the other, Zographos brought the two themes together in a single chair called the City. In this design, a fleshy frame of cherry wood loops around inset pads of soft black leather in a completely satisfying union of shape and contrasting materials *(pages 105-107)*. The City might have been called the Climax chair for all it summed up—it was the last of the carved wood chairs and the last of the buckets, and easily the most sophisticated of all.

Suspension profiles. The third chair theme was quite a bit different: it was driven entirely by rational conclusions about structure and efficient production. When he designed the Saronis chair in 1963, Zographos thought that he had resolved a successful seat assembly—a configuration of seat and seat back that provided the proper heights, widths, and angles for comfortable sitting. He embedded the configuration in his mind, drew its profile on paper, then began to lay all sorts of supporting frames on top of it.

Of course, separating a chair into two layers of support was exactly what he had been doing in his wood chairs. Now however, instead of integrating the layers in the same piece of wood, he suspended one inside the other in a structure made with component parts. The idea was a gust of fresh air. "Many factors go into the design of production chairs, and a very important one is the use of common, identical parts for a number of different chairs," Zographos

CITY CHAIR

says. "This makes for production economies in packaging, the stocking of fewer parts, and interchangeability. Two-dimensional chairs are more easily adaptable to this idea."

Drawing a simple structure in elevation on top of a simple seat assembly reflected the least expensive way a chair could be built. The method also provided a nice measure of design safety. "One knows the result well *before* the chair is made," he says, emphasizing his taste for prudence. But cost and safety were not his only motives: he found he enjoyed working within the tight constraints of component design. "I will not claim to be particularly concerned with production costs or ease of manufacture, but still, the idea of interchangeability is intriguing and challenging."

Four years after the Saronis chair, Zographos carried the seat configuration to the design of the Fifteen chair—his most direct application of the "suspension" idea. He used a flat, square wooden frame with two metal pins on each side to visibly cradle and support the fixed seat assembly *(page 152)*. Only one tool and five minutes were needed to assemble the chair. The natural texture of wood countered the straightforward geometry, and a solid fabric-covered panel could be added to fill the frame, disguising the construction altogether and giving the chair more mass.

In 1970 an equally basic use of the suspension idea appeared in the Sixteen chair. It was supported by two linear frames of bent steel bars with two cross-braces to hold the seat assembly, this time tightly wrapped in black leather *(below and page 153)*. This side frame was so thin and delicate that it was difficult to photograph. Component design couldn't get much more spare than this, and the American Society of Interior Designers gave the chair its international product award in 1987. Finally, in 1974 the Seventeen chair rose up to shatter the abstract reserve of the first suspension designs. Using the principles of chairs by Mies, Breuer, and Mart Stam, large steel tubes cantilever the seat assembly with two thick gestures of metal *(pages 154-157)*. The large scale of the legs used in the Museum bench (which Zographos designed at the same time) sweep with broad curves into the chair's supporting

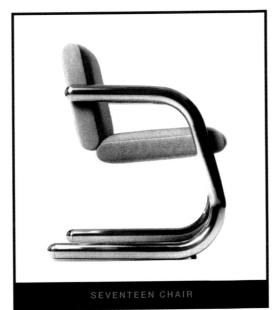

SEVENTEEN CHAIR

frame, making the other suspension chairs look solemn by comparison. The suspension principle remained untouched, but the Seventeen had a bouncy flair that verged on wit—it looked almost gestural and spontaneous. The Seventeen chair was the last in the series of suspension chairs, and the first one in which the component parts were given so much prominent bulk.

In designing four suspension chairs in ten years, the designer successively represented his Bauhaus, then his minimalist, and finally his own growing romantic manner—a striking evolution in style. He also showed how flexibly the architecture of a chair could be manipulated. Within component constraints, returning again and again to the essence of a chair, he had reduced four seats to their elementary parts. Still, the rigors of reduction could not guarantee a chair that wasn't costly to build. "God is in the details," the Mies dictum went, and Zographos said it too as he leaned far over to anoint these chairs with touches of fine craft and materials. After all, in the hands of a caring designer, economy is a relative thing and simplicity is seldom cheap.

Regardless, the idea was healthy and expedient. When the trade responded well to the suspension chairs, the company had its proof that it could at least simplify the manufacturing process. Component thinking would now invade almost every product the company produced. The temptation to indulge in costly detail would never disappear, but perhaps now it could be held at arm's length.

Modular components. The fourth chair theme slowly emerged when Zographos's ideas of bucket volumes and suspension systems began to trade ideas. Beginning in 1971, he took the component approach with three designs for lounge seating and began to thicken the seat assembly with units of greater mass and scale.

Before these designs, before developing the suspension idea itself, the lounge seats at Zographos were hefty, hand-made products. But in 1966 a more practical kind of lounge solution appeared when a sofa version of the Saronis chair was developed. Looking at a profile drawing of the Saronis frame and seat components, he conjured an image—he imagined his design pushing deep into the paper "like toothpaste extruded from a tube." Behind the drawn lines, down into the paper, the chair could have been umpteen miles long. Then, when he pictured the seat dividing itself into separate

cushions, he was picturing the units of his first modular design.

The trouble was that the chair he saw had no mass. It had no sense of the volume he strived to find in his buckets and certainly wanted in lounge chairs. Given his constant quest for solid-looking forms, but limited by the costs of building one, he began to explore other ways of producing a chair mass. He was aware of the plastic furniture developed by Knoll Associates, and he knew that some automobile parts were being made with mixed densities of urethane foam. Could he perhaps *pour* a suitable seat in one solid unit instead of constructing it with pieces? The idea of one-piece seats appealed to him, as it had appealed to Mies when he drew the shells of his conchoidal chairs made of body-fitting pressed plastic. So Zographos left his familiar methods, shelved every market caution he had, and began to pursue the possibilities of making chairs in molded units.

It was to be his sharpest philosophic departure in the making of a practical chair. It was also a healthy step away from the architectural membrane perception that characterized most of his other products. After one close encounter with stamping technology in 1966, a stacking chair called the Mayfair—a design that went no further than his desk—Zographos created the Synergistic series in 1970 *(pages 92-97)*. Using full-size drawings and shaping plaster models, he fashioned seating units that combined chair and body support (entirely consistent

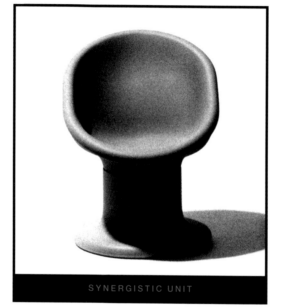

SYNERGISTIC UNIT

with his other chairs), but combined them in one piece of molded urethane. "I believe that we must totally get away from hard surfaces and hard edges and begin to round out forms as much as possible to make chairs easier to live with and to come in contact with," he says. "The beauty of urethane foam systems is that they enable us to get structure, comfort, and skin—one texture, one look, out of the same material. Plus, the entirely molded operation eliminates the staggering amount of handwork that goes into making most of today's chairs."

The Synergistic series used four basic components molded in two densities of one material. Soft urethane linings were snapped into rigid urethane shells to make bucket cups. Tetragon bases *(left)* or rigid drums turned the cups into

connected rows of group seating or single pedestal chairs. Tables were made simply by flipping the drum base over. The joinings were subtle; the overall effect was wonderfully holistic and technically satisfying. The process of molding was also wonderfully practical, Zographos thought, and of course it was.

And of course it wasn't. His company was just six years old, still gathering speed, and his partner saw far more risk than profit in the idea. Sadly, Zographos saw that too. "I could have altered the materials and made the design more feasible, but that would have watered down the idea too much and I just couldn't do it." So the grand idea became a wistful vision. The series aggressively dealt with advanced technology, and when he couldn't make it happen it became his most frustrating professional experience.

Several years later, he would produce a bucket pedestal base called the Omicron, "a reinforced, molded plastic base that covered the wheels, using a semiflexible urethane material, like a hard rubber." This base was the only molded design he was able to pursue into production, and even then it went no further than the prototype stage. He would say, "The material happens to be not quite ready, the technology is not quite there. But there is little doubt that a new material such as this—and new process—will result in new chair forms and get us out of the Bauhaus-inspired period that we are still very much in today." Judging by the "oneness" of the molded conchoidal chairs that Mies designed late in life, but never made, he might have said the very same thing.

A good idea is difficult to shake off. Inevitably, Zographos saw many later designs as candidates for molding, which probably had a lot to do with their appearance. For example, the first modular lounge he actually made, in 1971, had squarish shells made of wood, and they were as hard as any square frame in a suspension chair. But they also had linings of soft and supple cushions *(pages 128-129 and 132-133)*. This was the Twenty series—clean and spare boxes with pliant hearts, hard envelopes around soft comfort, much like the hard urethane shells around the soft urethane linings.

The Twenty was an honest-appearing construction, easily taken apart in one's mind and fitted back together. One buyer loved its clarity, bought four, then tried to build a fifth one himself. But when he lifted the cushions, he discovered the plain box was hid-

ing a puzzling array of strange bumps and ledges to support them. As C. Ray Smith wrote in his book *Supermannerism*, the minimal style "stripped non-essentials and minimized or miniaturized everything that might possibly be considered extraneous: joints, reveals, moldings, and the like. This neat technique looks effortless, but it was a kind of acrobatic prestidigitation that aimed to go unnoticed; it concealed extremely complicated internal systems of structural, mechanical, electrical, and joining elements."

The second modular lounge design was produced in 1977. Called the Thirty series, it was originally created for public spaces designed by the architect Harry Wolf. Because the side components that link the seats are wedge-shaped, a series of units undulates when connected, making a graceful, curving row of multiple seating. When Zographos redesigned the lounge as a single chair and added it to his collection, he replaced the wedges with straight-sided units *(pages 134-135)*. Both versions have tightly upholstered, leather-covered parts, with hard welting to emphasize their snug notching into the back of the seat. All together, the design was a weighty statement, even for a designer who loved large volumes. Its modular construction was not easily recognized; the chair appeared to be molded in one integral piece.

Then, two years later, Zographos created two totally new designs. The details in each were so unusual that they suggested a transformation was underway, or perhaps a conclusive blending of every theme the designer had been following until that point. The first was the Executive chair in 1979 *(pages 166-169)*. For the first time, he used components to build a "power" desk chair with a fixed seat assembly supported by a pedestal base. The modular, suspension, and bucket themes were linked all at once. The padded profile of the chair recalls the Ribbon chair done twenty years ear-

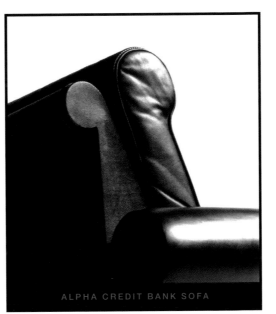

ALPHA CREDIT BANK SOFA

lier, and the circular rolls at the top of the seat and ends of the arms recall the bull-nose rims of the bucket chairs. It was a neat and unexpected gathering of familiar Zographos details, and it promptly gained popularity in the trade.

Then a unique conference table/desk appeared *(left and pages 162-165)*.

It was called the CTD and it used a similar kind of circular roll. Long and shaped like a capsule, the table floats off the floor on thick, dome-ended legs; slanting armrests run along the table edges. It is a complex piece of work and, like many products that imply a specific function, handsomely eccentric. The armrest had been solved by hand-shaping a model, so it was not surprising that the edge was plainly cylindrical—much like the hand-sanded rims in the plaster models of the Synergistic molded series.

Merging themes. Almost immediately, the emphasis on geometric detailing in both the Executive chair and CTD was carried into the design of a new modular lounge. For two decades, the four Zographos design themes had mushroomed separately, then burst together in one design *(pages 170-176)*. While it was called modular, the Twenty-Five really belonged to everything: bucket rims, carved contours, seat assemblies, component parts. Everything joined in a collected volume that was, for Zographos, quite idiosyncratic. Hard flats and soft rounds were freely mixed, then wrapped tightly or softly with black leather. More concessions were made to comfort than ever before—a bolster was even added for lumbar support. Inviting and obliging where it seemed to count, the spirited form struck deeper notes of aesthetic warmth than any design in the past.

The Twenty-Five profoundly affected every Zographos design that followed it. In 1984 Yannis Costopoulos, the chairman of the board at the Alpha Credit Bank in Athens, asked Zographos to produce all the furniture for the executive floor of the bank's new headquarters building. This was the same bank in which the designer's father had spent his entire career. The Twenty-Five was renamed the Alpha Credit Bank lounge series when it became a central element in the project, and its geometries were echoed in many of the other interior products the bank needed *(pages 177-192)*.

Even as he brought his themes together in the Twenty-Five, Zographos was able to unify them. He created one simple mass of geometric solids, just as he had created one simple tubular line in the last suspension chair, and one continuous wood line in the last carved chair. The Twenty-Five was the most relaxed work Zographos had ever done—a clear expression of the comfort he felt in mixing themes and reflexes no matter what form they took.

Every kind of Zographos work followed the same type of stylistic evolution as his furniture design. Ranging between his most severe and sculptural extremes, he designed six major corporate interiors and eight residences in Greece and America between 1967 and 2000. His first sculpted structure was done for his family in Greece. His father had asked him to build a summer house in Saronis, a seaside suburb east of Athens. So at the same time that he was drawing the stern and minimalistic interiors for a corporation in New York City, the designer took his tools in hand and carved a cardboard model of its complete antithesis: a formal, nearly Byzantine mass of vaults and blocks *(bottom)*.

The Saronis house had details that recalled the affection Zographos had for the chapel at Ronchamp by Le Corbusier, but the design owed much more to a deeply felt personal motive. "My father wanted an island house, a house that related to the hand-crafted shapes and contiguous qualities of the architecture on the islands of Santorini and Mykonos. I wanted to give him what he liked," Zographos says. He gave him a house with Greek island brightness in vocabularies both old and new—white stucco contours, shuttered windows, private terraces, and airy rooms arranged in a surprisingly symmetrical plan. It also had marble floors, custom furniture, and a soaring, freestanding spiral staircase in its center *(pages 50-53)*.

To Zographos the house was a modern translation of the traditional. To the magazine *Maison & Jardin* it was "a sculpture in the sun." To *Vogue* magazine it was "a parasol. A Berber tent. A villa with walls as thick as a fortress pierced with light." To *Abitare* magazine it was popular tradition and ageless materials living on, with vaulted ceilings turning "every room into a tiny house on its own . . . perfectly suited to the climate, perfectly in tune with the landscape, ideal for the kind of life one would like to live on a holiday." To *House Beautiful* magazine it was a dazzling white retreat, "a truly contemporary house that neither copies nor resem-

bles any particular building type." Said the writer, "Point and counterpoint, the counterpoint of the old against the new, folk object or antique as foil to the clean, sweeping lines of the architecture." Everywhere was exacting detail, with the interior rooms "beautifully expressed by the exterior forms."

The Saronis house was a tangential design that would not be repeated until Zographos built a house on the island of Mykonos thirty years later. These two were something quite alone, the most subjective structures Zographos ever produced. While the earlier Greenblatt house had been an elevation solution—born on flat paper—the Saronis house was conceived in the round, physically turned and shaped in model form in the designer's own hands. Sitting near his desk today, the original Saronis model still shows the

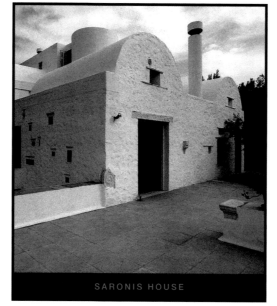

SARONIS HOUSE

marks of its sculpting. Right beside it, showing similar marks, are the plaster models of the Synergistic seats; both were created at the same time in the same hand-fashioned way. But this time, in the case of the house, production difficulties were overcome. Photographs show the painstaking process of pouring the large, virtually one-piece concrete and stone structure, but with the engineering support of the designer's brother, the house was completed in late 1970.

"One of the hallmarks of good architecture is the connection between the building and its place," says architect Harry Wolf of the house. "Here it seems just right. Here you can feel an understanding and affection for the way the winds blow and the sunlight falls." Wolf describes the many terraces that entice inhabitants outside and the "extraordinary arrangement of slender pieces of marble in the floor—a composition rooted in tradition, yet neither self-conscious nor nostalgic." Then he steps back. "The same is true of the forms in the house as a whole—clearly they relate to old island architecture, but the assembly is so pure and austere the house avoids the simplistic, imitative quality in recent island building. There is an authenticity here. Moreover, this isn't simply an amplified piece of furniture as are too many houses by furniture designers, this is real building."

At the same time he designed Saronis, Zographos produced a project that exercised his most objective tendencies. It is hard to think of any more bare-bones corporate interiors than the two he designed for the advertising offices of George Lois. "I tell you those

two places were *incredible*," Lois says. The man is a raucous performer in his own world of advertising, but feeding his fire are deep passions for craft, restraint, and utter simplicity. Lois and Zographos were a match made in Bauhaus heaven, and for many years Lois would be Zographos's most avid patron. "Just look at this table. No, I mean look *under* it, look at that base." He kneels and crawls under the table. "Look at that joint, you see that? Isn't that the most *beautiful* goddamn thing you've ever seen?" From the beginning of their friendship the two designers had traded crafts, Lois designing promotion and advertising for Zographos, and Zographos designing a series of vitrines *(pages 112-113)* to display the collection of valuable art that Lois owned. "That guy is a great designer, a great talent," Lois says. "We were so *simpatico*—what he liked I liked."

In late 1966 Lois asked Zographos to design five floors of offices for the New York advertising firm of Papert Koenig Lois (PKL), the first comprehensive interior project that Zographos produced. The results were startling. In the magazine *Architectural Forum*, the profession's most respected voice at the time, John Dixon wrote about the "cool interior world" of the place, describing its teak and black vinyl floors, sand-finished plaster walls, and tables made of slate cubes. All of it was tied together, he said, with the "Zographos way of placing objects in space—isolated spots or dense clusters surrounded by seemingly vast planes and

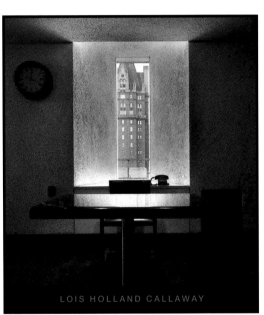

LOIS HOLLAND CALLAWAY

voids." He compared the clusters to "incidents distributed in expansive spaces—like Japanese gardens." C. Ray Smith also wrote about the space, calling it a minimalist refinement of Bauhaus goals. While retaining some functional structural articulation, he said, the designer "distilled and refined it to an almost surreal essence." But the function of the place didn't matter much to Lois: "I don't give a damn if a space works or not, I just want it to *look* great."

Certainly he got what he wanted, interiors that were spare beyond belief, spare enough to match what he cheerfully calls his own "fanatic neatness." When he founded a new firm, Lois Holland Callaway (LHC), in 1973, he asked Zographos to take the effect even further. The results went right over the edge *(pages 54-55)*. In *Fortune*, the prominent business magazine, the critic Walter McQuade elevated the space to "a private retreat." He quoted Lois: "This is
an environment for art directors—a thinking office, an ivory tower."

In his book *New York 1960*, architect Robert Stern described the LHC interiors by "romantic minimalist" Nicos Zographos as "an elegantly stripped-down working environment. The extraordinary absence of clutter and of color—the palette was confined to white, black, gray, and brown—created an environment of Zenlike subtleties." Lois's office was "a quintessential essay in power," and Stern quoted Michael Korda's article "Office Power—You Are Where You Sit": "The desk is small and simple, like a schoolteacher's, and faces an enclosed sofa on which visitors sit, like schoolchildren, at some distance from teacher's desk . . . the clean desk is carried to its utmost refinement. No humanizing touch is present, and the only point of attention and interest is presumably Mr. Lois himself."

Lois felt that both the PKL and LHC offices were "shockingly exciting" and said he deliberately used them as taste tests: those who liked and understood them were his friends forever. "The Zographos look was precisely what I *wanted* to achieve. Its pristine battleship ambience was sublime in conception and perfect in execution, bathed in the warmth and clarity of natural light." Clearly, Lois was the right client for a space that had less detail than an oil tank. The central LHC space was stark indeed—a huge, nearly empty void sheathed in slate, the most deliberately bare of any Zographos interior. "And it was *cold*," said Lois. "Let 'em wear sweaters, I say." Given this kind of promotional oomph by architects, critics, and the man in charge, it's easy to see why both spaces are clearly remembered after twenty-five years.

The two projects for Lois established Zographos as one of the profession's prime reductionists. C. Ray Smith traced the minimalist tendency of many designers at the time to Bauhaus principles, referring to architects Eero Saarinen, Gordon Bunshaft, and Kevin Roche as "exponents of the minimal substyle." Smith also thought that some of the interiors being designed more clearly expressed the minimal movement than did many of the more noted buildings by glass-wall architects. The work of Florence Knoll, Ward Bennett, and the "offices and other interiors by Nicos Zographos all were designed by a generation trained in purga-

tive puritan exclusion and alignment—the straight and narrow way. They seemed to equate aesthetic with ascetic."

But these words take Zographos too far into one particular branch of design. While he did reduce the Lois offices to skeletal frames, just as a minimalist would do, he also did what no minimalist would ever do: he tweaked them with accents of the unexpected— a surprising curve, a diagonal wall, a slanted window—details so quietly contrary they drove home the effect of overall restraint. The designer didn't exploit the big exterior windows in the LHC offices; rather he reduced them to narrow, funneling slits. He also pierced a porthole in the boardroom door. Accident or not, the porthole faced west, and when the sun set the hole projected a circle of light on a facing wall, a huge red dot. George Lois was fascinated. "Like God did it, you know, blessing my space with a beautiful thing," he said. "But soon I could see the dot was slowly getting smaller and much flatter on the bottom. *What is God saying?* I thought. *My beautiful and divine thing is dying.* I looked out the window and saw why: a new building was going up down the street, a *Bunshaft* building. When I saw the guy at a party and I told him his damn building was killing my dot, he laughed. He didn't say he was sorry or anything, he *laughed*. Then he said he wanted to come and see it. *The bastard wanted to come and watch his building make my beautiful dot disappear*."

Adding notes of contrary detail became a common Zographos tendency. The deHavenon Gallery in New York was a long and bland space, but the designer broke it into small triangular rooms with angled walls. "He turned the place into

a lyrical experience," says Lois. The same was true of a small house he designed with the architect Paul Mitarachi for a friend in South Salem, Westchester *(left and pages 56-57).* The house was a squeaky-clean cedar pavilion with an open, nearly square symmetrical plan. But each corner had deep-set sheets of glass divided by a wide diagonal wall—a small factor, but enough to offset and invigorate the austerity of the whole. "I was afraid my house was going to look awfully stiff," the owner says. "I couldn't see what those walls would look like from the drawings. Now I walk

off to see the house from a distance, a sculpture sitting in the woods. Then I walk back and wrap my arms around that corner wall."

Counterpoint defines the point. For his own house in Bridgehampton, a house Carl Fischer calls "a quiet little gem," Zographos built a cube of wood in the middle of an acre of grass. Then, through a hole cut in one side, he curved a long wall into the core *(right).* The house looks solid when the windows are covered with sliding panels, but when the panels are open, the receding wall

draws the eye inside the hard cube and suggests a soft interior lining—like the inside of a seashell. Fittingly, the ocean surf can be heard a short distance away.

Diagonal walls, curving walls, spiraling stairs: Zographos could not resist tweaking. It was a mischievous gift he had, and it prompted him to round the SOM table cage, pierce a square wall with a round window, and divide his own showroom diagonally. Those impulses gave him warm shadings and leavened his aesthetic severity. They helped him straddle his most shapely and planar extremes, thus avoiding the constraints of either one. He showed his flexibility in the parallel design of the Saronis house and the PKL interior, and again in a house for Carl Fischer in Connecticut. Developed with the architect Norman Jaffe, the structure was a balance of asymmetrical forms, a balance so intuitive it could not be related to any other Zographos design theme *(below).* The house expressed his urge to explore random forms, much as the Synergistic seats had shown his urge to find better technologies.

In the offices for *Avant Garde* magazine, designed at the same time as the spare voids of the LHC offices, he finally let his impulses

run loose: one continuous form snakes around to enclose the entire entry area *(pages 60-61).* It "fills the reception room with its presence," said Roger Yee in *Interiors* magazine. "Bathed in darkness which dramatically frames the entry beyond, the form has uncommon visual power. This may seem strange coming

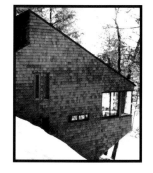

BRIDGEHAMPTON HOUSE

from a designer of sleek modern furniture," but after all, "the firm needed a strong visual identification that visitors could readily grasp. And the client was very sympathetic to aesthetic matters."

To say the least. Ralph Ginzburg, who owned the magazine, was just as vividly articulate as George Lois: "The times we worked in these offices were the happiest times of my life. Nicos created a magical place. It announced you were entering a hallowed, highly creative space—just what the offices of *Avant Garde* had to be." The reception area with its contiguous structure was called "The Ingress" by his wife, writer Shoshana Ginzburg. "The tunnel drew you in, the arch swept around and became seating, then it continued on to enshrine the receptionist," she said laughingly. "There was definitely a lot of P. T. Barnum theater to the thing, but it was beautiful and practical too. Behind the reception area, our offices were very ordinary, but Nicos raised the floor of the executive suite so that the large windows began near your feet, giving the space a much grander feeling." Yee described the serpentine form and then he quoted Zographos: "It's a nice object, that's all, one object, not many. Perhaps the most important aspect is that it doesn't pollute space." Yee called him too modest: "A mere object need not undulate, encircle, or entice you to enter and sit down. Zographos's object has a life of its own."

Caring about space pollution was not a small concern for a designer who lived to reduce everything to almost nothing. In fact, that's just what he said in his one public lecture, in 1977 at the Cooper-Hewitt, the Smithsonian's National Museum of Design. "I would make the whole world out of one material if I could," he said. "What material?" he was asked. "Anything—but just one. Pancake batter!" Well, designers should have goals and the logical conclusion for a reducer was the sum of one thing. Or maybe even less: "I am for eliminating furniture. Despite the fact that I design furniture for a living, I'd like to get rid of all chairs and all furniture. I'd like to make the floor take the place of all this stuff that we think we need." Has he ever tried living on the floor for a month? "That's a floor! I don't mean a floor! I mean a soft floor that is raised *off* the floor." The *Avant Garde* snake seems to come close to what he had in mind.

In 1985, twenty-one years after Zographos Designs Limited was founded, Jack Creveling died and Zographos was left the sole

MYKONOS HOUSE

owner. Three years later, following the industry's logic of gathering the contract furniture companies in one handy place for buyers, he moved the firm across the East River to the International Design Center in Long Island City. But despite the convenience, Zographos felt creatively remote. The move had reduced his contact with architects and designers, the part of the business he most enjoyed. In 1992 he decided to market all Zographos products through distributors in America and Europe and concentrate on larger projects. The Alpha Credit Bank was expanding to more branches needing more furniture, and the architect Tasso Katselas wanted multiple seating for the new Pittsburgh airport *(page 134)*.

Then a call came from the ETEVA Bank in Athens. ETEVA is a subsidiary of the National Bank of Greece, and its chairman, Dimitrios Pavlakis, had seen the Alpha Credit Bank interiors. "He asked if I would design his executive floor. He's a young, very alive guy, and after we talked he decided he wanted no presentations, he just wanted me to go ahead and do what I thought would be right." Zographos was delighted. "Things just don't happen that way, you know. We gutted fifty-five hundred square feet and rebuilt it with custom furniture made in a small shop in Athens. Aliki chose materials and colors, and Thanassi Bakas helped with drawings and supervision." The space was finished in eighteen months *(pages 62-64)*.

At the same time Zographos was continuing a ten-year labor of love: a house for Aliki and himself on Mykonos. The one-floor, two-bedroom structure has a concrete frame and masonry walls surrounded by a rough stone pavement. "And when I say rough, I mean *rough*— local granite we got from the excavation. The whole thing is compact and not at all slick; the furniture is built-in marble and wood. Very basic. With Aliki's help, the house ought to be done in early 2000." The Mykonos house is traditional and informal *(right)*. The little dome nestled in the stone walls reflects the natural urge Zographos has for intuitive planning, just as the Alpha sofa reflected his urge for intuitive furniture. But what do you make of the ETEVA Bank rigidities and the Mykonos spontaneities being created at the same time?

A long metal box rests on the wall in the Zographos family's living room, calmly facing the clutter of traffic moving down Second Avenue. Chaste and white with sliding glass walls, softly glowing with ventilated lights, the structure holds a treasure of objects from ancient Greek tombs. There are terra-cotta toys and tools nearly three thousand years old, and a fine Hellenistic head. All the shapes are closely scaled and warmly monochromatic.

This is the Zographos tokonoma. In every part it has beauty, severity, and efficiency, even though it takes the patience of Job to actually open the thing. Zographos carefully removes one of its tiny mullions. He holds the part gently, as he does the parts of any well-made thing. He moves the little diorama minutely, shifting the ancient forms within the modern frames, refining their relationships. This is the interior landscape that the designer has been molding in larger spaces for forty years. There is architecture and there is sculpture, there are flat walls and arbitrary shapes, all radiating to interact in the spaces between. That's the balance, the harmonic concert, of walls and furniture that modernists have worked for decades to create.

Perfection in a rarified space—that's his quest, plain as day. Reveling in principle and old loyalties, his mind has long been made up. "Well, he's lucky," says George Lois. "He believes in himself. He may fall on his own sword now and then, but he's his own man. People who don't know that can call him uncompromising, but he's a practical guy and that saves him. And he's right, you know. If he can make a living that thrills and satisfies him by designing his own way, why shouldn't he work for himself?" He slaps the table hard. "Still, there's no good reason why he's been such a goddamn *secret* all these years."

Zographos has made chairs that can stand beside the finest chairs designed by anybody, architect or designer, in the twentieth century. Even so, you could swing a long stick in a wide circle and hit nobody outside his profession who knows who he is. Whatever his reasons, he has never been one to make a lot of noise.

Not long ago, traveling by taxi in the rain down Second Avenue, Aliki Zographos was talking about the things people threw out. "Look at that bed," she said. Nicos looked. "Stop the car! Stop!" He jumped out and looked at the pile of trash with disbelief. On top, cracked and bleached, was the day bed designed by Mies van der Rohe. "It looked terrible, but good God," and he called Donn Moulton. "Donn said, 'Don't move, I'll be right there.'" Zographos laughs. "There I was, in the rain, with my hand on my own Mies bed. I just couldn't believe it, I still can't believe it. When Donn came we tied it on his car—and tied ourselves outside the car at the same time. We had to crawl in the windows to drive the thing home. It was so unreal, we couldn't stop laughing." He looks at the refinished bed sitting in his living room. When asked what he will do with it, he looks surprised. "I never thought about it. I have absolutely no idea."

Zographos is worried about Mies. He worries about Gordon

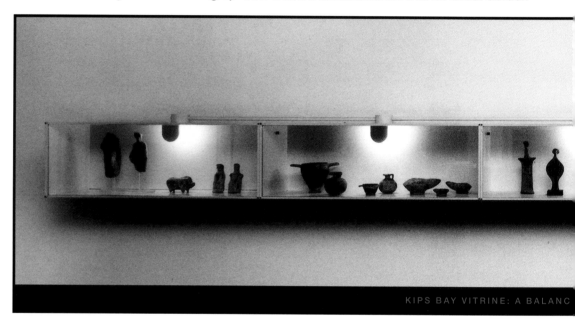

KIPS BAY VITRINE: A BALANC

Bunshaft too, as he watches the man's work slowly ebb in the regard of architects. But Zographos has always practiced the same disdain for popularity that Bunshaft did, so he understands the consequences. Mies is different. "What's wrong with these people? Have you read what they're saying? How cold Mies was, how plain and inhumane his spaces were? What's going on anyway?"

Speaking from his own perspective, Zographos is baffled. "You know, the whole idea of being *modern* was built on the principles of social response and continual change. This country has never seemed to fully grasp that." Now the movement is being relegated to a period, an "ism." "Modernism is boring," said Philip Johnson in the *New York Times*. "It's been around too long and it's time for a change." No, no, says Zographos. "Modern *means* change, it means continual adjustment to new possibilities. How can that be around too long? Listen, the logic of modern design has been 46

accepted by the rest of the world. Nobody builds old stuff, Louis XIV stuff, like America does. The reaction against modern is here, in this country. It just doesn't make sense to me, you'd think the opposite would happen in a society like this. Try to figure that one out."

You are a romantic, somebody once said, when you expect things to be the way you want them to be. When Jack Dunbar and his wife, June, traveled to Greece, they visited Nicos and Aliki in Athens. "We walked their favorite walk one day, all day," Jack remembers. "It was an extraordinary experience. The place seemed so right for him, the trees, the fragments of ruins, everything. He pointed out the little things he liked, a nicely turned corner on a building, an old detail, three gypsies on a street corner. It was a very special time. I was seeing Nicos at rest, seeing beneath the so-

MMUNITY OF OBJECTS IN SPACES

phistication that Nicos and Aliki have in New York. The time felt so earthy, so easy, and after it I understood better the single glass, the single plate, the single utensil, the simplicity he liked in everything around him. I remember thinking, *Ah, now I get it*."

There is no dissonance around Zographos, none at all. He looks at every object carefully, then he chooses it or weeds it out. He likes the simplest things, no doubt about that, and he blends what he likes into an equally simple sphere of experience. That's what the Dunbars saw, the pattern of consonance that Zographos has woven tightly around himself. Such patterns are characteristic of superior product makers, like Ettore Bugatti: "Faced with the attractions of large-scale series production and lower costs, he retained his independent outlook, his freedom to invent and his urge for perfection down to the smallest details." But classic cars by Bugatti and fine chairs by Zographos are not consistent with prod-

ucts of the machine century no matter how modern they look. They have too much craft in them. These people love to reap the benefits of machines but they also love to defy their limitations.

Demanding perfection from machines is idiosyncratic today, and Zographos knows it. "Everything I do, it's *all* about turning corners," he says. Then he listens to himself and he laughs. Yes, he is ruled by such determination, but he isn't blind to his own blindness. This is simply the way he wants to go. Niels Diffrient makes a tidy distinction: "Almost anyone will appreciate a thing that works well for them. The best avenue I have found to satisfy people is performance." He pauses. "On the other hand, some very good designers like Mies, Breuer, and Nicos purposefully limited their scope to appearance—so that they could grasp and master it. You have to limit the problem if you want mastery. Nicos chose to make objects that architects would want to put in their spaces. Anything that swiveled and rolled around could disrupt his purpose, even though he knew he had to satisfy those minimal functions too."

Yet Zographos can't resist a useful device. His eyes glint when he takes an object from a shelf and hands it over. It is a Soss elbow hinge, an impossibly intricate device that folds invisibly within a door. A silly thing, solid brass and heavy enough to break your foot. But he handles it like fine glass, like he handles his other toys: a set of ancient, razor-sharp calipers wrapped in tissue, a heavy khaki-colored aircraft bolt with a frilly nut, a piece of aluminum mesh just like the one that sits beside Diffrient's desk.

Each one of these things is far removed from its real job. He treats them reverently because they are so explicitly purposeful, so *eloquent*. Like handsome dovetail joints in wood, now rendered obsolete by screws and glue, it is hard to resist fondling them. Who doesn't respond to the textures of hands-on craft? But today, industry has cast a long shadow over the hands of craftsmen. Like a master carpenter, Nicos Zographos has been rendered untimely and irrelevant. But still he sails on, making his artful devices that merely satisfy the need to sit down. He actually thinks everybody has the same pride he has no matter what they do. If you work with him, you find you can't resist his pride, you rush to keep up with it. After all, you don't want him to strive in solitude—you can't let him think that you're not just as crazy as he is.

I am deeply grateful to my teacher, John Schulze, and to Carroll Coleman and Dale Ballantyne; to the many architects, clients, and craftsmen who have become my allies, including Gordon Bunshaft, George Larson, Tasso Katselas, Phil George, Donald Gratz, and Karl Meyer; and to my close and lasting friends, George Lois, Carl Fischer, Donn Moulton, Gary Fujiwara, and Peter Bradford. My special thanks to Yannis Costopoulos, who continues to support my work and this book. —*Nicos Zographos, Mykonos, 2000*

NOTES TO THE TEXT: All comments by Nicos Zographos and his friends and associates are taken from interviews conducted between March 1994 and December 1999. References to the Zographos creative process are partially taken from his lecture in the series "The Evolving Chair" at the Cooper-Hewitt Museum of Design in New York in late 1976. The lectures appeared in the book *Chair* (New York: Thomas Y. Crowell, 1978).

Other brief excerpts from books and magazines are acknowledged with the author's appreciation: Page 15: Dmitri Kessel, *On Assignment* (New York: Harry N. Abrams, 1985). Page 17: Peter Blake, "S and E" (unpublished essay). Page 18: H. D. F. Kitto, *The Greeks* (Harmondsworth, England: Penguin Books, 1951); Edith Hamilton, *The Greek Way* (New York: W. W. Norton, 1930); C. M. Woodhouse, *Modern Greece: A Short History* (London: Faber and Faber, 1977); Will Durant, *The Life of Greece* (New York: Simon and Schuster, 1939); Andy Grundberg, *Alexey Brodovitch: Documents of American Design* (New York: Harry N. Abrams, 1989); Werner Blaser, *Mies van der Rohe: Furniture and Interiors* (Woodbury, N.Y.: Barron's, 1980; also pages 19, 24, 27, 38). Page 19: Walter Gropius, *The New Architecture and the Bauhaus* (Boston, n.d.); H. W. Janson, *History of Art* (New York: Prentice Hall/Harry N. Abrams, 1995); C. Ray Smith, *Supermannerism: New Attitudes in Post-Modern Architecture* (New York: E. P. Dutton, 1977; also pages 27, 30, 41, 43). Page 22: Tryntje Van Ness Seymour, *Dylan Thomas' New York* (Salisbury, Conn.: Lime Rock Press, 1977); Larry Rivers with Carol Brightman, *Drawings and Digressions* (New York: Clarkson N. Potter, 1979). Page 23: Peter Blake, *God's Own Junkyard* (New York: Holt, Rinehart and Winston, 1964); Stanford Anderson, foreword to *Gordon Bunshaft*, by Carol Herselle Krinsky (New York: Architectural History Foundation; Cam-

bridge, Mass.: MIT Press, 1988; also page 25). Page 24: George A. Larson and Jay Pridmore, *Chicago Architecture and Design* (New York: Harry N. Abrams, 1993); Davis B. Allen, in Maeve Slavin, "Jeddah Intelligence," *Interiors*, April 1985. Page 25: Victor Papanek, *Environment/Planning and Design*, summer 1971. Page 26: Ralph Caplan, "Caplan (continued)," *Chair* (New York: Thomas Y. Crowell, 1978). Page 28: Elaine Kendall, "A Man's Office Is His Castle," *New York Times*, March 15, 1964; Prince Francesco Caravita di Sirignano, "Alfa from the Start," *FMR*, September 1984. Page 30: Thomas S. Hines, "A Star Is Built," *New York Times Book Review*, March 19, 1995. Page 36: Veronica McNiff, "The Best of Showrooms," *New York*, April 28, 1975; Philemon D. Sevastiades, "Sculpture in Space," *Greek Accent*, July-August 1986. Page 42: "Sculptée par le soleil des Cyclades," *Maison & Jardin*, August-September 1971; "Sun House 1973," *Vogue* (British ed.), January 1973; "Popular Tradition Lives On in a House on the Aegean," *Abitare*, August-September 1971; Susan Grant Lewin, "Greece: Above Ancient Waters, a New Translation," *House Beautiful*, January 1972. Page 43: John Morris Dixon, "Madison Avenue Was Never Like This," *Architectural Forum*, January-February 1967; Walter McQuade, "The New Look at the Office," *Fortune*, January 1974; Robert A. M. Stern, Thomas Mellins, and David Fishman, *New York 1960* (New York: The Monacelli Press, 1995). Page 45: Roger Yee, "Sit Down, Says the Serpent," *Interiors*, August 1976. Page 46: "Home Design," *New York Times Magazine*, April 10, 1994. Page 47: L'Ebé Bugatti, "Bugatti Royale," *FMR*, January-February 1987.

CREDITS: All photographs by Carl Fischer except: Pages 18, 26: Werner Blaser. Page 19: Chicago Historical Society. Pages 43, 54-55: George Cserna. Pages 86-87: DeWayne Dalrymple. Pages 19, 24, 25: Hedrich-Blessing. Pages 36, 50-53, 58-61, 177-192: Michael Hirst. Pages 56-57: Joseph Jurson. Page 26: Knoll Associates. Pages 62-64: George Papantoniou. Pages 38, 39, 41, 46-47, 80-81, 113, 118-121, 126-127, 140-141, 144-147, 153, 172-176: Michael Pateman. Pages 22, 23, 24: Ezra Stoller/ESTO. Pages 17, 18, 21, 28, 29, 31, 35, 40, 41, 42, 44, 45, 49, 94-97: Nicos Zographos. Design by Peter Bradford, Danielle Whiteson, and Joshua Passe. Copy editing by Phyllis Thompson-Reid. Printed by Simon Britton and Chameleon Offset Limited in New York City.

NICOS ZOGRAPHOS

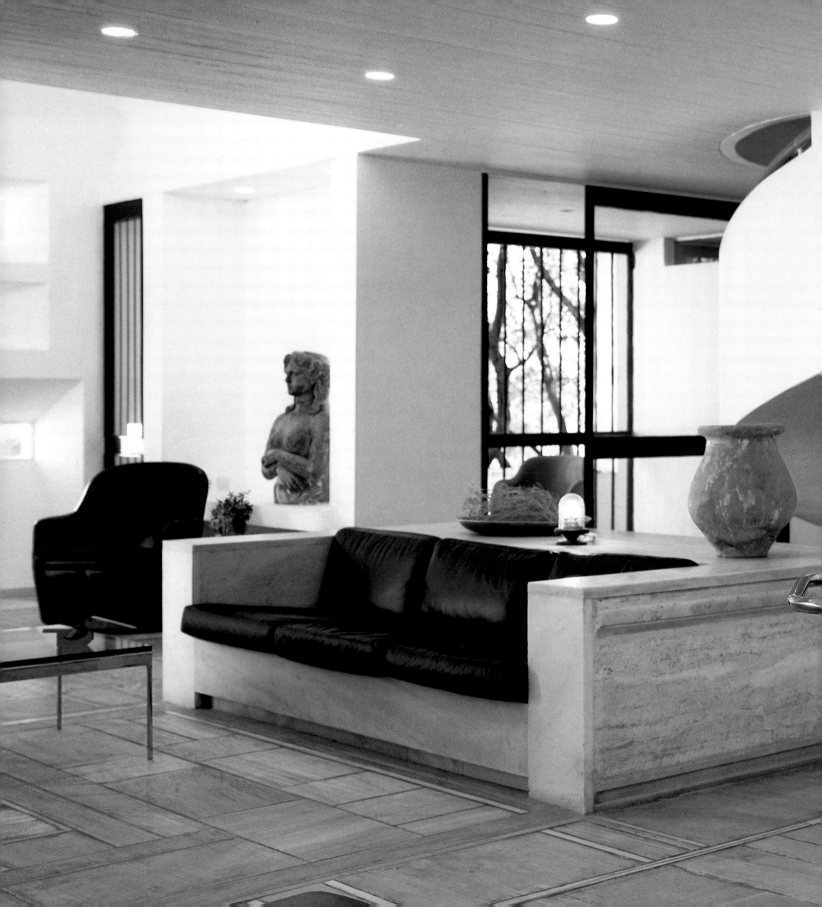

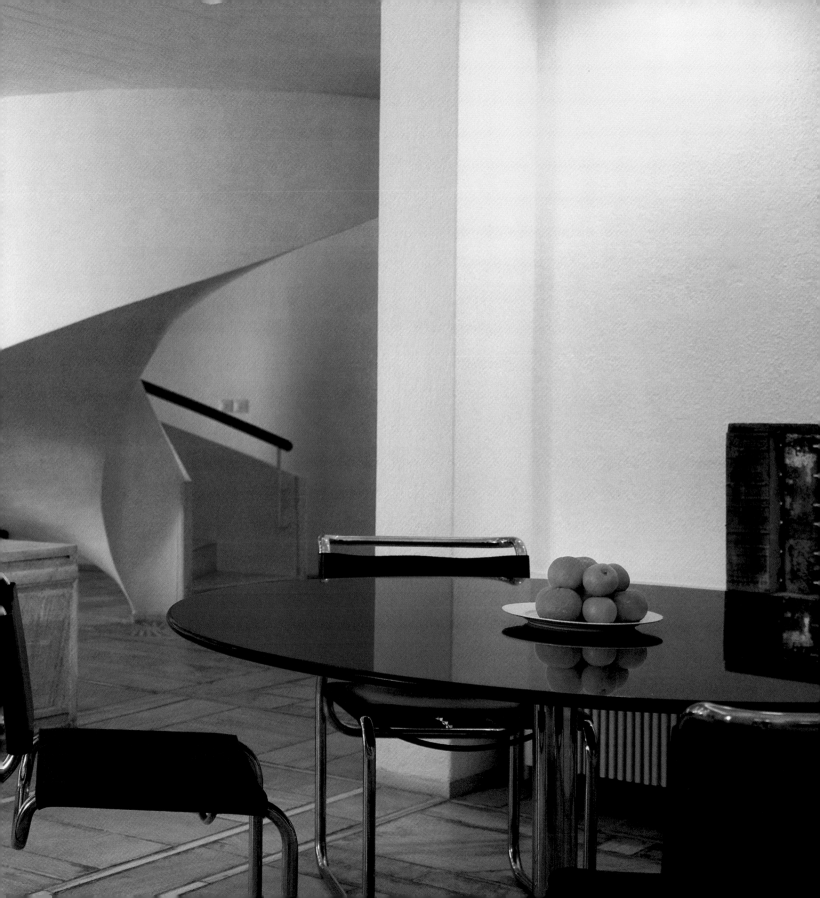

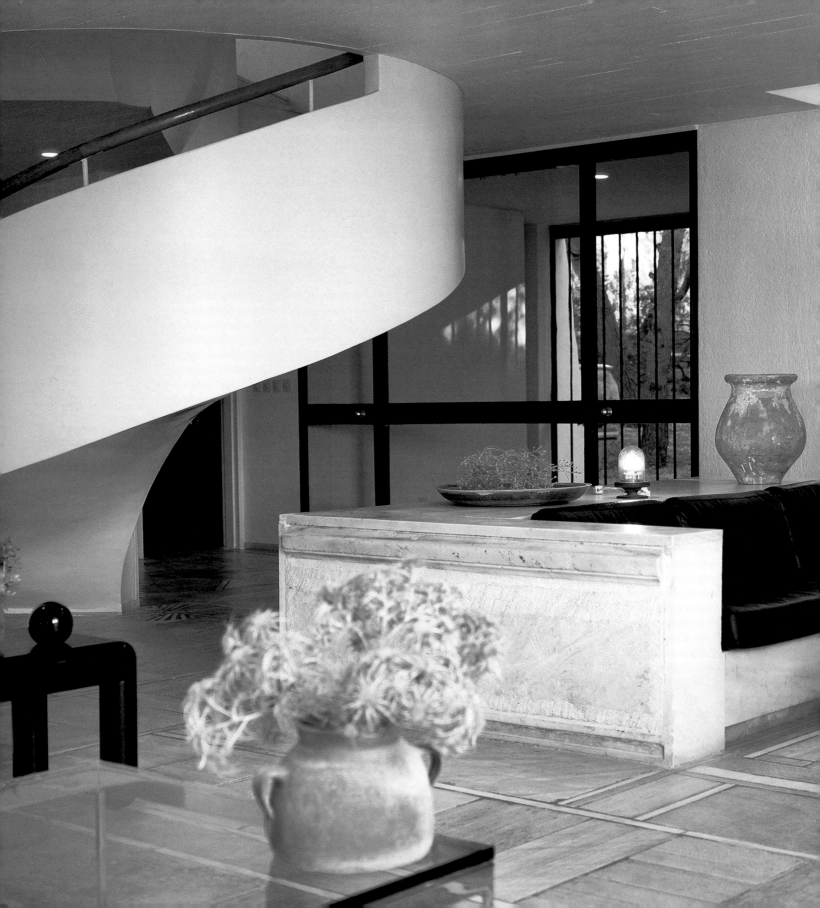

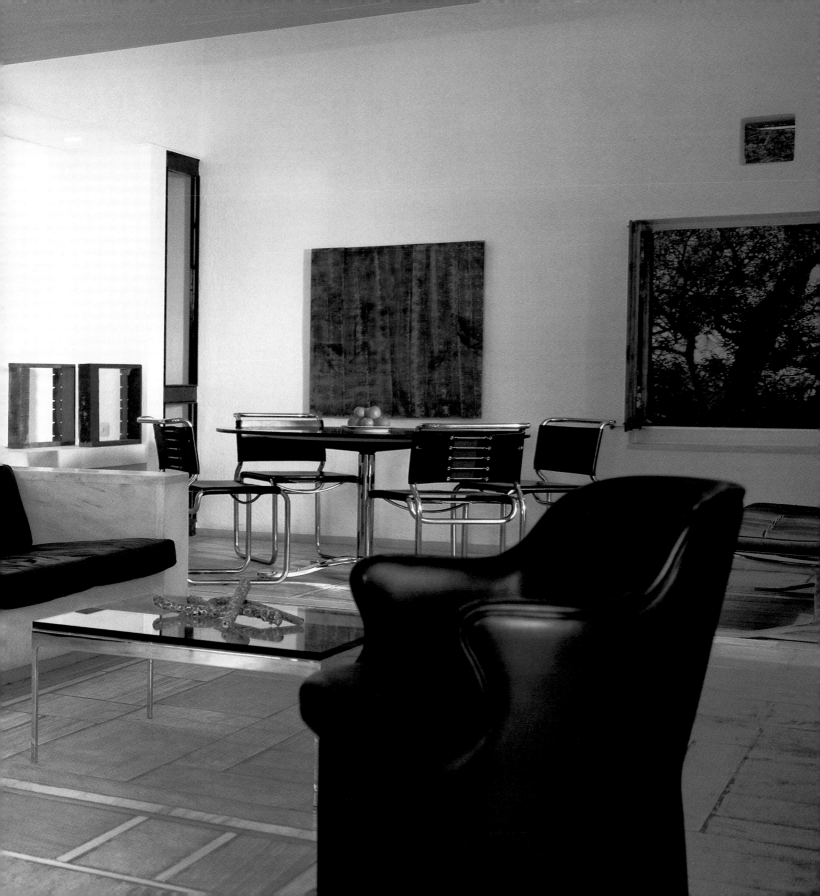

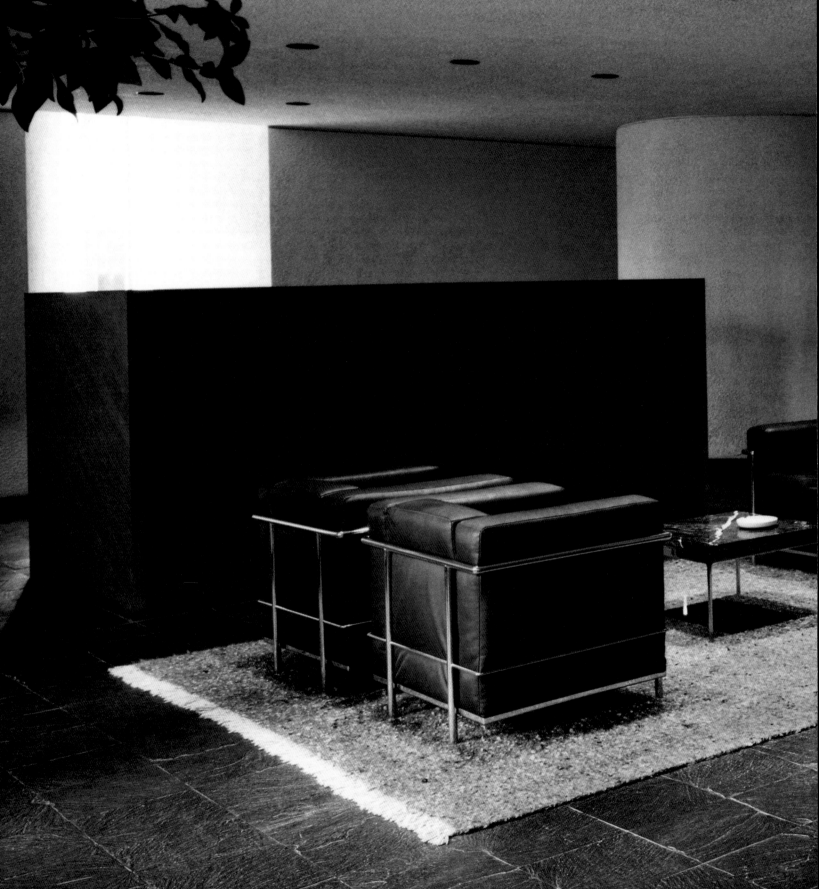

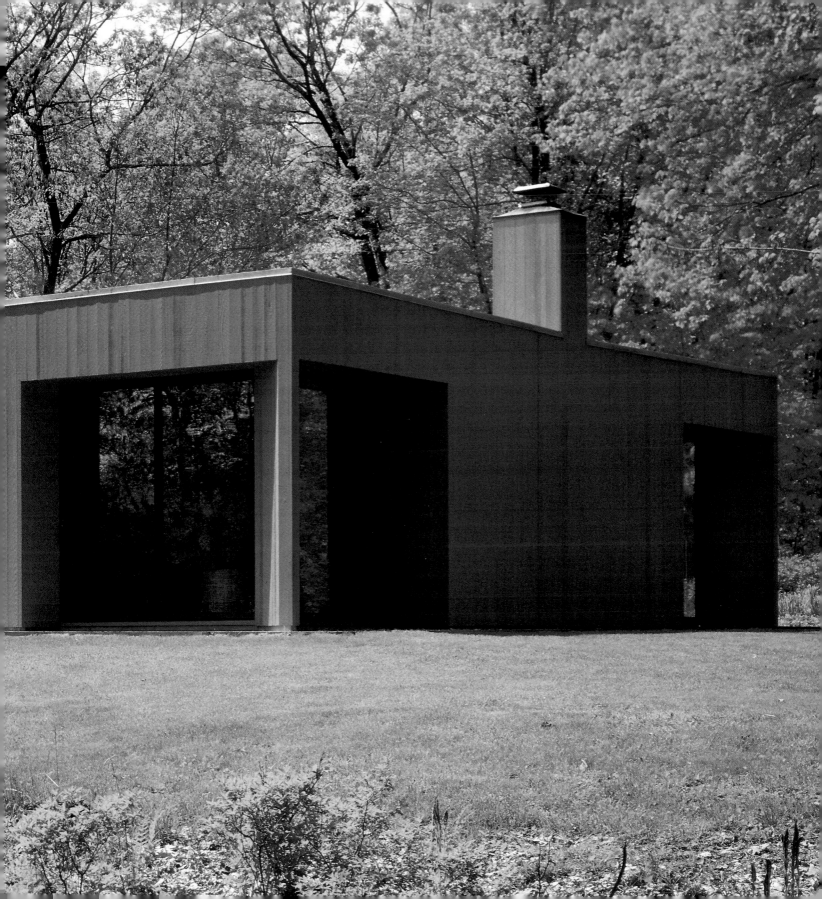

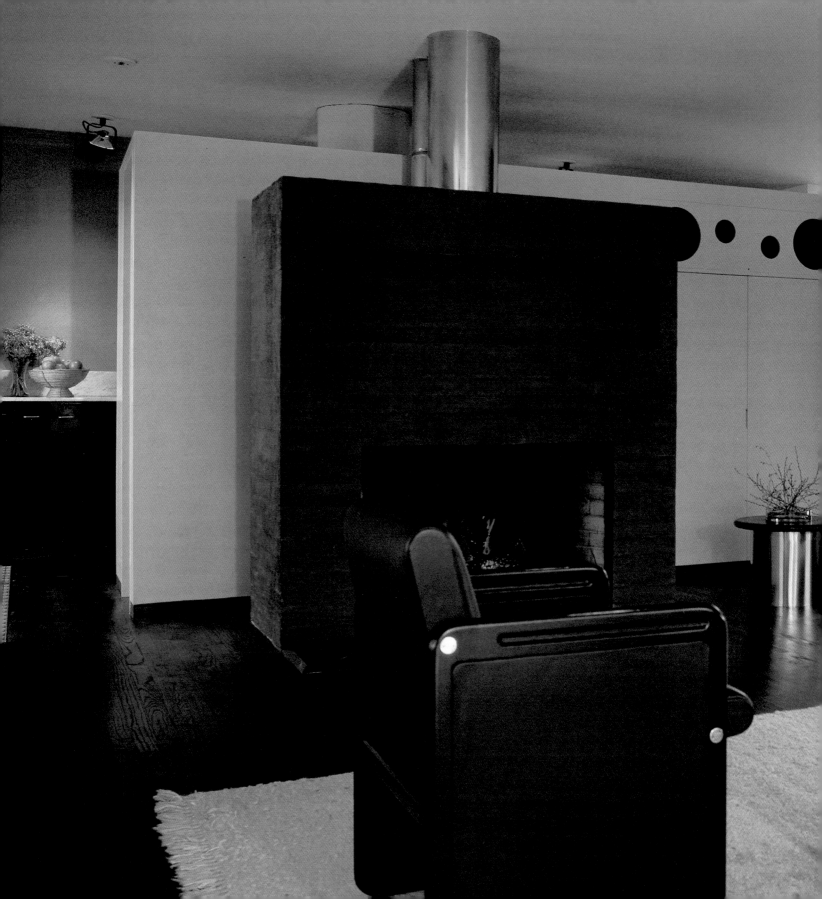

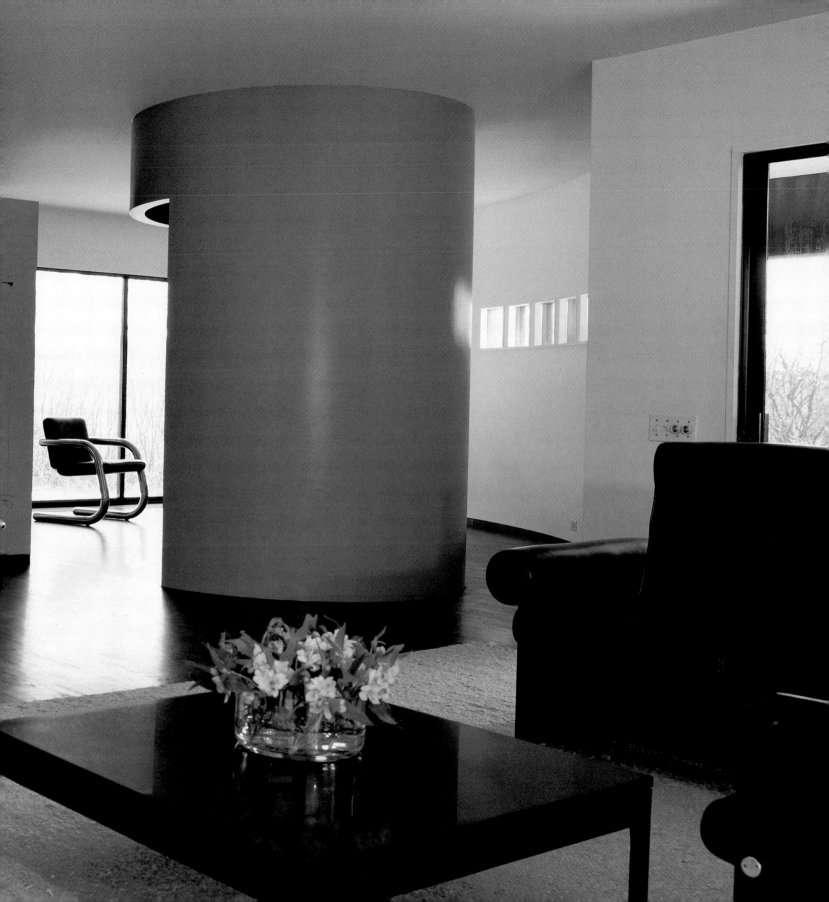

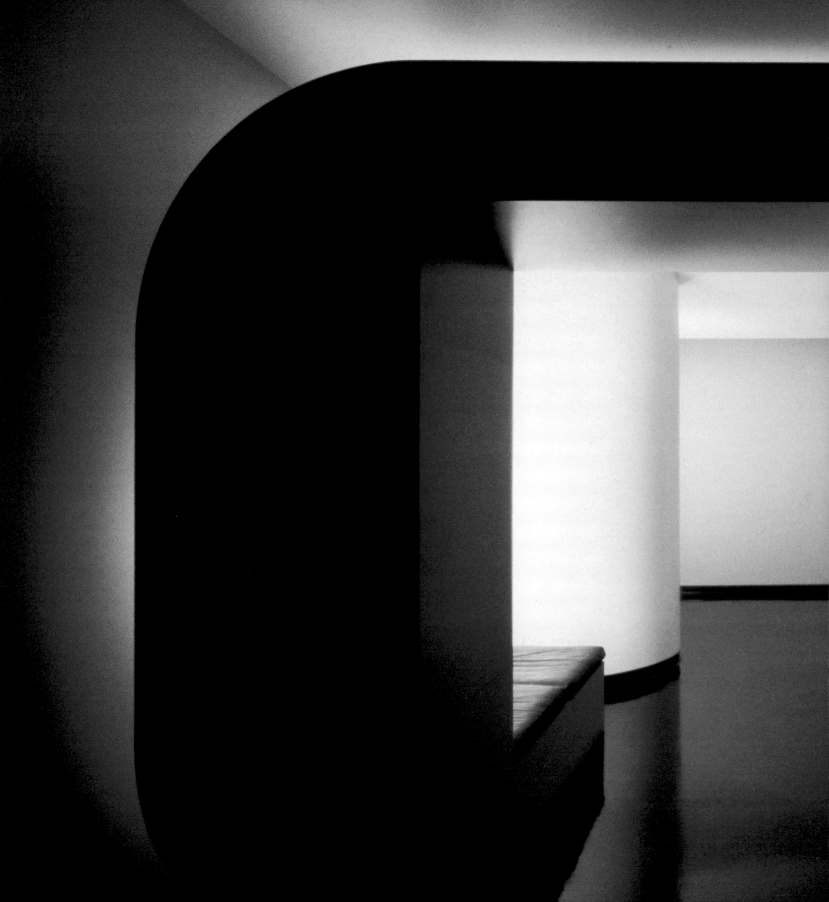

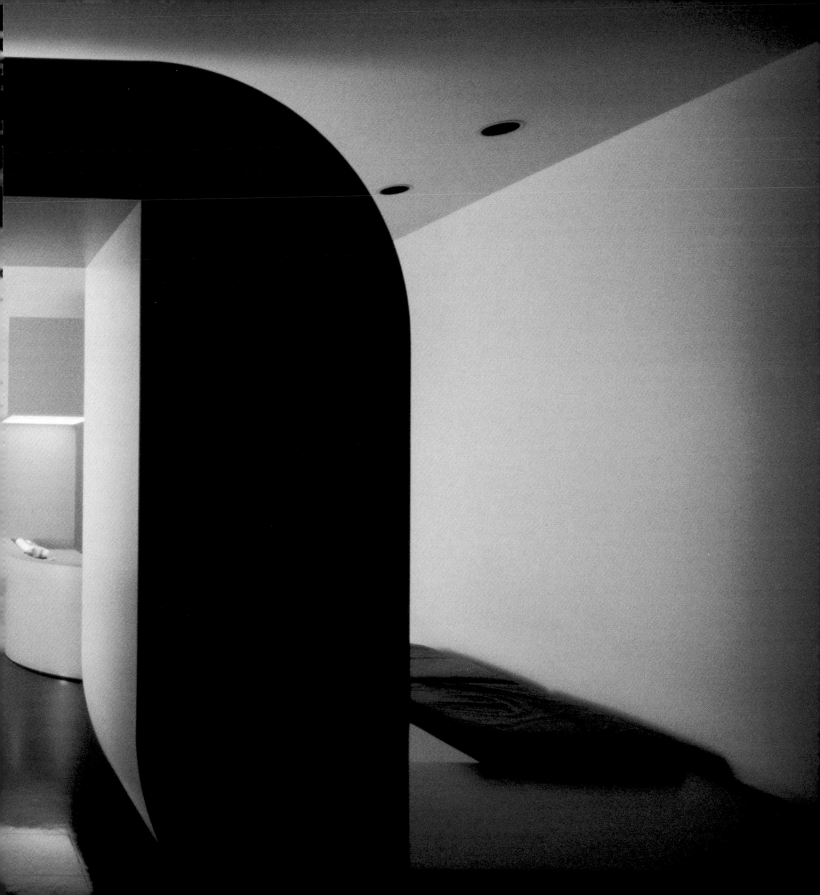

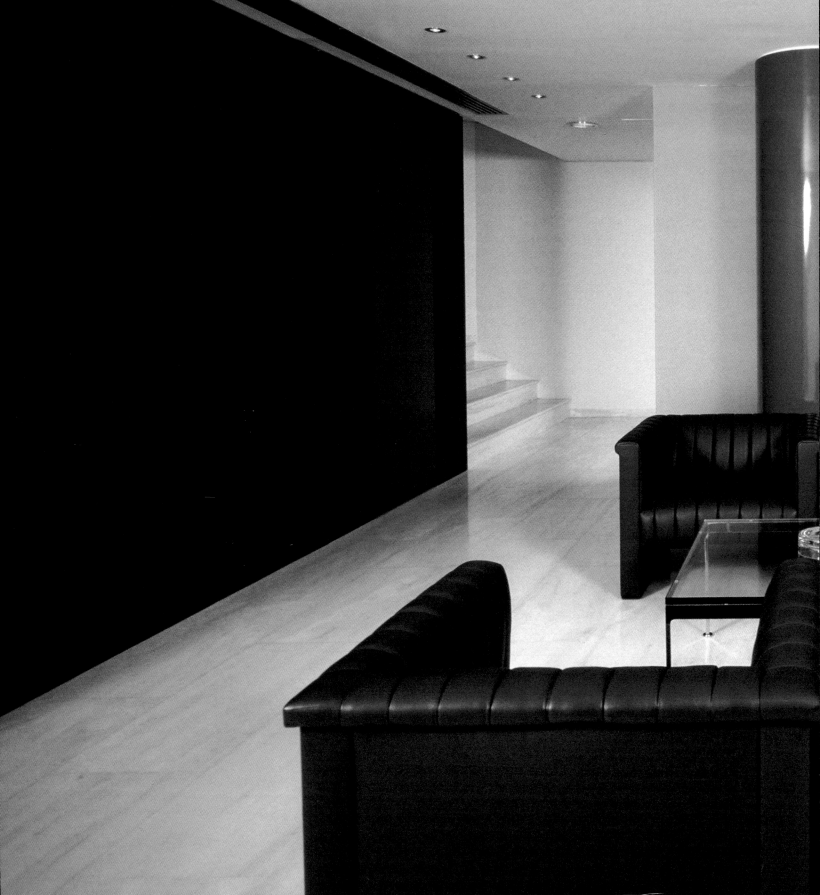

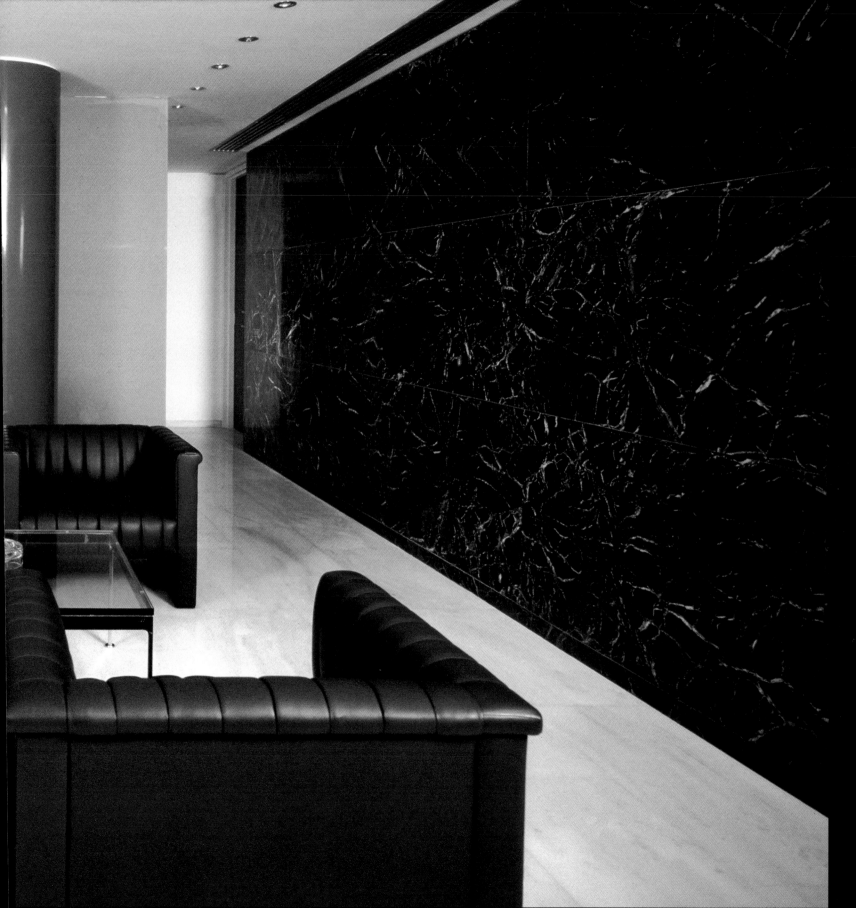

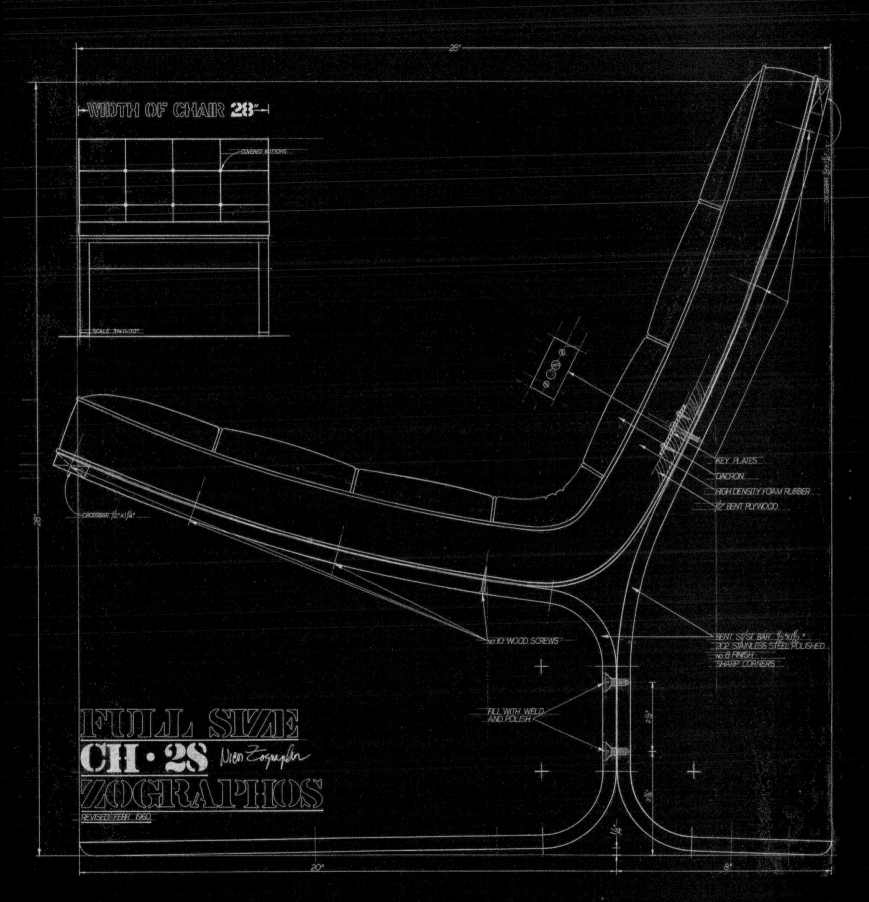

WIDTH OF CHAIR **28"**

COVERED BUTTONS

SCALE 3/4"=1.00"

CROSSBAR 1/2" x 1 1/4"

28"

CROSSBAR 1/2" x 1 1/2"

KEY PLATES

DACRON

HIGH DENSITY FOAM RUBBER

1/2" BENT PLYWOOD

no 10 WOOD SCREWS

BENT ST/ST BAR 1/2" x 1 1/2"
202 STAINLESS STEEL POLISHED
no 8 FINISH
SHARP CORNERS

FILL WITH WELD
AND POLISH

2 1/2"

3 3/4"

1/4"

FULL SIZE
CH · 28 Nico Zographos
ZOGRAPHOS

REVISED FEBR. 1960

20"

8"

■ **THE RIBBON CHAIR** "The seat of this lounge was made in 1959 following the shape of a lounge bench I had designed in school a few years earlier *(page 21)*. At that time I was feeling strong Bauhaus and Mies van der Rohe influences, so the chair has some obvious aesthetic debts. ■ One of the first things I did when I came to New York was to buy two Barcelona chairs. I also bought two of the chair's companions, a stool and a low table, although I could ill afford any of them. All the furniture made use of the Barcelona's most recognizable detail, the joined cross of metal bars that supports the sides of the chair or, horizontally, the glass top of the table. I think this idea of a design *relationship* between different pieces of furniture probably has had a greater and more subtle influence on me than the design of the Barcelona chair itself. ■ Mies based the size of his chair on a cube of seventy-five centimeters, and his table was one hundred centimeters square and fifty centimeters high. When Knoll Associates began producing his table in the United States, they lowered the table top because they thought the American market would not accept the Mies height. Lowering the table, of course, completely ruined the purity of the Mies module. I know that he understood and approved the change, but I still have an intellectual problem with it. I think all the things Mies did in the 1920s were perfect, perfect by general consensus, and they should be left as he left them. ■ Mies was a big man, bigger than I am, and his chair reflects his size. But I think the Barcelona is a little *too* monumental. To bring my chair closer to what I think is human scale, I reduced the size of the Barcelona cube by four centimeters to seventy-one, which

is twenty-eight inches, which breaks down into four seven-inch multiples. Because of my training in America, I prefer to think in terms of inch measurements—I seldom work with the metric system. This module of seven inches has become common to all my designs, and it came from simply wanting this chair to be slightly smaller than the scale of the Barcelona. After doing that, everything I did began to fall into increments of seven inches. ■ The frame that supports my chair was drawn in profile, much as I drew most of the furniture for SOM. Because it was created for a furniture competition, the first version was only one-quarter full size, or *(laughs)* seven inches. The side bars of the frame were bent more sharply and had a cross stretcher between them, but later I changed all that. The seat is a piece of bent plywood with foam cushioning covered in leather, and it simply rests on the frame. It was also drawn in profile, and its seat-back angle was slowly developed by trial and error. ■ A more symmetrical version of the same frame was used to support the Forty-Two glass table *(pages 70-71)*, but I continued applying the seven-inch module. Even the little buttons that support the glass top are seven inches from the legs. When I placed a marble top on the frame, I made it forty-two inches across *(page 32)*; the low tables are fourteen inches high *(page 33)*; and the occasional tables are twenty-eight inches high. ■ While I believe I owe a big debt to the Barcelona design, I must say the Ribbon frame is a completely different way to support a chair with steel bars. It is much easier and less costly to construct because the bars are simply joined with weld-covered bolts, not crossed and filled with welded pieces like the Barcelona."

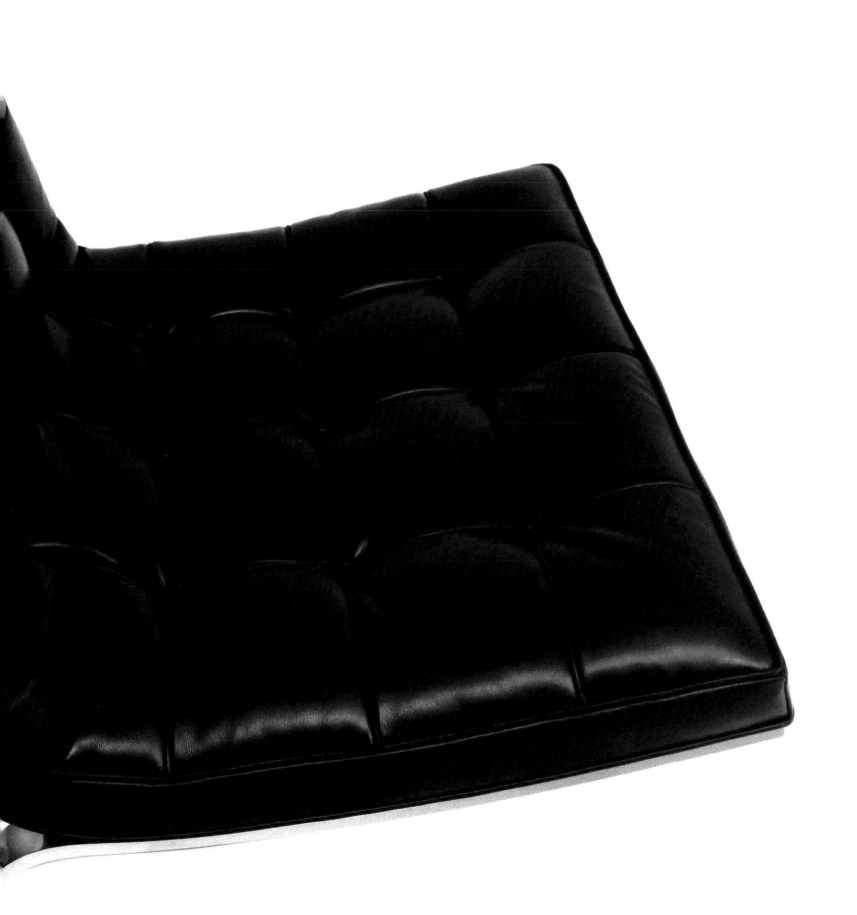

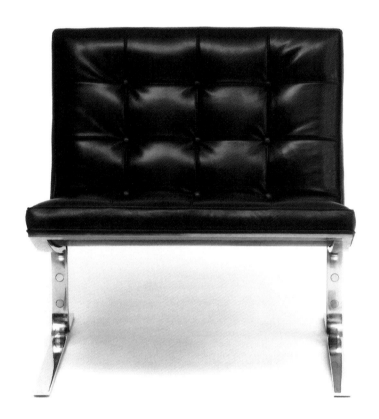

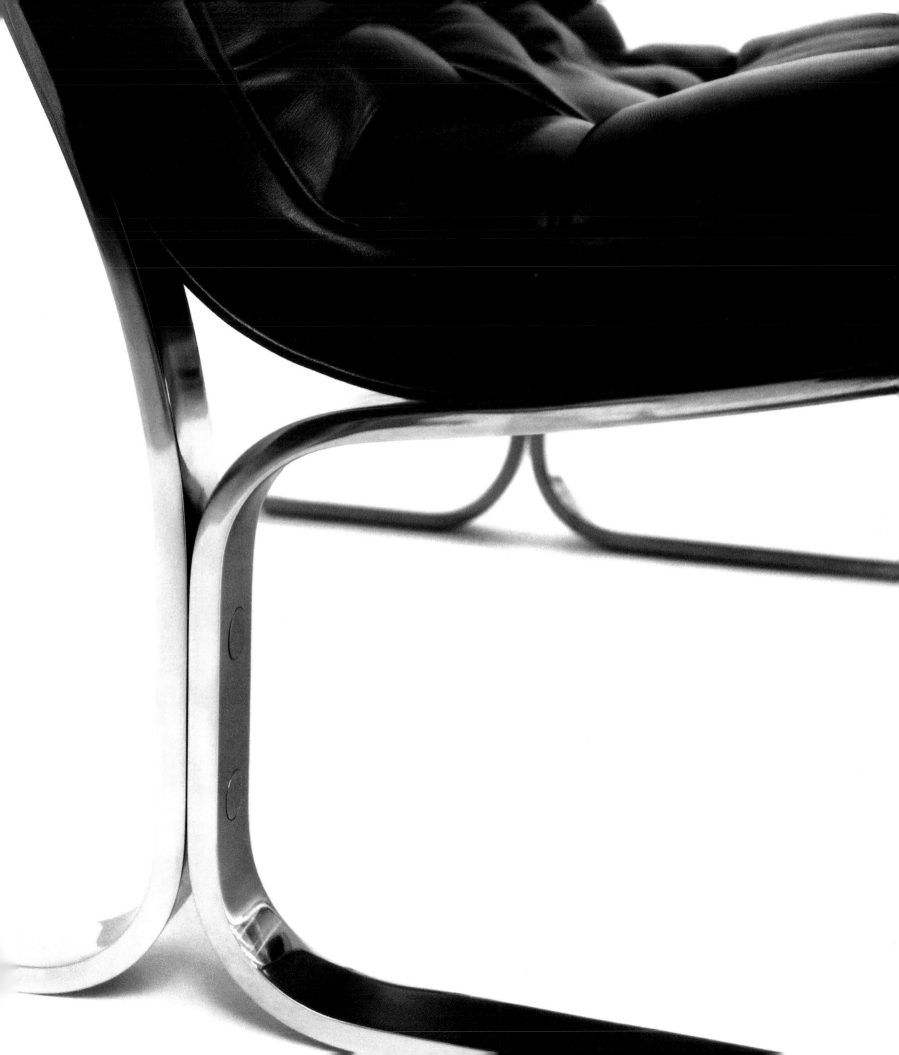

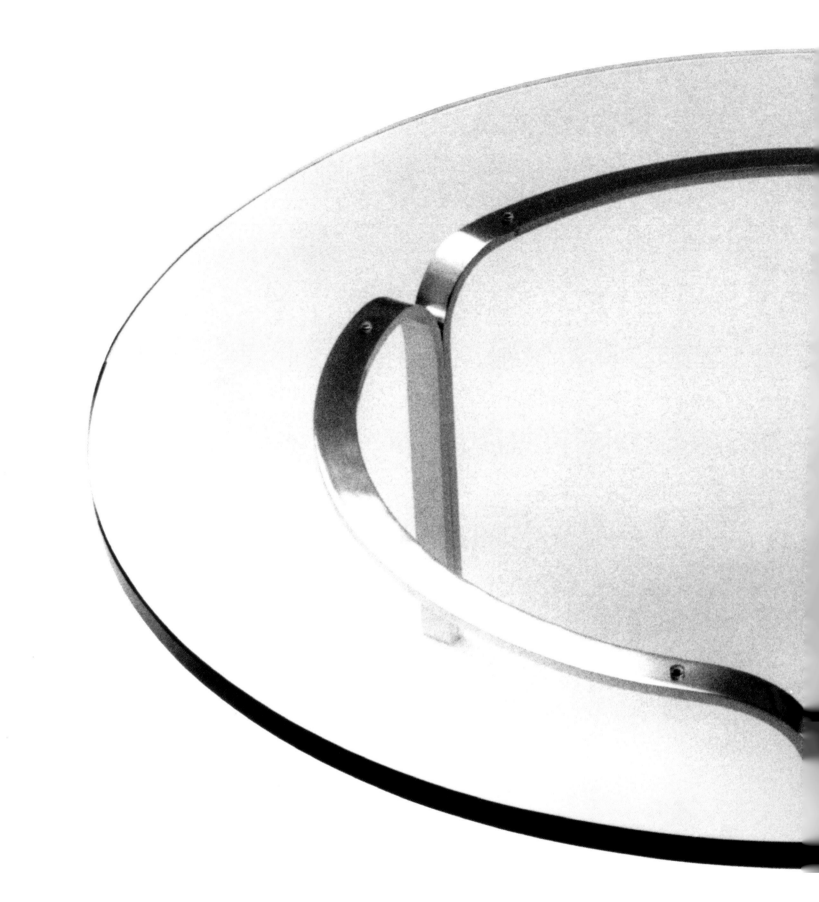

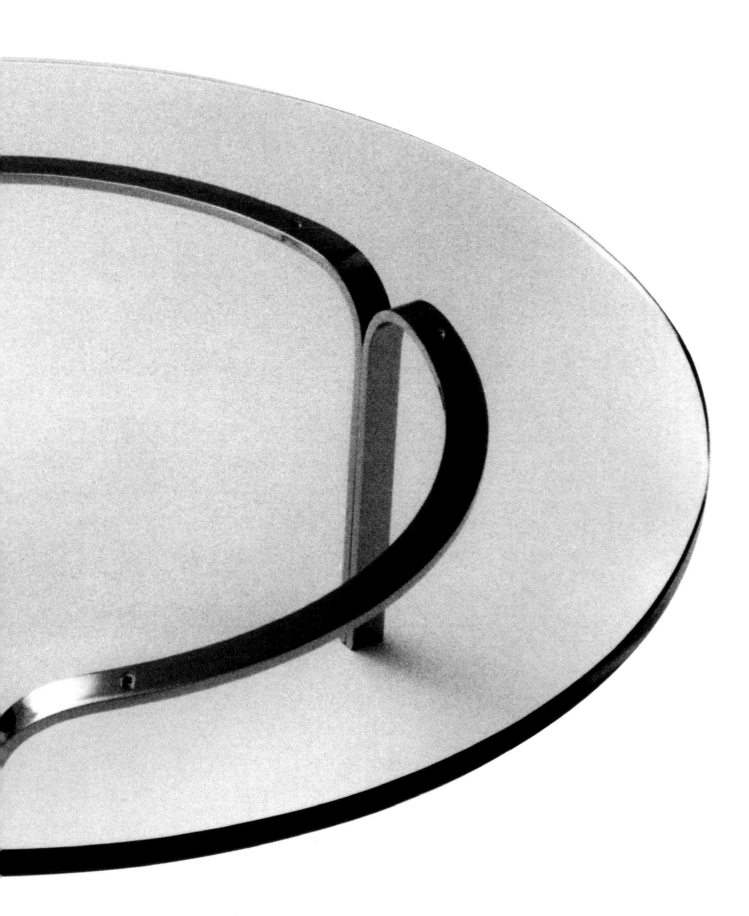

71 RIBBON TABLE, 1960

■ THE ALPHA BUCKET CHAIR

"You can see a lot of my design evolution in the Alpha bucket; the first version *(opposite and next pages)* was much leaner than it is today. Maybe I shouldn't say this, but aesthetically I still like the early version best. George Lois has a set of them around his dining table, and every time I see them I am surprised by all the changes that have taken place. ■ The early seat shape was more defined, almost *skeletal*. The seat cushion was filled with feathers and down and the front edge was much sharper—nearly knifelike. But when I changed the back a little to give it a better pitch, I also made the whole chair slightly more round and thick. Now the seat cushion is filled with shaped, Dacron-wrapped foam to give it that thicker look, then tightly enclosed in leather *(pages 84-85)*. The cushion is semi-attached with twine, while the original cushion was loose and just sat there. ■ From the very first, I wanted the outside shape of the Alpha chair to be a very simple tub, as clean a form sitting in space as I could create. However, the interior surface of the bucket had to be sympathetic to the shape of the sitting human body. Therefore, while the bucket chair looks like one cohesive form, it is actually a combination of two surfaces, each one serving a completely different need. ■ Developing the two surfaces, an outside form that was pleasing aesthetically and an inner surface that was good for sitting, was a painstaking process of trial and error. It was a hand-crafting process that took many stages. I began by taking a conventional armchair with a wooden frame. I removed its four legs and all the padding, placed it on a table, then sat in it and hand-shaped its structure around my own body. After

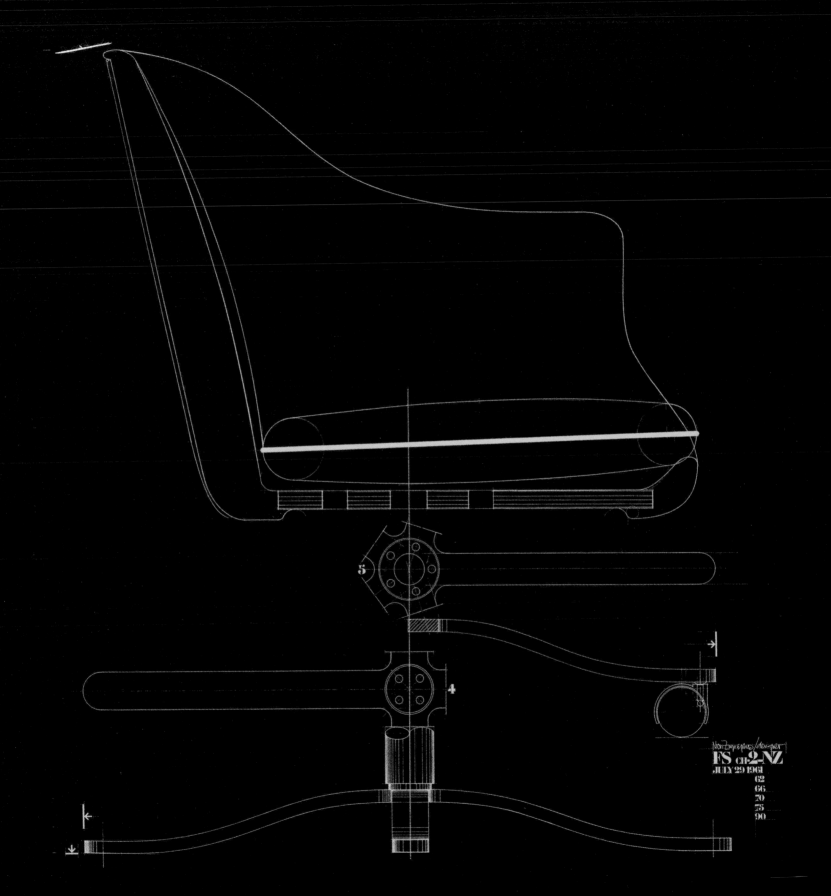

FS CH 2-NZ
JULY 29 1961
62
66
70
75
90

73 ORIGINAL DRAWING: ALPHA BUCKET CHAIR, 1960, FIRST CALLED THE TWO CHAIR

■ **THE ALPHA BASE** "My second design for the NCBI furniture competition was a spring-suspended bench in 1960 *(page 29)*. The bench was supported at the ends by legs made with two thin metal bars curving like springs to give the seat some resiliency. A full-size prototype of this design was never made, but the curves of those legs led directly to the curves of a new kind of pedestal base for my first bucket chair. This was the Alpha base *(opposite and next pages)*, which has been used to support thousands of my chairs, tables, and desks. ■ It may sound odd, but I think the purest use of this base demands some kind of circular surface on top of it, like a round marble slab *(pages 78-79)*, rather than a bucket seat. Variations of the table have been endless, and I have used two, three, or even four Alpha bases under one tabletop depending on its size and weight. It seems like I have done special boardroom or dining tables for hundreds of architects over the years, more tables than anybody ever has. ■ Usually, I make a table with an Alpha base because the architect wants one to match his Alpha buckets, to keep things consistent. Even more, I think, architects ask me to produce a table because they want me to insure its stability. While they know how to structure buildings, architects don't know as much about supporting a free-floating surface in space. It's a tricky craft and they would rather not worry about how much the table might shake or sag. ■ The first architect who wanted an Alpha table was Gordon Bunshaft, then I. M. Pei wanted a few, then I remember Louis Kahn and Jonas Salk coming to my little showroom to talk about using the Alpha chairs and tables in Salk's new research building in La Jolla."

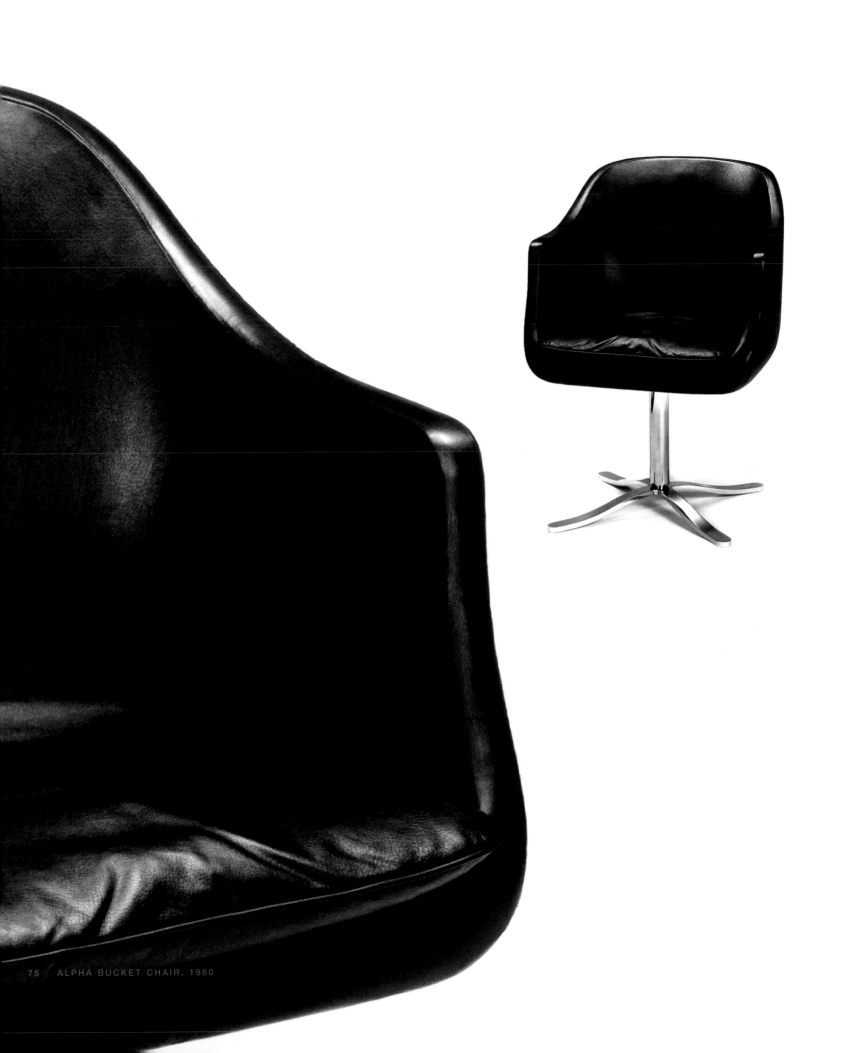

75 ALPHA BUCKET CHAIR, 1960

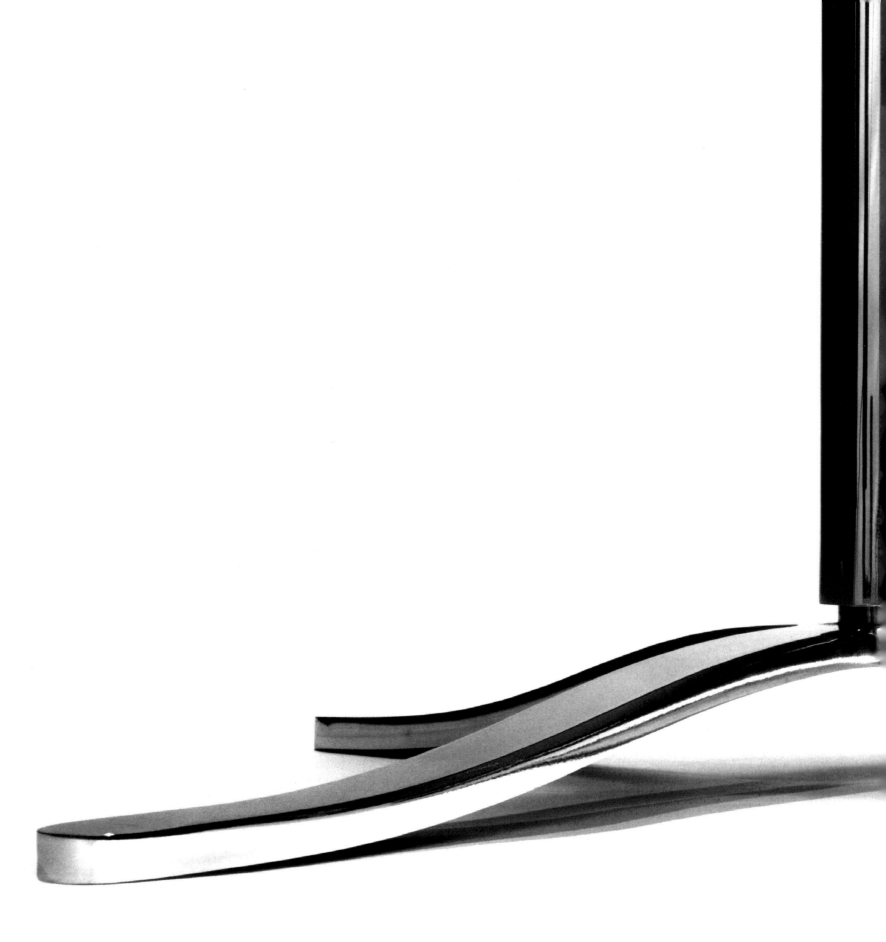

77 ORIGINAL ALPHA BASE, 1960

■ ALPHA MIGRATIONS "Many people have said the Alpha base has been my most valuable contribution to furniture design. Maybe they think it's important because it has been used so often and looks so familiar. But you know, I can't get all that excited about it because the base is not a complete object. It's always part of something else, like my high stool *(pages 80-81)*. I think the stool is a terrific design because it has so many other elements in it that I like. In fact, I love the looks of that footrest ring so much, I really don't even see the base. ■ No, I take that back, I do see the base, it isolates what sits on top of it and makes the whole thing *work*. It isolated the bucket seat it was first designed for, which helped you see the bucket's shape. But as I said, the best shape to put on top of the base is something circular, and that's why I like the stool so much. The seat is just as symmetrical as the base; you can turn it and nothing changes. ■ It's a matter of purity. The combination of a round top, especially one with a bullnose edge, is pure to me *(opposite)*. It looks the same from every side, which I can't say about my ten million bucket chairs. ■ I don't rave about this base, but that doesn't mean I don't think it's half my work. What more can I say? I've used it for just about everything you can imagine. But you really can't separate it, it always stands beneath something—that's what a base is for. The real reason it's important is that it makes me concentrate on making things just as good to put on top of it. In that sense, the base has contributed to *me*. ■ Look, I'm not going to be modest about this. The base is the one design I call better than anybody else's. But that's just what it is, a good base and nothing more."

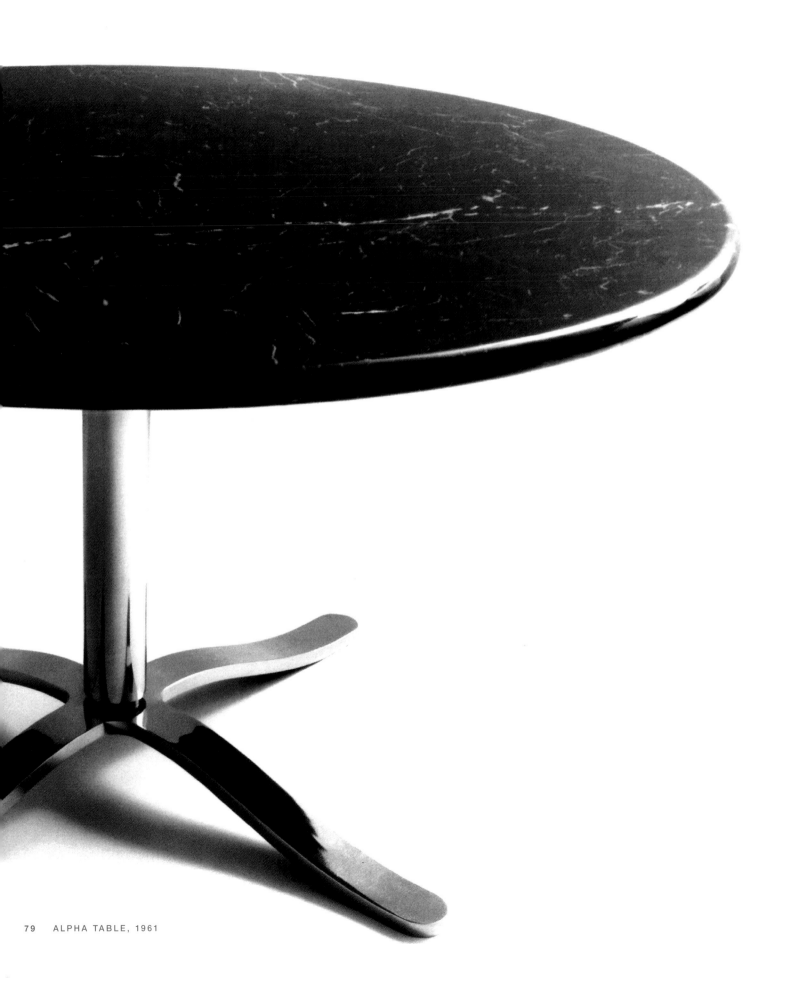

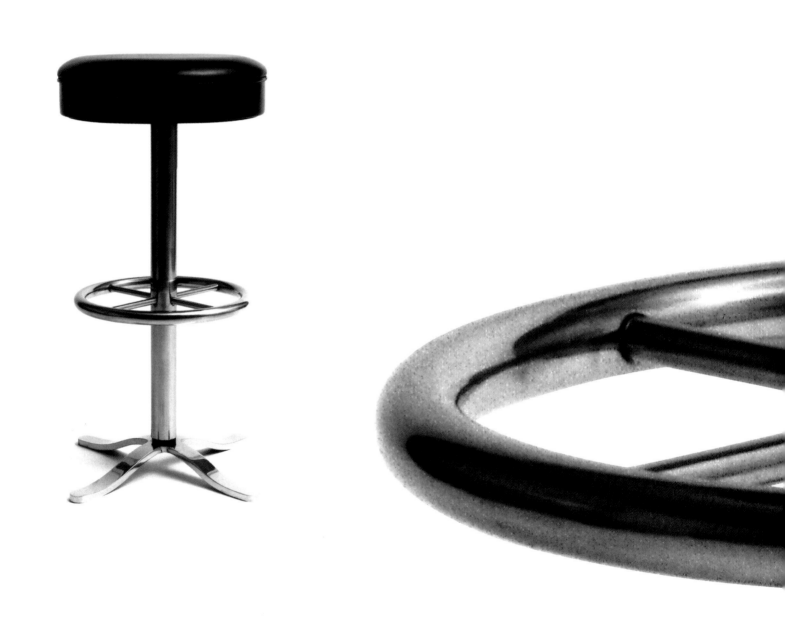

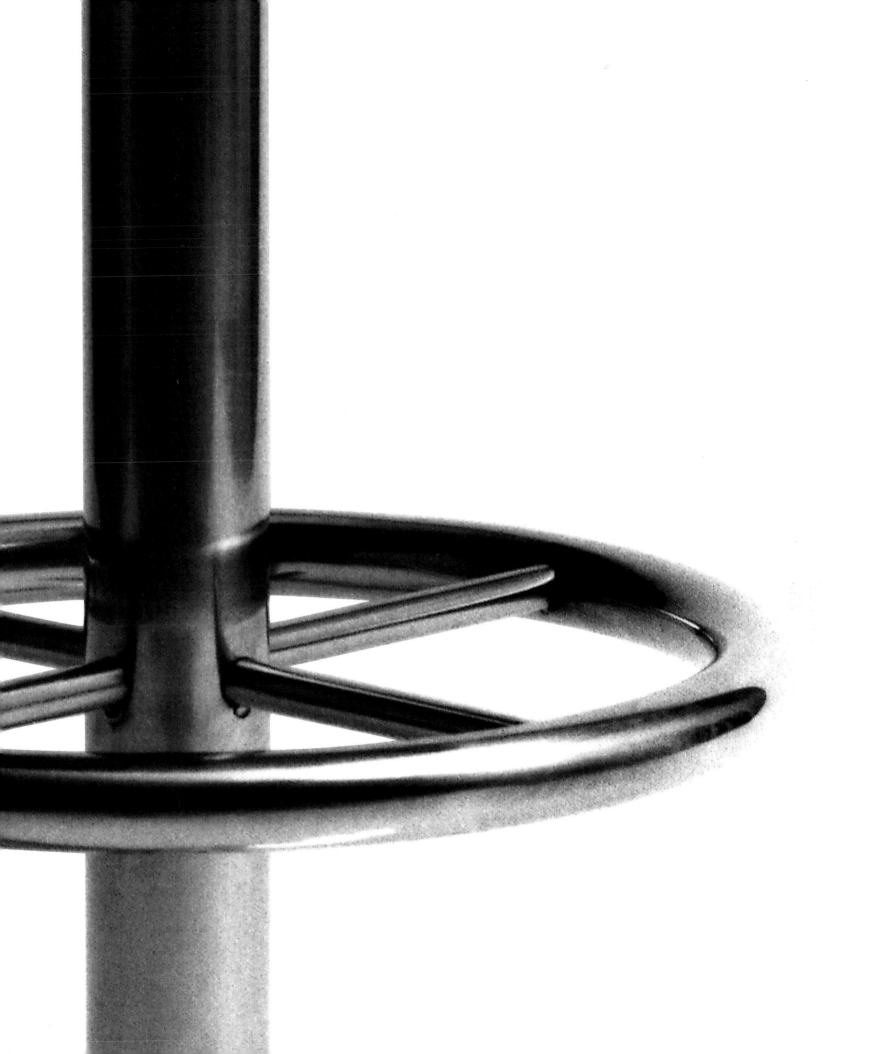

■ **THE ALPHA BENCH** "Like a lot of my work, the first version of this product was designed for a friend. Tasso Katselas, an architect in Pittsburgh, had just finished his own house in 1963 and wanted a bench to place in front of his living-room fireplace. ■ Again, the dimensions I used were multiples of seven—the bench is twenty-eight by fourteen by seventy inches long. The curve of the legs is perhaps a little flatter than the Alpha base legs, and the pedestal that supports the bench is a rectangular bar instead of a round column. In effect, the base at each end of the bench amounts to a side view of the Alpha base, which happened, I think, because I was using a profile drawing when designing it. ■ But I think the bench as a whole is a totally different design. The rectangular pedestal merges with the lower legs; there's no break in the continuity like the one in the Alpha bucket base. I have always felt that this gave the bench a certain sense of structural *spine* that carried under the entire length of the bench, a feeling I have been trying to incorporate in a number of other products. For example, when the same architect, Tasso Katselas, asked me to design multiple seating for the Pittsburgh airport, I produced a series of semi-circular benches that were made of curved stainless steel sections supported beneath by a spine—like a bent structural H-beam *(page 134)*."

■ **THE ALPHA STOOL** "This design *(pages 80-81)* was originally done in 1966 for the photographer Robert Huntzinger, a friend in Kips Bay. He had built an unusually tall worktable but couldn't find a chair for it. So he asked me to make a tall backless stool. I like it a lot. As far as I'm concerned, the design is one of the best things I have ever done."

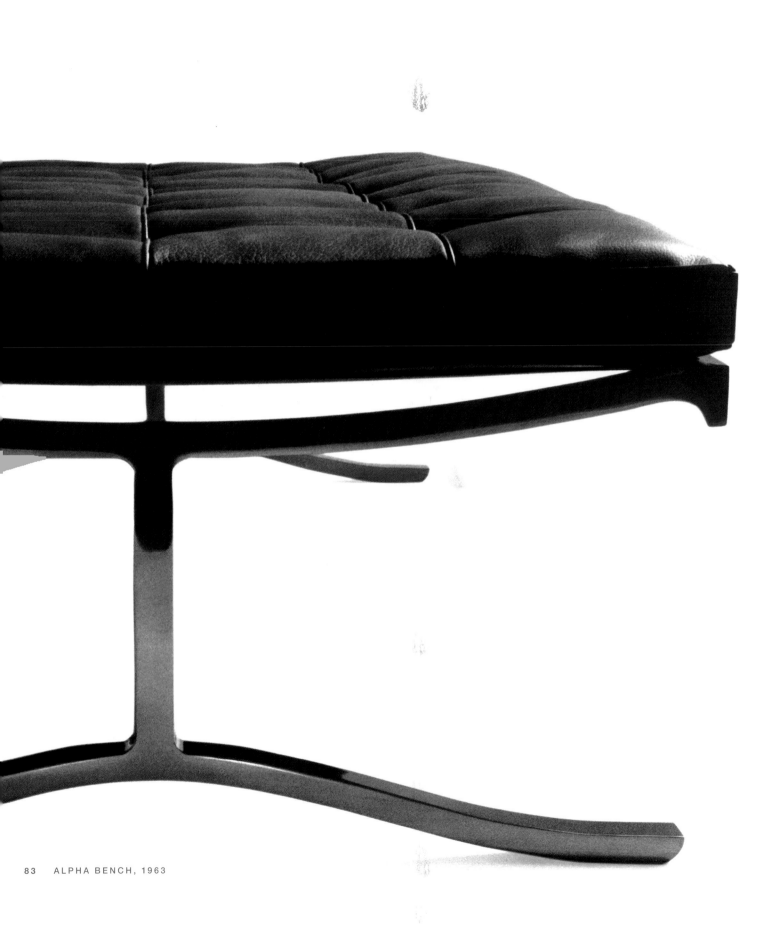

83 ALPHA BENCH, 1963

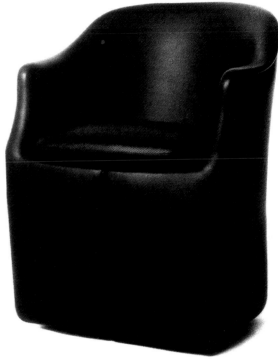

85 TWO CHAIR, 1990, AND TWENTY-TWO CLUB, 1974

■ THE BUCKET COLLECTION
"After the first Alpha bucket chair began to sell well, I produced many variations for architects who wanted different chair sizes and different adjustable mechanisms. If they decided to use the Alpha bucket as a chair for visitors in an office, they always asked for a high-back version to put behind the office desk. They wanted to balance the original Alpha design with a similar but larger, more comfortable, and plush Alpha bucket for the occupant of the office, the executive who would be sitting there for eight hours a day. ■ In this way, the Alpha design began its evolutions, as did all my other buckets. There were medium backs and high backs and buckets with four wood legs. Then I carried a bucket shape down to the floor for the first time in the design of the Twenty-Two chair *(page 85)*. There was also a secretarial chair with a separated back that could be raised or lowered, and moved forward or back, as the user wanted. ■ All these buckets were offshoots of the first Alpha design, and almost all were prompted by the market or by my own desire to offer more choices. I even tried one with extremely tight seat upholstery *(near right)*. It was supposed to be cheaper, but that didn't work out and the shape wasn't too great either. ■ You know, after a while, you can really exhaust an idea. There came a time when I had done so many buckets I didn't think I could make another distinctly different one. I was bored solving the same problem over and over. So after the Three bucket *(top right)*, I began consciously looking for new forms, starting with the Four bucket *(next pages)* and continuing with the Nine family *(pages 90-91)*. After that, the shapes of the buckets became even more individual."

■ THE BUCKET BASES "There are usually four prongs in the legs of the pedestal bases I do, for the sake of the symmetry I like, I guess. The five-pronged base is primarily a European standard, originally from Germany I think, which spread with the common market throughout the continent. The five-pronged base makes the chair almost impossible to tilt over, and I provide one when asked, but it is not a world standard and it is not legally required in the United States. ■ For the sake of the sitter's comfort and mobility, I had to add some mechanisms to the original Alpha base design. Casters came first, then swivels and swivel-tilt mechanisms under the seat on the pedestal column. That's really all I did. The casters bothered me a bit at first, but now I think the base looks as good with casters as it does without them. Everything I do looks best, I think, when it's sitting in a big space with very few things around. I design for that kind of isolation. When casters lift a chair up, they isolate it from the floor in the same way. ■ As I have said, most architects and interior designers seem to imagine me as represented by the Alpha base. To get away from that, I designed different bases for the new buckets I was making. I wanted them to generate new interest, but that didn't happen. Everybody kept wanting the original base much more than the others. A new base done in 1981 called the Gamma has sharper, more angular bends, but it still has the feel of an Alpha base and I think its shape is just as successful. But you know, it doesn't have those sweeping curves, and people think of it as my base number two. I don't agree at all, I like it a lot. Well, maybe in twenty-five years they'll wake up and catch on."

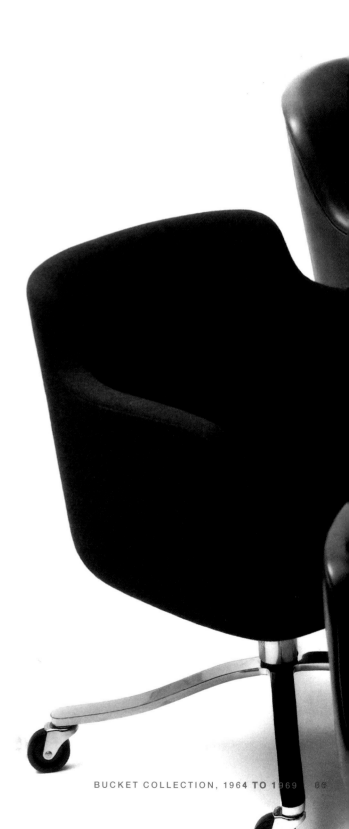

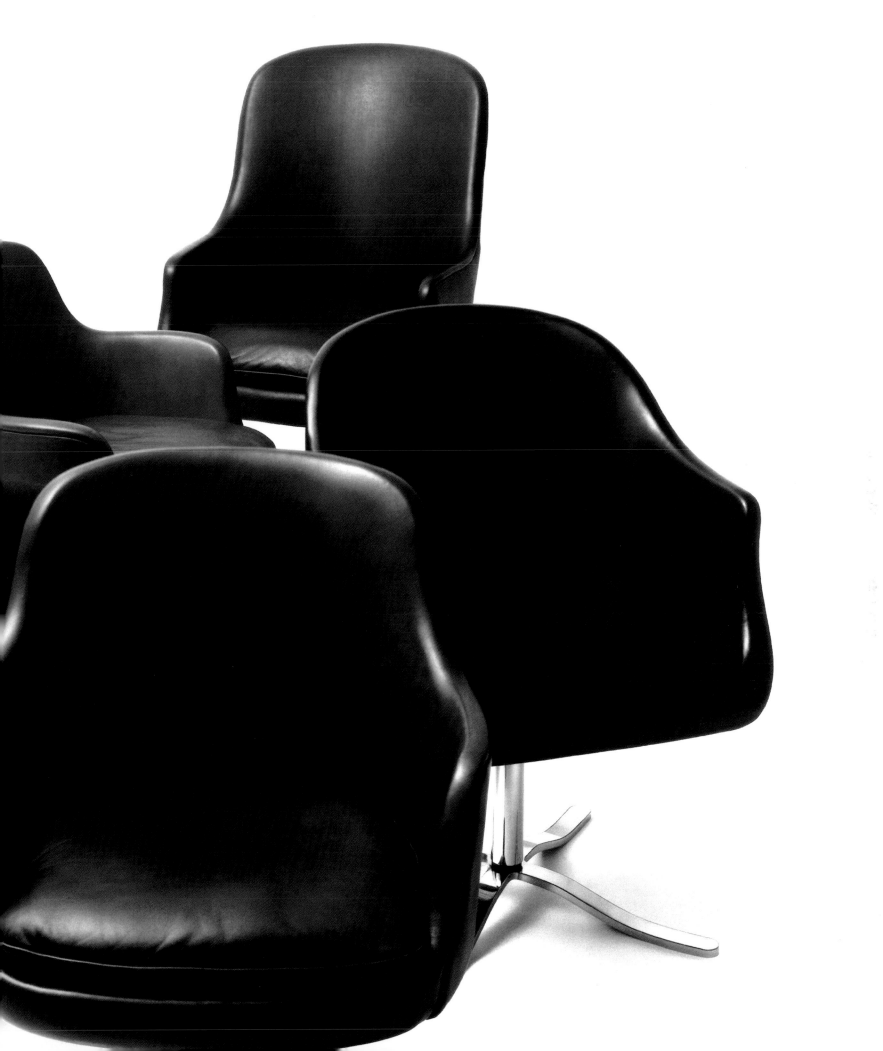

■ THE FOUR BUCKET CHAIR

"In 1962, before my company was founded, I spent a year working in Greece. For the sake of a furniture competition in New York City, I decided to try a different approach to designing bucket chairs. I wanted a cheaper, more easily produced, almost plastic shape. This time I made a full-size model of the chair. The result was a much more integrated shape *(opposite)*, and that shape has affected every bucket chair I've done since. It's a *sculptural* shape. This was before I began using plastic for the frames of my chairs, way before. So I'd have to say that I had both an aesthetic and practical goal: I wanted to make a more continuously contoured shape and I was gripped by a need to adapt to mass production. ■ Sometimes it's hard for me to choose between aesthetics and sensible production. I have always felt that economies would come if I could just simplify my aesthetics. When I think of which comes first, aesthetics always wins. It really has to, absolutely. I can't see things any other way. Even the plastic I finally used for the Alpha frame really came from a reaction against making the thing out of ugly little sticks of wood. I've always wanted things to be pure and simple, even if I seldom succeed. ■ I called this new bucket the Four chair. The real advance was the continuous rim and the cuplike integrity of the seat. Also, for the first time I think, I enclosed the cushioning of a chair with a tight leather envelope and maintained a good outside shape. ■ The Four was wide and loungelike, but the Five was pushed way too far—a big disaster. So I moved back closer to the Alpha scale in the Six chair and carried that on to the Seven, Eight, and Nine chair families *(pages 90-91)*."

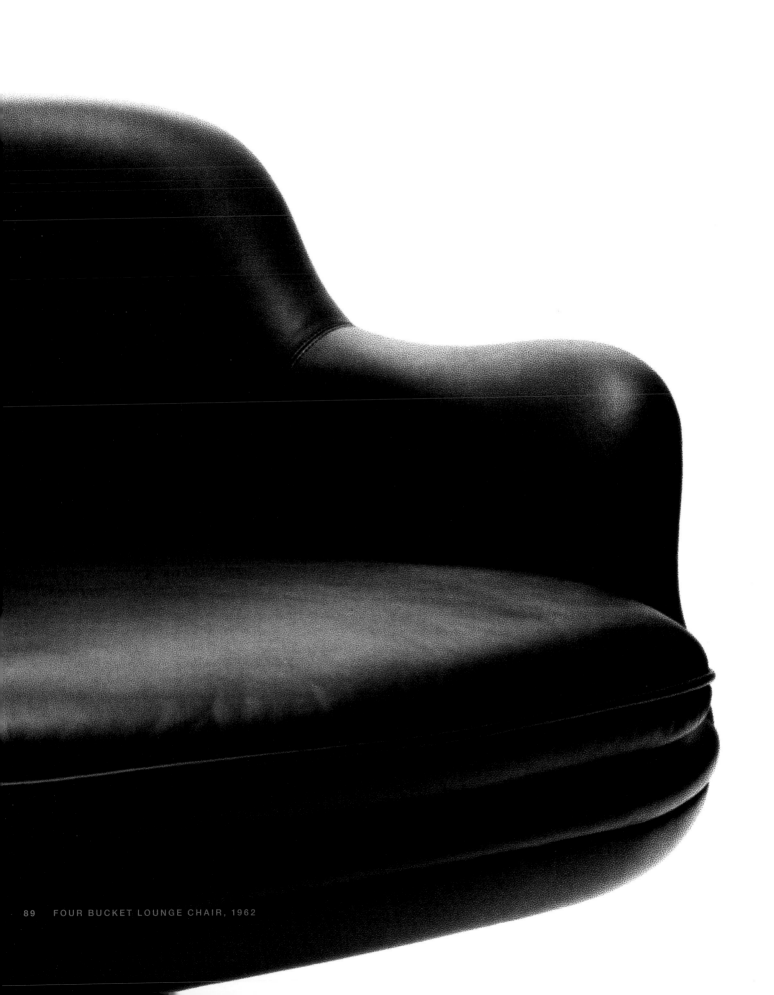

89 FOUR BUCKET LOUNGE CHAIR, 1962

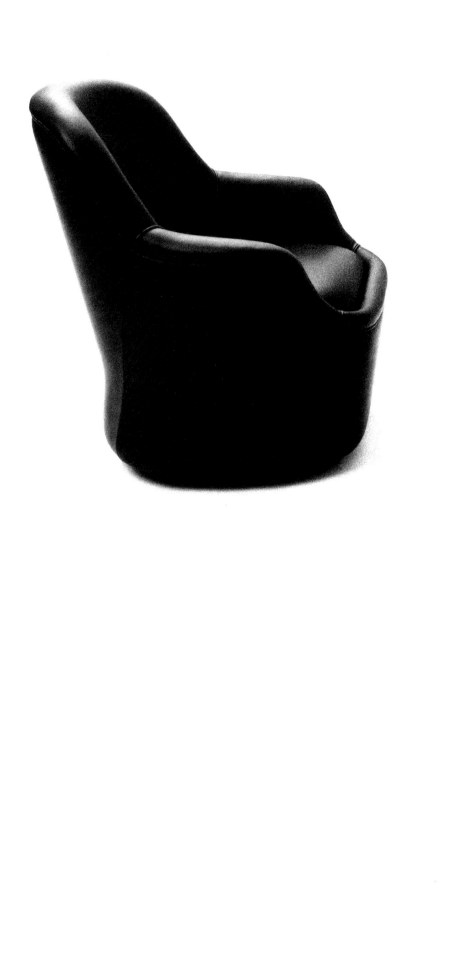
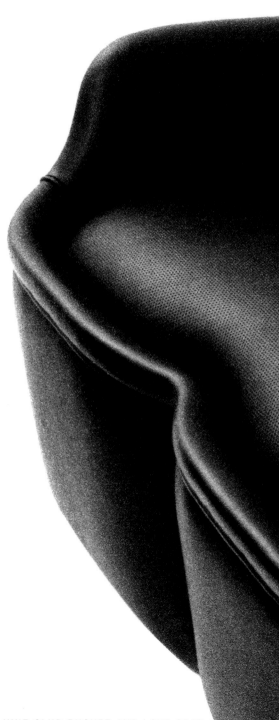

NINE CLUB BUCKET AND LOVE SEAT, 1977–80

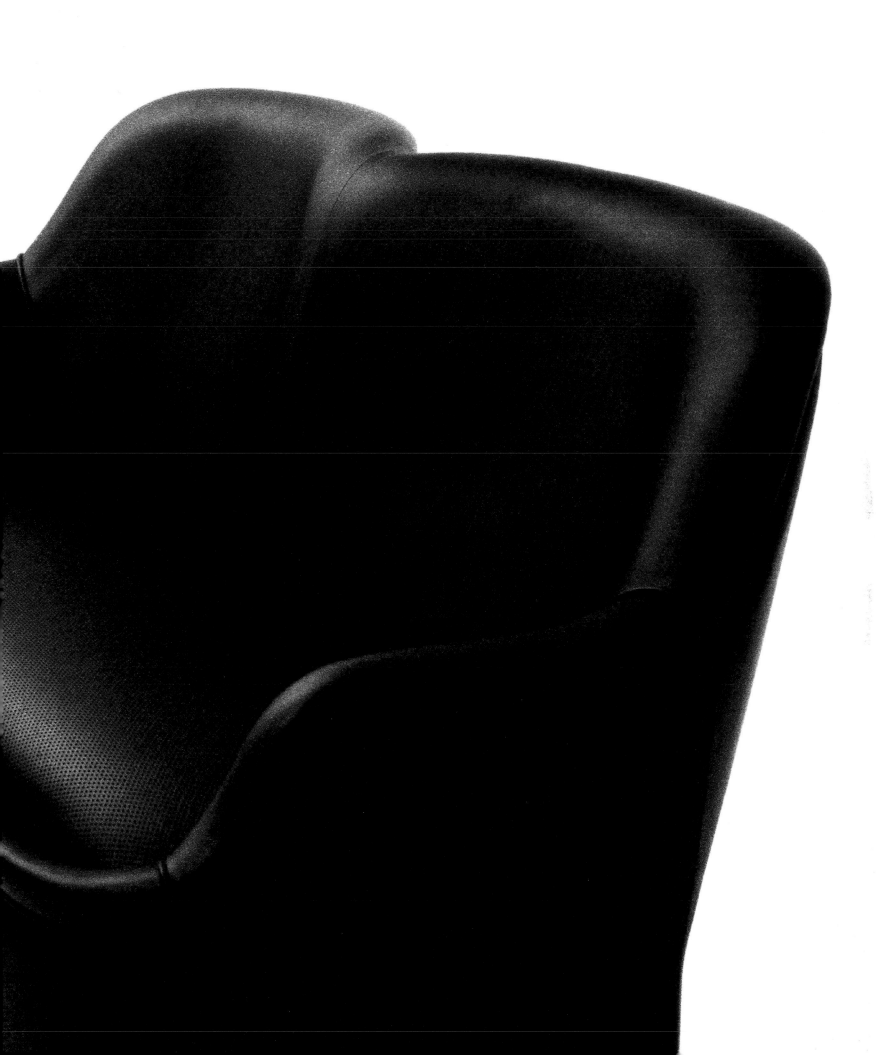

■ THE SYNERGISTIC SERIES

"By 1970, after more than ten years of manufacturing my chair designs, I had gone through a series of very bad experiences with upholsterers. I felt their work was really screwing up what I was doing. I wanted every finished chair to look exactly alike, *precisely* alike, and that simply was not possible. When I went to Germany to pick up my first Mercedes, I asked about a process that might help me make more consistent chairs. I knew they were using flexible urethane to cast door handles and one-piece dashboards. They gave me the name of a urethane manufacturer in the United States. I called the company with the idea of making a chair out of two kinds of the same material, soft self-skin urethane for the seat part and hard urethane for the outside shell and base. ■ A sample of this stuff had been under my desk for years— a part of a coffin top *(laughs)*. It was sliced in half so you could see inside, like a section. It was made of the rigid urethane. That was all figured out, so I knew I wouldn't have any problems with the rigid shell. But I found that nobody had solved the self-skin flexible urethane, the material I wanted for the inner surface of chairs. The soft stuff had a lot of surface bubbles and manufacturers could not get rid of them. Still, I went ahead and designed just what I wanted: a series of molded chairs using two densities of the urethane material poured in one single piece. ■ This was the Synergistic series, and its design was possible, *theoretically* possible. But while the urethane blend was actually being used in a few small products, the technology wasn't far enough along for the big forms I needed. So I decided to make the same urethane chair, but in two pieces instead. A soft-skin surface for the seat would be snapped or glued inside a rigid shell—the pliable interior would be supported by a stiff exterior, and a little reveal or notch would separate the two materials. But I found that this could not be produced either; there were still those bubbles and the large size of the forms I needed. ■ The technology wasn't adequate, but even if it had been, there was no way we could pursue the idea. My company was young, we didn't have the money to produce large molds, so we couldn't afford to make the great number of chairs that would keep the unit cost low. I remember we needed about $100,000 and we just did not have it. ■ I really don't know why I was so determined to make this chair work. I just couldn't let the idea go. I guess it's a matter of temperament—I *wanted* this thing to happen. This was the right way to make multiple seating for airports, I thought, simple units of group seating without a lot of messy supports, without ten thousand legs holding it up. Also in the back of my mind was that urethane frame in the Alpha bucket. It was a low-cost unit that helped to keep the price of the Alpha chairs under some sort of control, and it satisfied my need to clean up the messy interior construction. But I could not find the means to use the same logic in the Synergistic series. ■ The design was always supposed to be for multiple seating, not for an individual chair. It was going to be a square-block base in which was stuck a shell-like seat *(pages 96-97)*. You could place the blocks beside each other in all kinds of configurations and connect them with hidden channels. The whole mass would become a sort of barrier in a space, a necessary barrier in a huge space like the typical airport waiting area. I thought it would look like one terrific block of marble with seats stuck on it. ■ That was the whole idea, a big and simple mass without busy, leggy structures, and it came from the nature of the material. That's the nice thing about new technologies— they help you reach for something new. The process was easy to imagine, and I could see the pure mass it would produce. After that, it was easy to see the obvious by-product, a single chair shell supported by its own drum base *(pages 94-95)*. The shape of the base allowed for the sitter's legs, and it could be turned upside down to make a table. ■ The single shell appeared to be one thick volume, really simple and very much like the shell-frame inside the Alpha bucket. I liked that look. At the time, all my work was moving in a sculpted direction, one piece of something carved out of one material. I thought a machine process like this was the only way to produce large quantities of those forms. *That's* why I was excited about it, I wanted to work back from the capabilities of these machines. I wanted to get past the building up, all the piecemeal stuff. ■ There was another detail I never got to because we could not solve the money problem. I wanted to corrugate the soft inner surface of the chair with a rib so it would breathe when you sat down in it—a rib that was fluted like a Doric column. The fluting would die out near the outer edge of the chair, I don't know where exactly, but that was the general idea. The ribbing would have given the chair a rich and interesting texture, and it would have been more comfortable. The perforated leather I was using to cover bucket chairs at the time had the same appeal— it breathed and *looked* interesting."

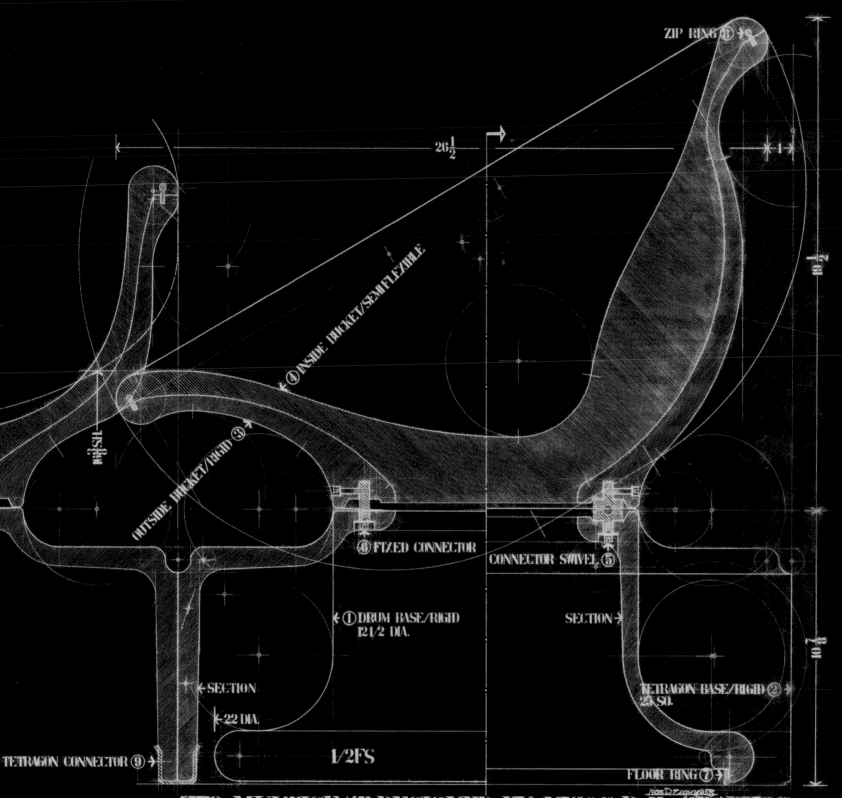

ZIP RING ⑧

26½

INSIDE BUCKET/SEMI-FLEXIBLE ④

OUTSIDE BUCKET/RIGID ③

⑥ FIXED CONNECTOR

CONNECTOR SWIVEL ⑤

SECTION →

①DRUM BASE/RIGID
12½ DIA.

TETRAGON BASE/RIGID ②
25 SQ.

← SECTION

← 22 DIA.

1/2FS

TETRAGON CONNECTOR ⑨ →

FLOOR RING ⑦ →

Z70 MULTISEAT DESIGNED BY NICOS D. ZOGRAPHOS
OF INTEGRAL SKIN MOLDED POLYURETHANE

REVISIONS: 30·4·70 31 MARCH 1970

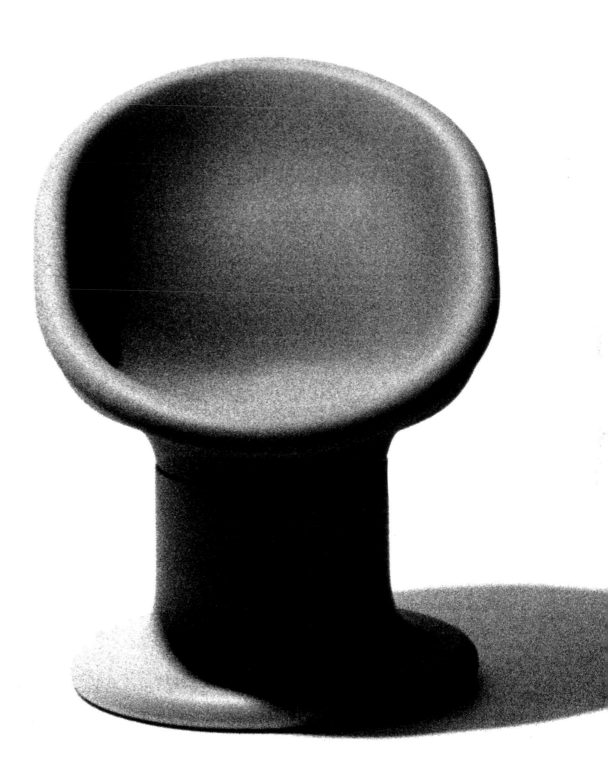

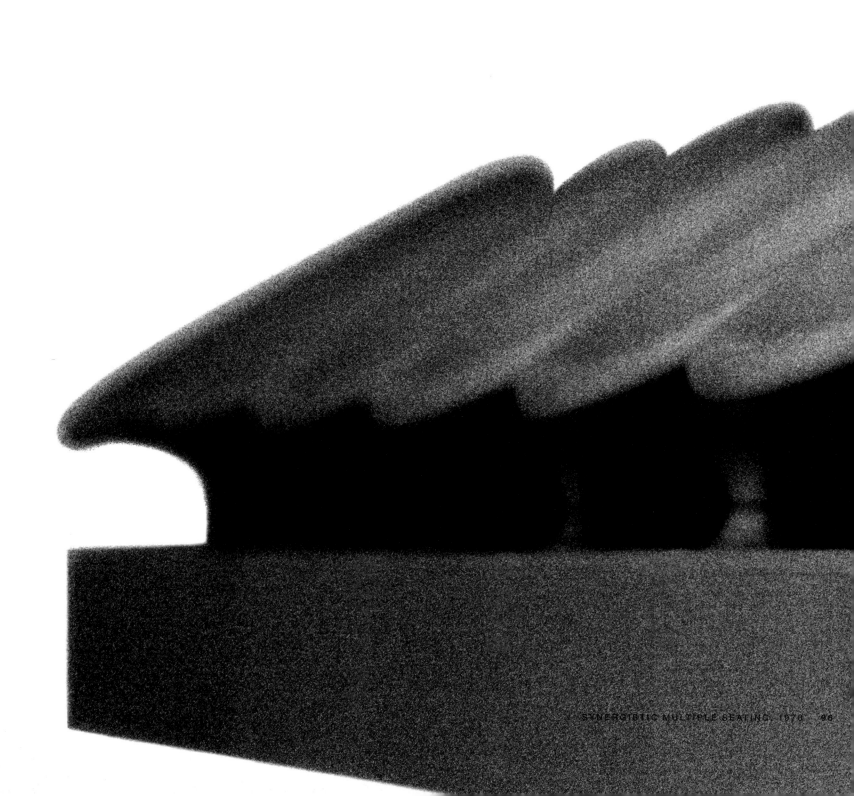

SYNERGISTIC MULTIPLE SEATING, 1970 98

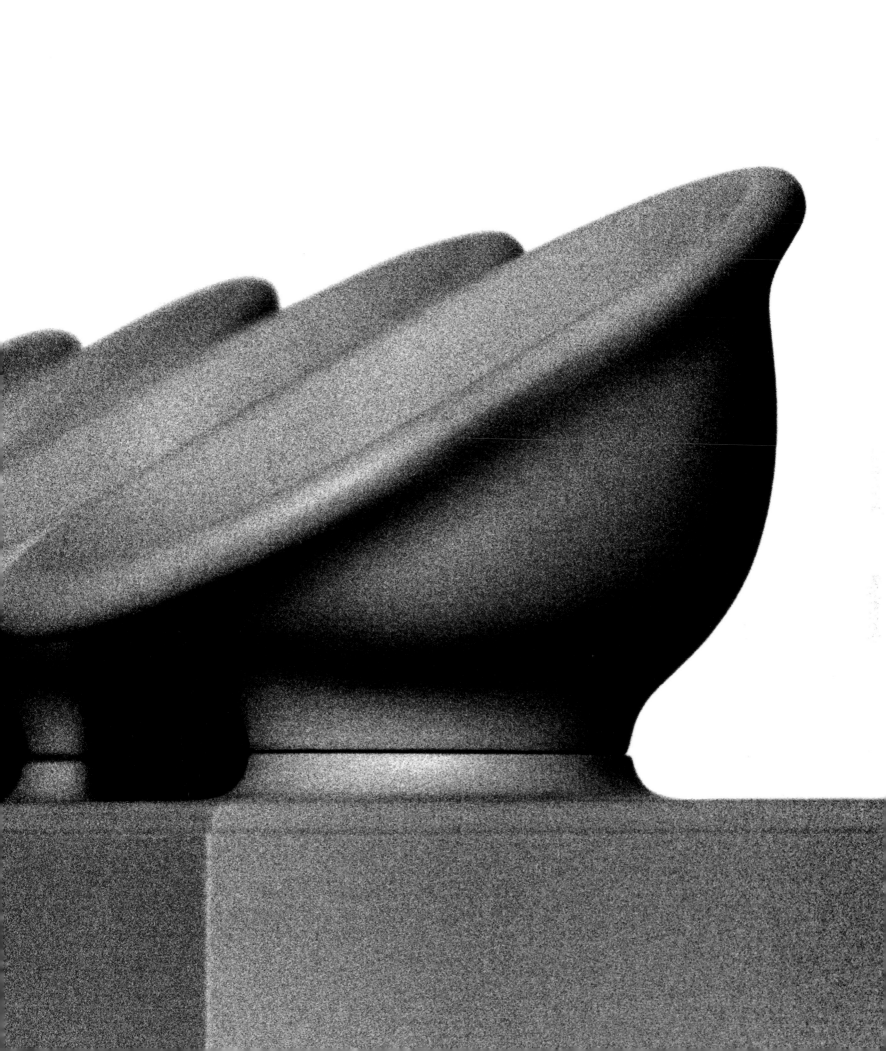

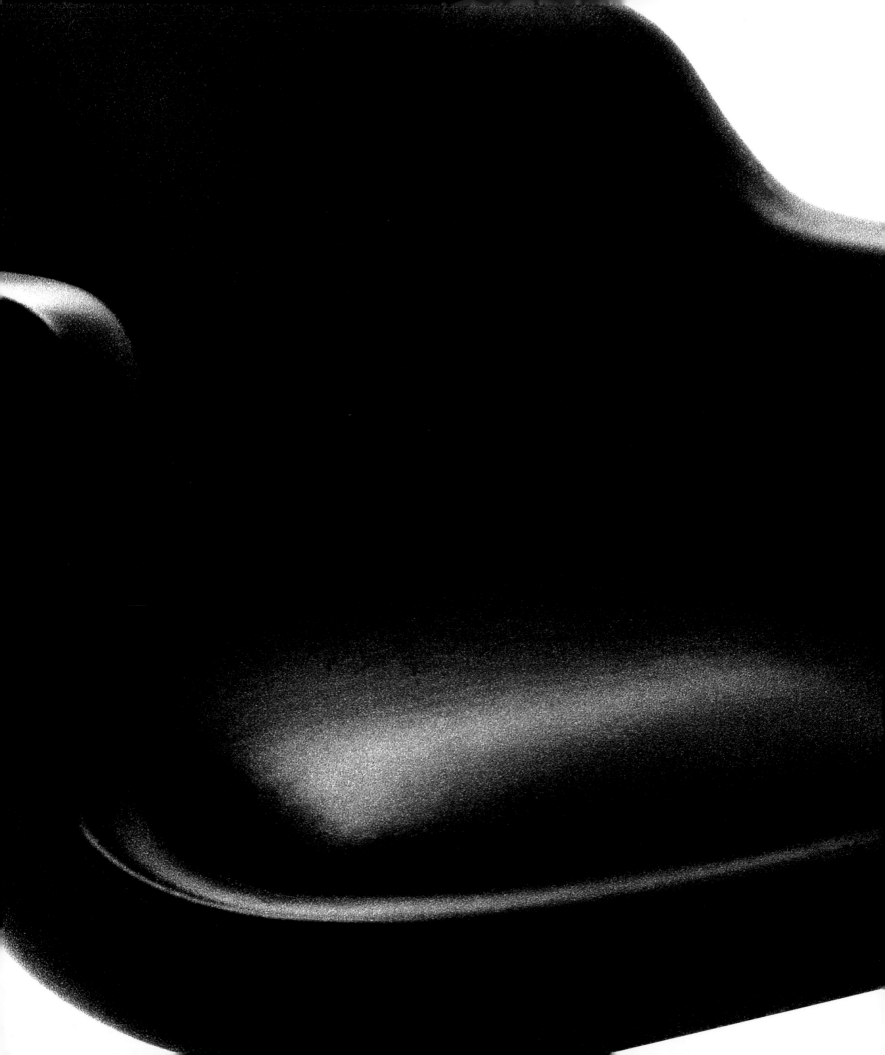

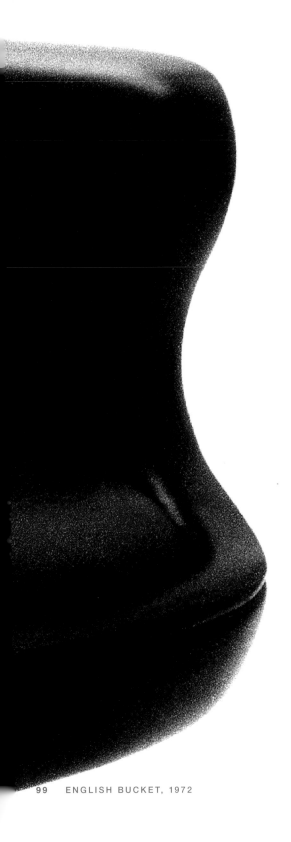

THE ENGLISH BUCKET "This chair shape was designed in 1972, and it has become the most easily recognized bucket chair I have done. The front of the arms has a reverse curve, which allows for side movements of the sitter's legs. The rim also has more subtle shapings along its outer contour than other chairs. It starts rather thin at the top, then widens for the sitter's arm, then narrows again near the bottom. ■ This meant designing a completely different inner frame. To do this I had to shape the frame by hand around my own body, just as I had done with the first Alpha bucket. But this time, I didn't feel I was building the frame piece-by-piece. I felt I was chipping the form out of a block of stone. Like a sculptor, I kept removing material until only what I wanted was left. The more material I took away, the leaner and better the shape looked. The whole process was free-hand and tiny adjustments were possible, so I could vary the thicknesses of the rim where I wanted. ■ At the time I began the chair, I remember thinking of old office chairs made of oak, but those forms were hard and much more confining. The contoured leg accommodation is interesting, but that was never a big concern. I think that if I work visually and succeed, function will always fall into place."

THE AMERICAN BUCKET "This chair *(page 101)* is identical to the English club in construction, except that the inward curve in the arm is eliminated. The design has become a standard in the Alpha Credit Bank interiors in Athens *(pages 177-192)*, because the rounded arm fits so well with the bank's circular themes. But strangely, while the American bucket has become more popular than the English bucket in Europe, it has not done well in the United States."

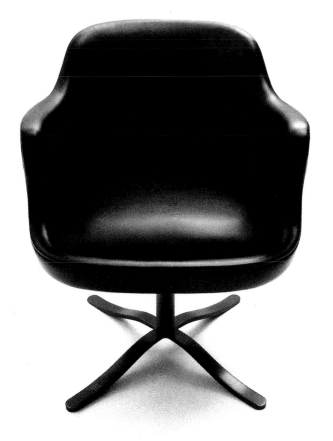

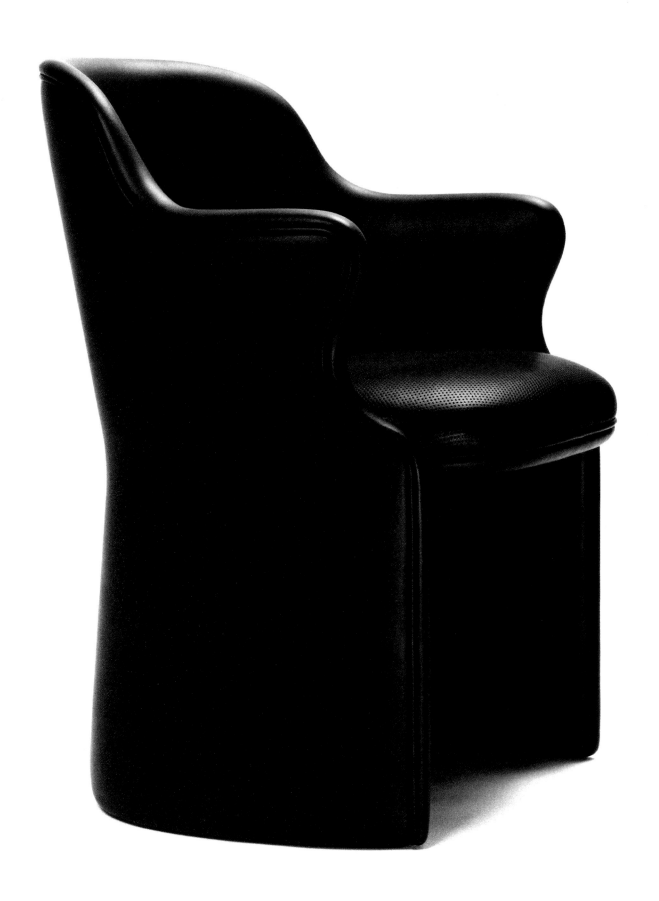

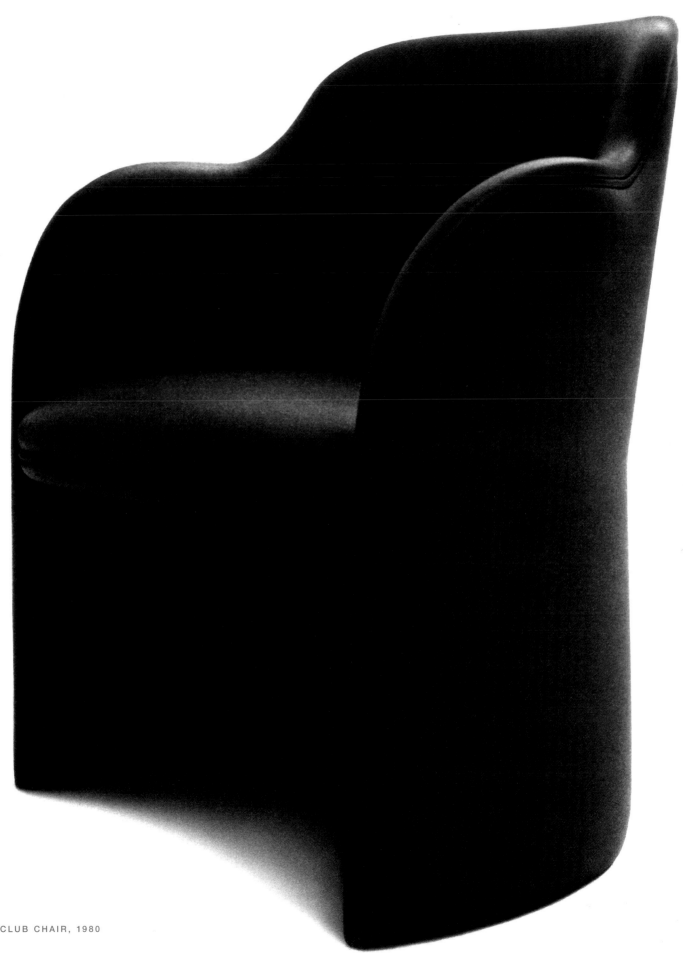

101 AMERICAN CLUB CHAIR, 1980

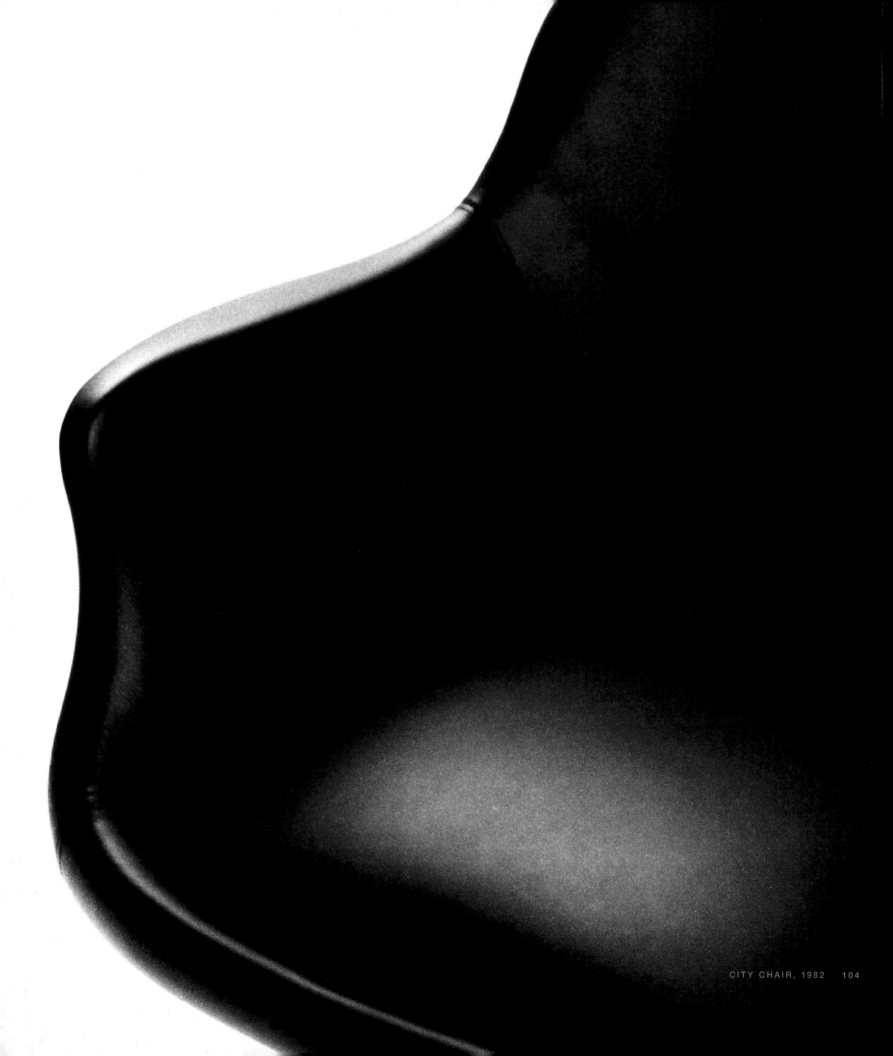

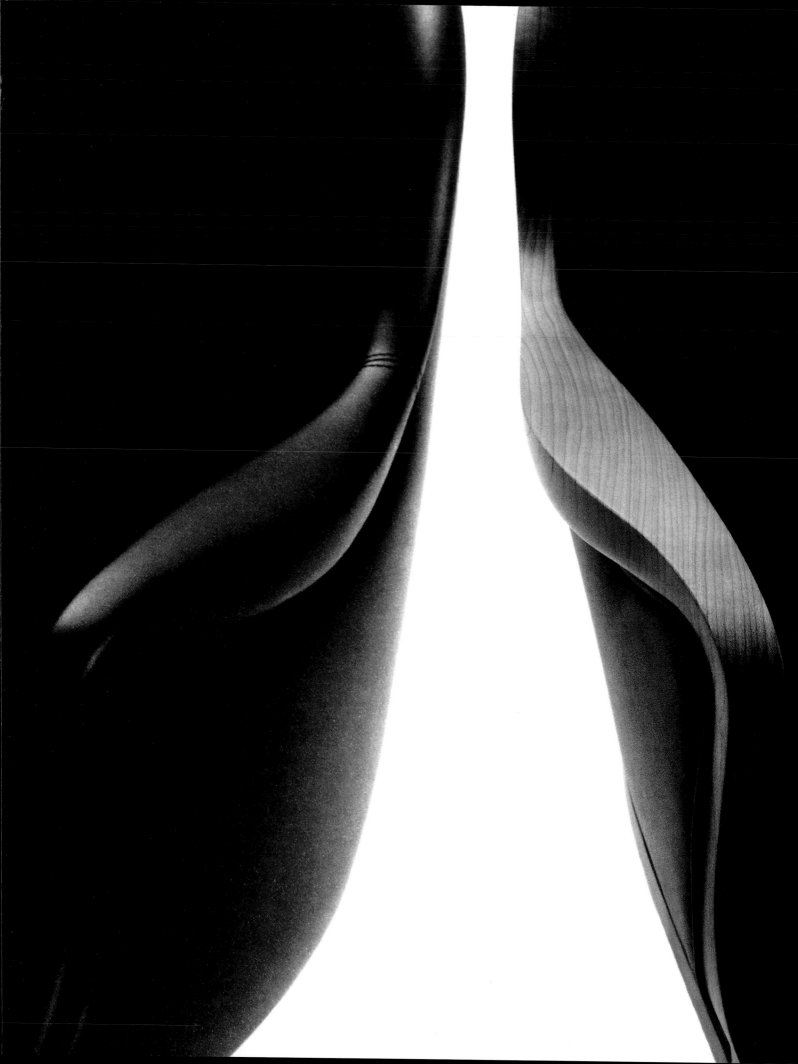

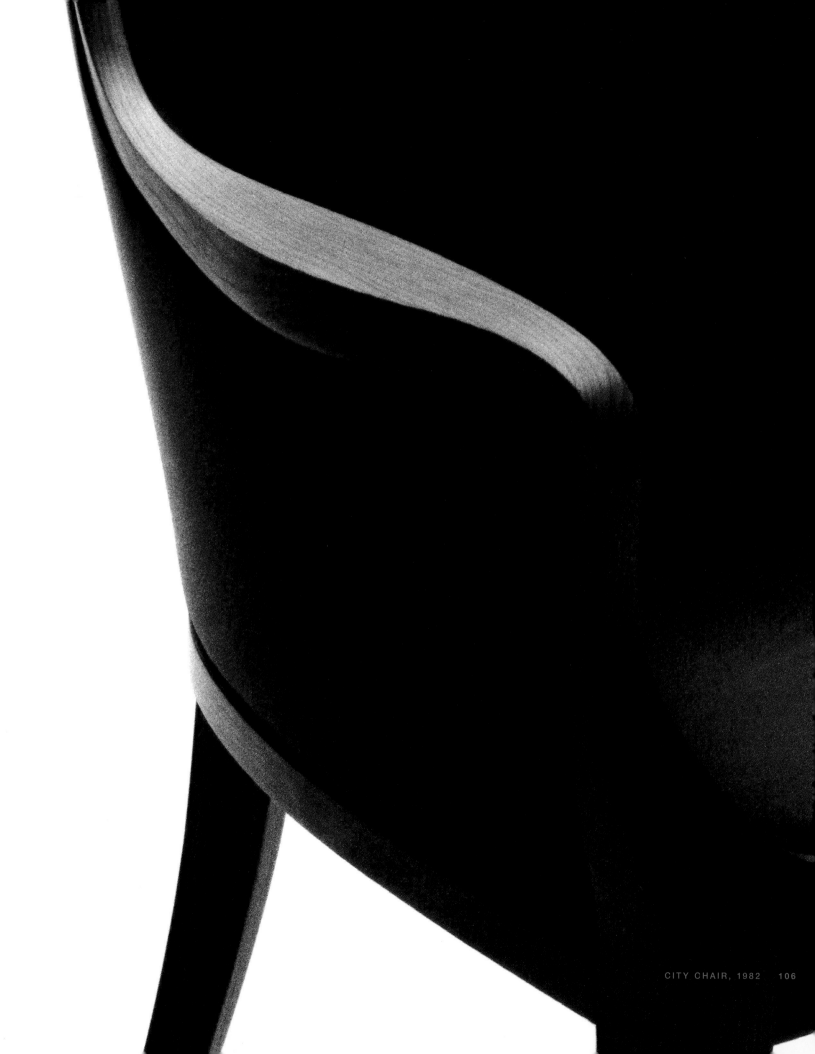

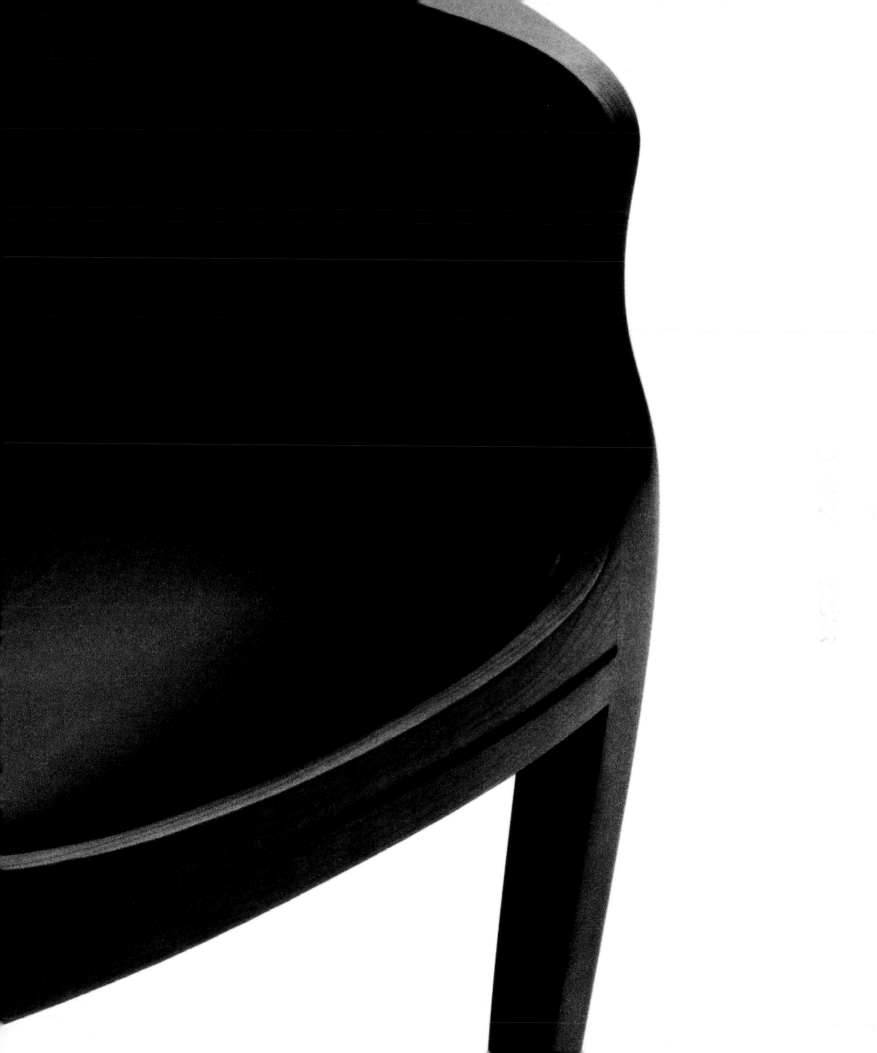

All the furniture I designed at SOM was boxy and architectonic, just like the SOM buildings. Shapes were almost always cubelike, whether they were table frames or chairs made with blocks of cushions sitting on frames. There were no curves at all; everything had to have straight sides and straight backs. Gordon Bunshaft designed a large coffee table like the ones SOM was doing, but it was a very heavy job. The legs and stretchers were wide, the welded corners were hard and sharp, and it had a thick glass top. ■ In 1960, I designed a side table that later became part of the Thirty-Five series. It had much thinner proportions—thin legs and thin stretchers, and a rounded corner where the leg and stretcher met. It was built the same way that Mies built the Barcelona table. The stainless steel parts were pieced, then welded together and ground down to look integrated. ■ But that corner, that rounded corner was a *major* departure for SOM. When I started the table, I had just drawn the Alpha base in which I made the same kind of roundness where the legs cross. I think when you join two members of a structure like this, the intersection is always easier on the eye when the joint isn't sharp. Also, when you weld this kind of joint, the process of welding itself suggests a roundness. ■ This detail of the Thirty-Five table was my reaction against the SOM way of doing things, but I really did the table for myself, for my own furniture collection. Still, I had hopes that the architects at SOM would like the table and use it, and they did. Then I carried the design to different size tops, both glass and marble, both round and square. But never rectangular. I never did rectangular tops unless I was forced to.

I just don't like the shape in plan. When somebody insists on a rectangle, I prefer to use two squares, one right beside the other. I've done that many, many times. Two squares might vary by one sixty-fourth of an inch, but a difference like that isn't visible to the eye. Unlike the many variations you always get with upholstered chairs, the nature of metal results in precision. You get things exactly the same almost every time. ■ My temptation has always been to fasten things together instead of gluing or welding them. A fastened joint is cleaner, more precise, and usually cheaper. It's also less bulky to ship because you can knock the pieces down. These tables are the simplest kind of structure you can make, four legs, four stretchers, and a roof, and I think the methods you use to build them should be simple. So I like to think I can bolt, screw, or rivet the pieces of such a simple structure together. Also, it's easier to drill and polish a few small pieces of metal separately than to weld one big frame unit and then polish *that* to perfection. But you have to remember that fastened joints must be as strong as welded joints. Still, in the end, the logics of production mean much less to me than looks. The Thirty-Five is not complicated and I wish I could ship it in pieces, but its thinness and rounded details mean that it must be welded in one strong unit at the factory. ■ In terms of form, I think round tables are easier to live with, especially if you have children. They could kill themselves on square corners of glass or metal. A round is friendlier I guess, and a square is less friendly. But I still prefer the square *(laughs)*. A square fits my way of placing things in space, in plan. But at the same time, I feel the circle is a much simpler shape—

round is by far the simplest shape there is in geometry. ■ The tables that came after the Thirty-Five were also drawn using modules of seven inches, that same magic seven-inch dimension system I first began using in the Twenty-Eight or Ribbon chair. The tables are fourteen or twenty-eight inches high, and twenty-one or twenty-eight or thirty-five inches square. But my preoccupation with the module ended after I finished this series. That seven-inch rule was something I needed when my mind was stuck in concrete, when I still wanted to be very absolute about things. I *had* to make up things like that to support what I was doing. It's really strange, it's pure instinct, my whole system of measurements just floats there in midair without any good reason at all. But even worse, it took me five years to figure it all out *(laughs)*. ■ Besides, when you're combining tables with chairs, you have to adjust your measuring system anyway. The arm of a chair is usually twenty-five inches from the floor and you have to allow a little more room to fit your fingers. Then when you add the thickness of the top, you get a height that doesn't fit my seven-inch module. So I had to play with the sizes. The problem of arm heights gets even more acute with bucket chairs because the arm heights aren't straight, they rise up toward the back of the chair. So to avoid damaging the rim of the chair you must also soften the underside of the table so that the edge won't knife into the chair's arm. ■ All these tables were designed in elevation drawings before they were built, and I never made mock-ups of a single one. I mean, you can *see* if a table is going to work in a drawing. If you had to make mock-ups of all these things, there would be no end to it.

Nicos Zographos / designer
TA-35G-NZ
JANUARY 28 1960

ORIGINAL DRAWING: THIRTY-FIVE TABLE, CORNER DETAIL, 1960

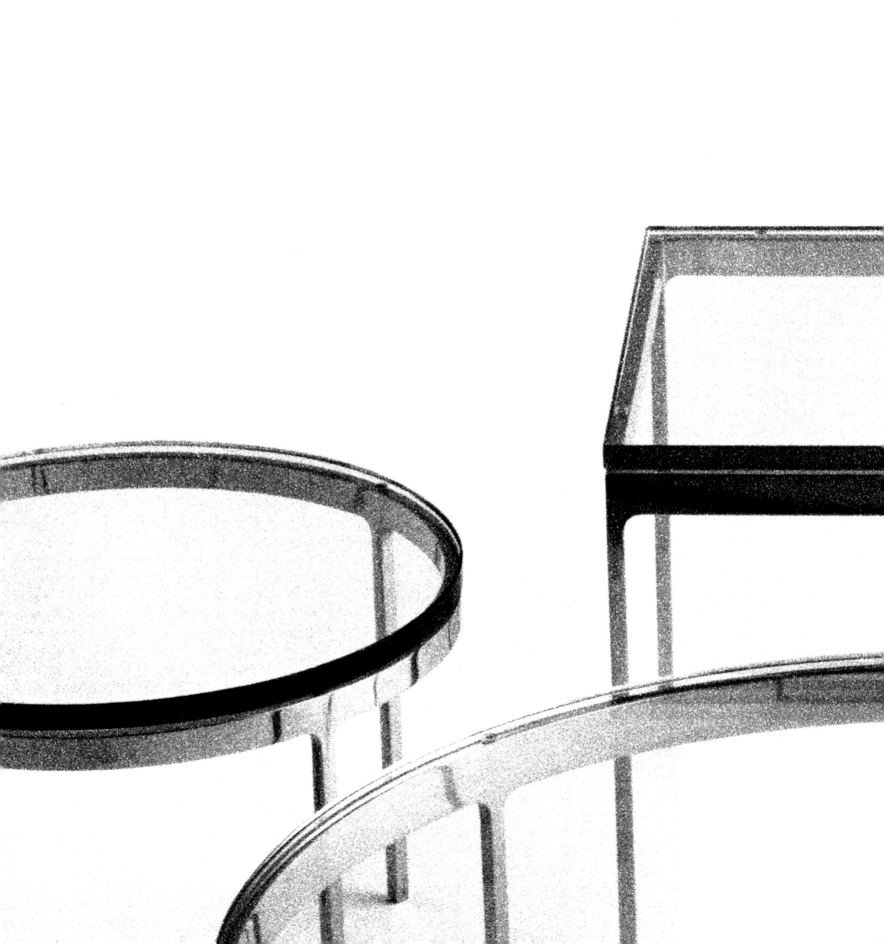

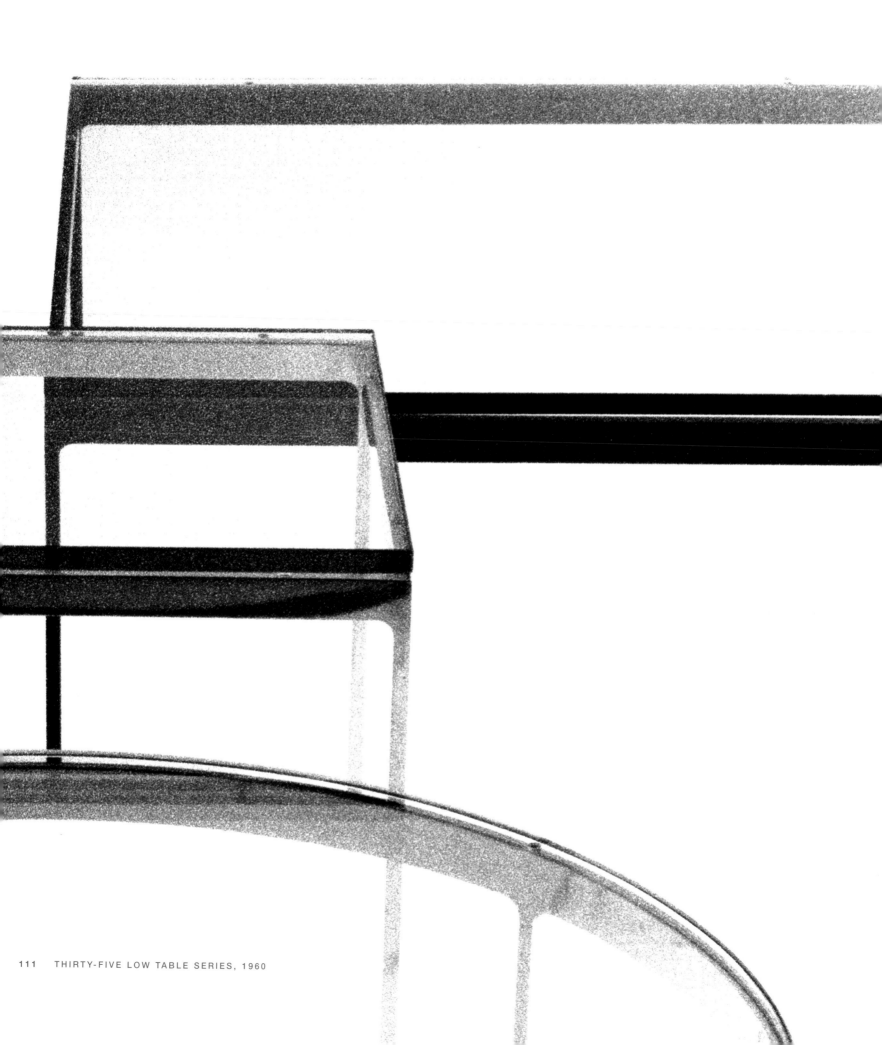

111 THIRTY-FIVE LOW TABLE SERIES, 1960

■ **AMPHORA VITRINE** "George Lois bought an ancient Greek vase and he wanted a beautiful case to display it, so he asked me to design it. Borrowing from the mullions in buildings designed by Mies, I tried to make a minimal structure so that the vase could be seen without too many obstructing lines. The glass slips in from the top without bolts to hold it, and because the vitrine is in a private home and it's hard to open, no locks are really necessary. ■ To me, this is a very architectural piece, a building really, cool and clean and not soft at all. Quite a few people have liked the vitrine, so I have made others in all kinds of sizes and materials. I still prefer the square plan shape, but George had a lot of rectangular ones made for other pieces of art he owns. ■ The base is made of four marble panels glued together, and it has an open corner detail just like the mullions of the frame above it. These mullions are not extrusions or combined metal angles, they are solid square steel bars with grooves milled for the glass to slide in and out. The mullions are welded to the stainless roof plate and to the open frame at the bottom. The roof of the vitrine is slightly lower than eye level, and it's as thin as I could make it, a solid stainless sheet only one-eighth of an inch thick. The floor is white plexiglass with a light underneath. The whole structure is not sealed, but as far as dust goes it's pretty damn tight. ■ Several of the houses I have done, and definitely a lot of the tables, have details that are very much like the vitrine. It's just a smaller example of the sense of architecture I have when turning a sharp corner in the detailing of a house or combining elements in one of my chairs. It's just the way I go, I really don't think about it anymore."

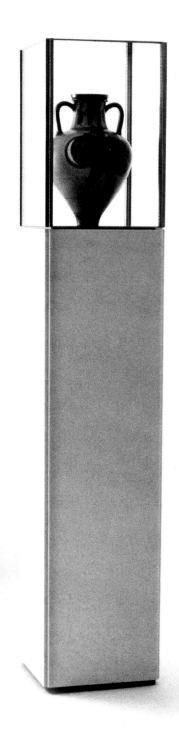

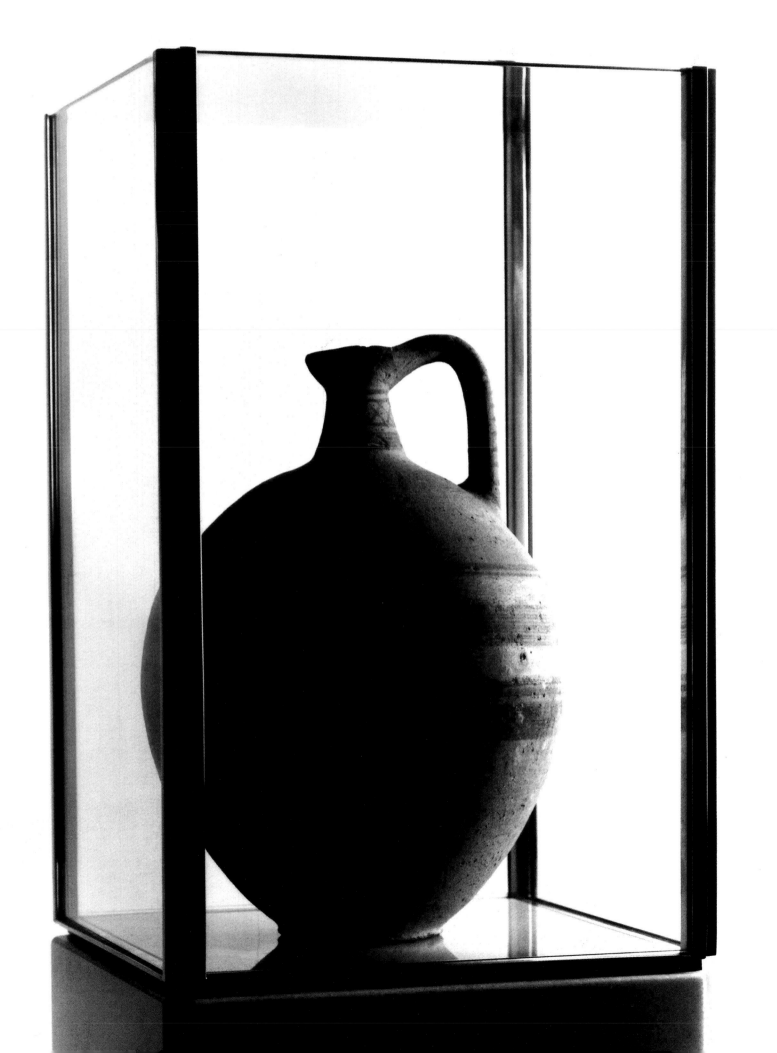

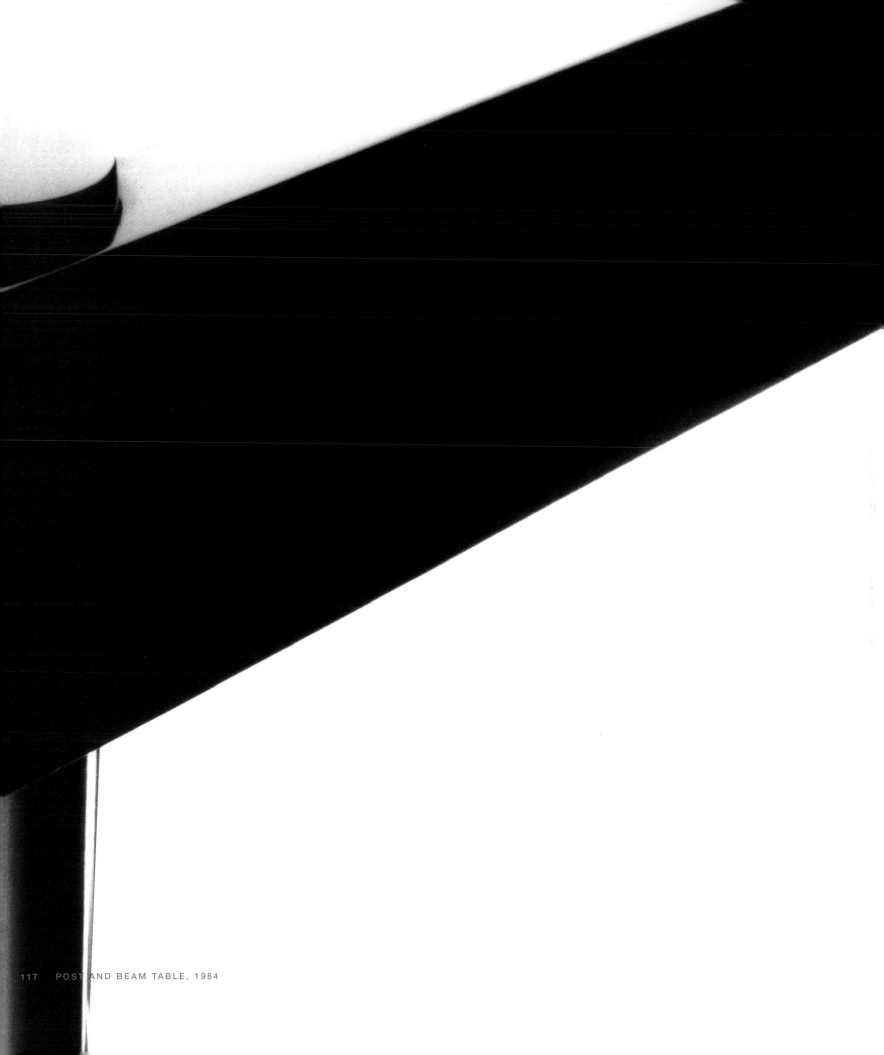

■ THE POST AND BEAM TABLE

"In 1984, I shoved a post through a frame of a table to make a nice little detail you can see through the glass top *(pages 114-117)*. I didn't think the post had to align with anything else, so it isn't welded, it's just tightly fitted with a mechanical pin. I think of it as a round column supporting an ancient temple, so the post can't line up with the beam, it has to be inset. ■ I drew the table in plan so I could determine how much the corners had to be thickened with quarter-rounds inside the frame to allow enough drilling room for the post. If I drilled right into the stretcher beam without thickening it, the post would've been too skinny. So I filled each of the corners like I did on the Thirty-Five table, but in plan instead of elevation. ■ Of all the different Post and Beam tables, I much prefer the round glass top. That is how this table should look. I think it's perhaps the most beautiful table I have ever made—maybe because the top is thirty-six inches across. Finally, *finally*, I had made one dimension that isn't divisible by seven *(laughs)*. I finally gave up that old module, that crazy seven-inch itch."

■ THE METRON TABLE

"This design is put together like a puzzle. It's a simple puzzle really, there is nothing complicated about it *(opposite)*. But later, after I drew the table frame and had it made, I needed to redraw it while I was away in Athens. They called from the office and asked me for a new drawing, but I couldn't for the life of me remember how I had put the thing together. ■ It was designed on an airplane late one night, in a sketch. Most of the time I use graph paper for designing because I like the little squares, but this was done in freehand. I drew it flat first, and then I drew an isometric view.

And then, I forgot what I had done. I could not find the freehand sketch and I couldn't remember how those corners worked. But I did remember that the leg was consistent in plan all around the table; the detail was just rotated to turn each corner. When Peter Blake designed his own house in the Hamptons, his solution was much the same. He had big sliding panels that closed the four corners of the house. The corner detail was exactly the same, but it was turned ninety degrees as it was repeated around the structure. The panels made the house look like a pinwheel in plan and that is what Peter called it, the Pinwheel House. ■ This kind of solution has to be intellectually satisfying as much as it is visually satisfying. I have always liked this sort of thing, and I use the word *abstract* to describe it. Compared to how I approach the design of my bucket chairs, which are more plastic and sculpted volumes, I think the word *abstract* best describes my aesthetics when I work with mechanical constructions. ■ The plate glass top of the Metron table has a beveled edge, giving it a greenish tint. Plate glass comes like that, and I like the color much more than tinted glass or the white-edged glass from Europe. In fact, I don't like tints at all, they're no better than those horrible smoky dark mirrors. ■ The Metron table frame is fastened with Allen-head screws, and it is electrostatically painted for economy. It should really be made of stainless, come to think of it. Yes, I have been thinking of making one for myself and that means it's *got* to be perfect *(laughs)*. The frame definitely should be stainless. You know, I'd like to do a top that is stainless steel, no glass, all stainless. It would be absolutely gorgeous. I'd better make a note."

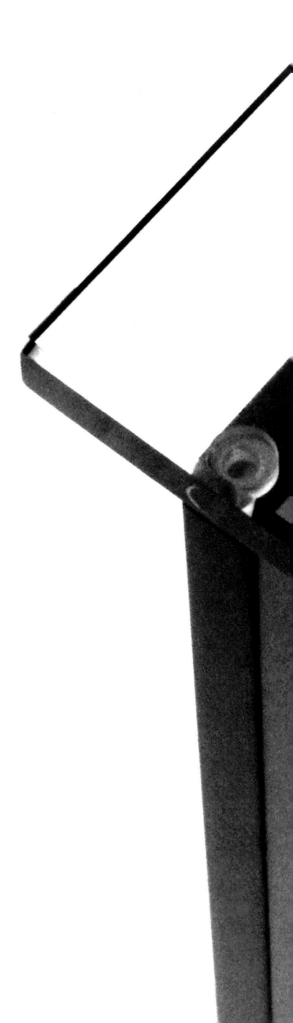

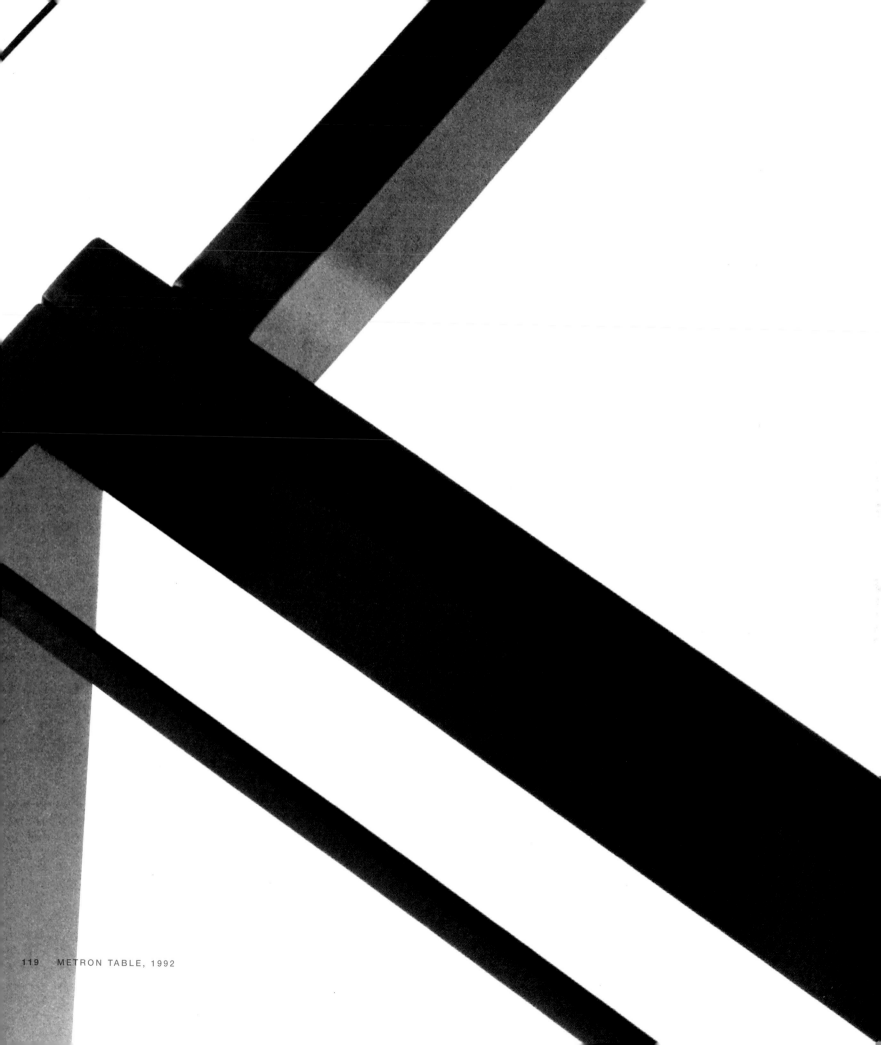

119 METRON TABLE, 1992

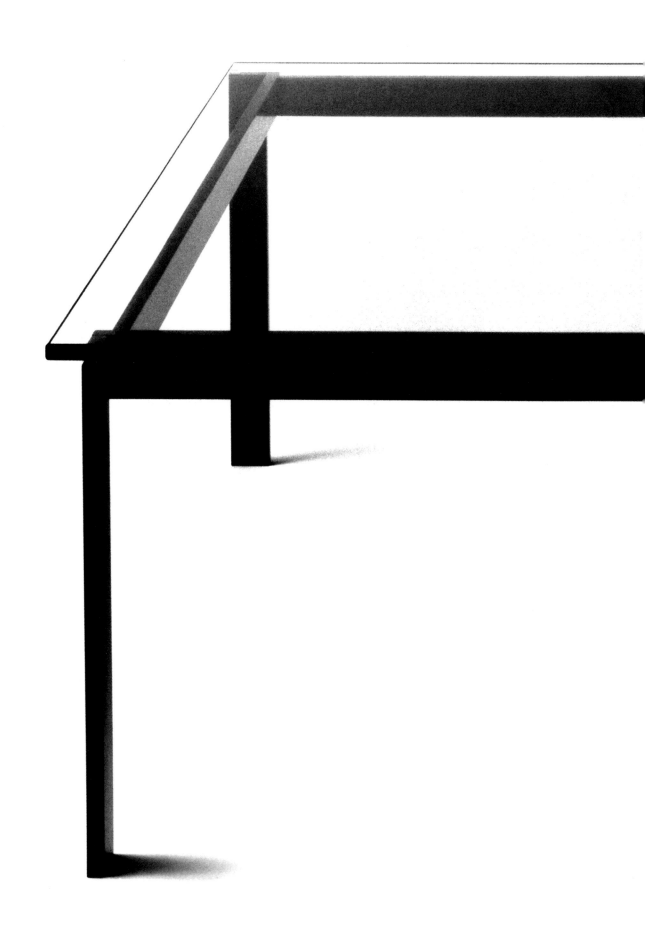

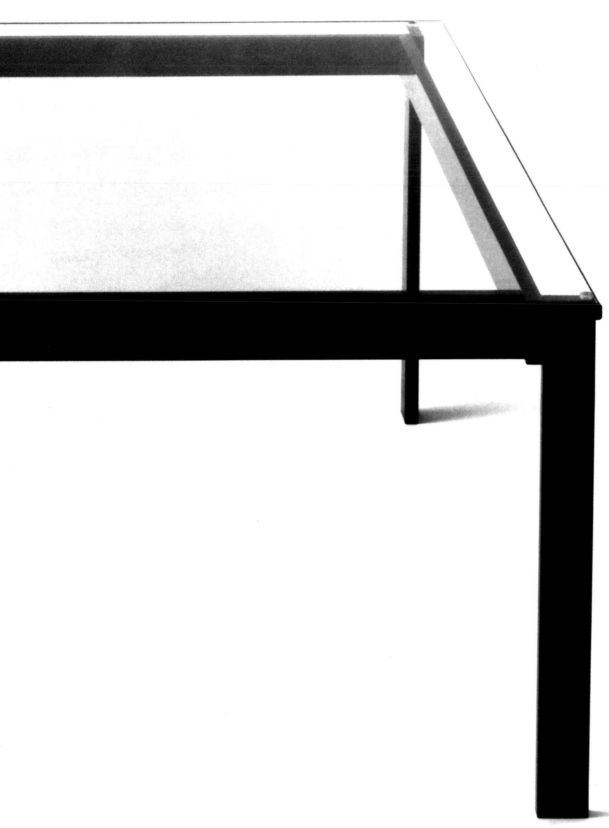

121 METRON TABLE, 1992

■ **THE SIXTY-SIX CHAIR** "To be a furniture designer today and *not* try to make a good chair with tubes would be a little unnatural, I think. Every one of the great designers has done at least one—Mies, Breuer, Corbu—so it was something I wanted to try. I wanted to see if I could continue the tradition. ■ Designed in 1966, the Sixty-Six chair is a simple structure of bent metal tubes that acts as a double cantilever. It uses only two kinds of tubes, a vertical side piece and a horizontal stretcher piece. That's the important thing about this chair: I wanted to have as few tubes with as few bends as possible. I fooled around with this idea for a very long time, drawing in side views, so my approach to the design was always two-dimensional. ■ The seat is and always was parallel to the floor. But the springs that hold the sling seat and back, the flex of the tubes, and the cantilever provide the slight pitch you want in any chair when you're sitting in it. Also, the leather seat is cut on the bias so there's greater tension on the front springs under the seat and less farther back. The round bar under the seat was there from the beginning. It had to be there to keep the sides apart. I really wouldn't say this chair was designed with comfort in mind, but it turned out to be surprisingly pleasant to sit on. By comparison, when I designed the suspension series much later, sitting comfort had to enter the picture from the start because those seats and seat backs are rigid, much more rigid than this. ■ In the Sixty-Six, all the pieces actually move, giving the seat and the back quite a bit of flexibility. The seat leather is a little slippery, but if the seat does what it's supposed to do, if it gives more at the back, then you don't slide forward when you sit. The other side of the leather is rougher, but I never considered using it, the roughness just doesn't look good. A suede surface is something else, it's finished differently and isn't slippery, but I much prefer the smooth leather surface. ■ The first design of this chair did not have arms. I was asked constantly to put arms on this thing. You know, that happens with almost every design I do; *somebody* comes along and wants a different version of it. If you have arms, they don't want arms; if you don't have arms, then they want arms. So I was pushed into adding them. In the end though, I guess the arms work well enough—at least I don't hate them. Costly damn things though, those arms were really expensive. ■ The chair tubes are chrome-plated steel and the leather slings are brown. The leather turns around the frame and is joined with springs in the back and under the seat. In the first design the seat was seamed with the leather turning around the frame and stopping beneath it. Only one or two models were made like that, then the leather began to stretch. I could see that the seat wouldn't work: the sitter's weight had to be taken up by something other than the leather material itself. Therefore, the springs. Now the leather returns to where it should be after the sitter stands up. I like that better, but of course the spring detail is yet another debt to Corbusier's furniture. ■ At first, the springs and Allen-head bolts held the tubes of the Sixty-Six chair together, and the bolts in the back kept the leather from sliding down. It was truly a knock-down chair. That was what I wanted in the very beginning; that was what this chair should have been. You should have been able to dismantle it and fit all the pieces in one small, flat box. But all mechanical connections tend to loosen after use, so the chair would've wiggled a lot, so welding the frame seemed more practical. But I couldn't weld the original version, it had to be mechanically fastened, because the seat was seamed and had to be put on last. But then I changed the seat and I could weld the whole frame. The structure did become sturdier, but the chair was no longer a pure knock-down product. ■ Sometimes I wonder if wanting designs that can be disassembled is cerebral, a kind of aesthetic preference rather than a practical way to make chairs. At first it bothered me a lot that I had to weld this chair, it still bothers me. But you know, once any chair is put together it ought to stay together. So the weld and spring solution was the right way to produce the chair no matter what my aesthetics were. ■ When the General Fireproofing Company asked me for a chair design, we asked if they would like to produce the Sixty-Six instead. Even though it was already on the market, they said yes. They were very successful with it, selling more than ten thousand of them in ten years. ■ Later on, when Ivan Chermayeff nominated the chair for the furniture collection of the Museum of Modern Art, it was a pleasant surprise. I didn't even know he had the chairs in his office because he had bought them from General Fireproofing. He called and told me about the nomination, then I received a letter from Philip Johnson. Since then, I have learned that other companies, like Knoll Associates, often donate their chairs to the MoMA collection. By now, the museum must have a cellar full of great chairs, but you know, it seldom shows any. It probably thinks that nothing in its collection is as important as the Barcelona."

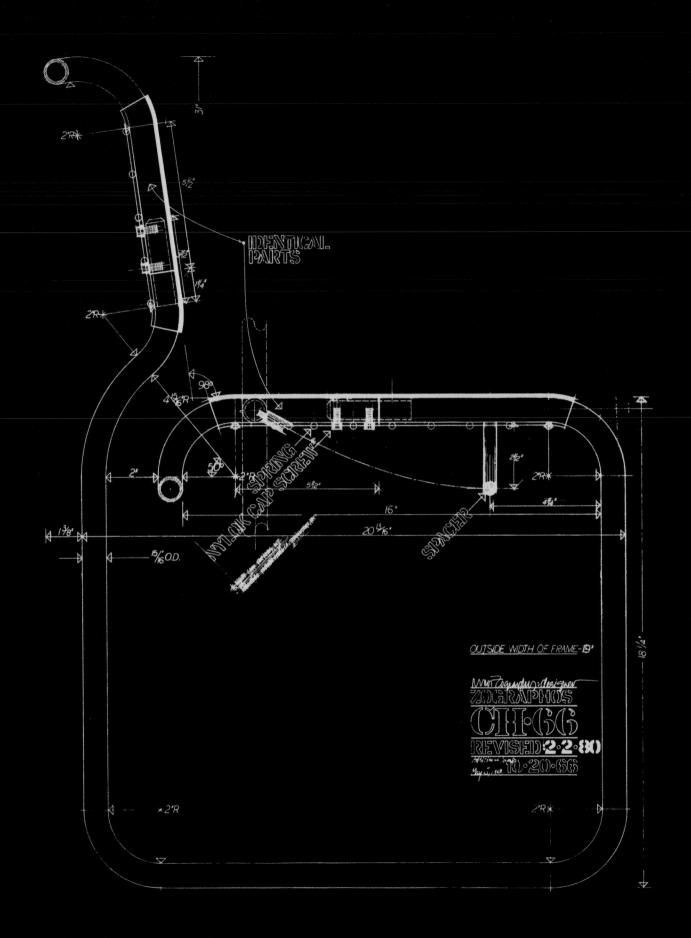

IDENTICAL PARTS

SPRING

NYLOK CAP SCREW

SPACER

OUTSIDE WIDTH OF FRAME—19"

Nico Zographos: designer
ZOGRAPHOS
CH·66
REVISED 2·2·80
10·20·66

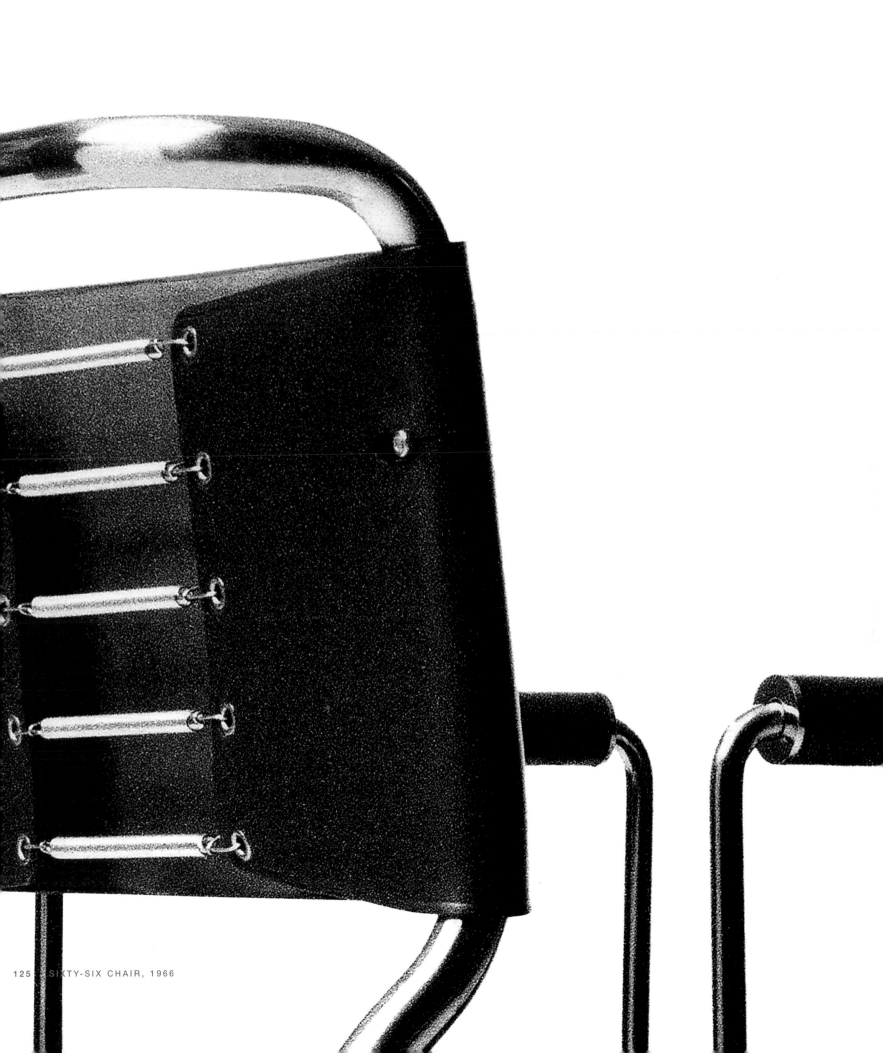

125 | SIXTY-SIX CHAIR, 1966

■ THE IKAROS CHAIR "This was another attempt I made to work with only one material, and as usual, it was prompted by my desire to cut costs. At first I wanted to make it all steel. I still have the drawing of that design, but it was too new and nobody knew how to produce it. All the same, the Ikaros chair came from that drawing. It's just a much more conventional solution. ■ I also wanted to make a simplified version of the Sixty-Six. So I began with tubes, and then tried to eliminate the slings and the cross stretchers. I knew the frame had to be strong enough to handle the cantilever and still hold the two sides together. That sounds very simple, but actually it was very complicated. I found I needed to use two pieces of stamped sheet metal to replace the slings. To make them strong, but still thin and light, I would have to stamp them into compound curves, like those in a stainless steel sink or a car fender. That would take a very big stamping press, and that meant huge costs. So instead, I decided to use two continuous steel bars for the sides of the frame, then connect them with a seat and back made of angle-frames holding panels of leather. These panels are very stiff, so I gave the seat a pitch and also curved the back. ■ Even though I am not sure the Ikaros is really finished yet, it's going to be the last of my cantilever chairs. I still love the idea of an all-metal design—I think that it could be the ultimate chair even if terribly expensive. It could be painted metal or stainless steel. Terrific. But you know, a really good chair in one material seems remote. Sometimes I think we have already decided to make only one chair like that. Of course, it's made of plastic, there seem to be a billion of them, and every one ugly beyond belief."

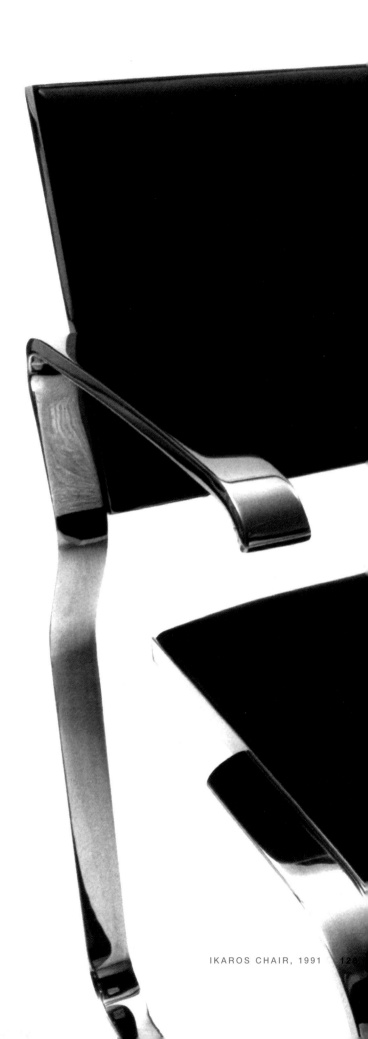

IKAROS CHAIR, 1991 128

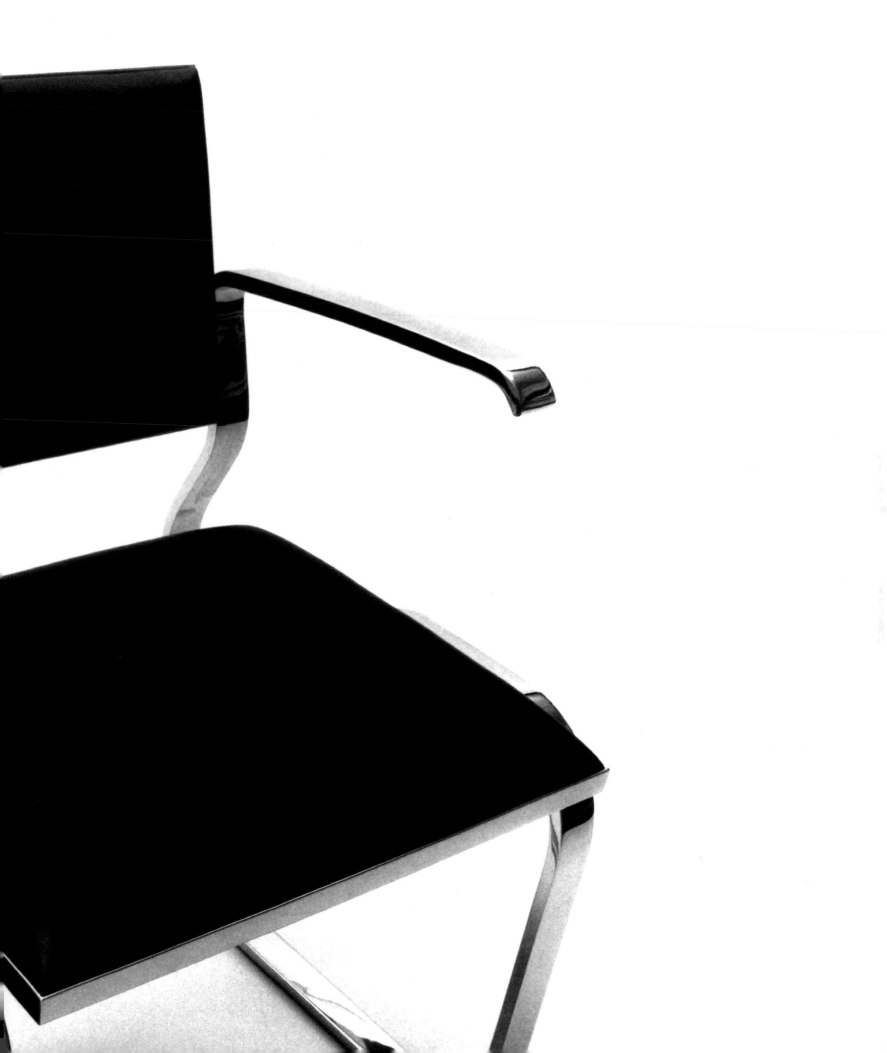

■ THE LOUNGE COLLECTION

"Every single piece of furniture I designed at SOM had a metal frame. Whether it was a desk, table, cabinet, or chair, the frame always had a square metal leg with a very thin stretcher. As I have said, Bunshaft's glass table was the only exception to this rule: it had thick square legs and hugely thick stretchers, and it had sharp corners where the two met. When I made a frame, I almost always reduced those thicknesses, even if the frame had to support one of those SOM boxy lounge chairs. Later on, I made some chairs for my own company that had the same elements, but those were responses to market demands and I wasn't too happy with them. ■ In 1965, when I started designing my independent lounge chairs with the Thirty-Three *(pages 130-131)*, I took a totally new direction. This chair had nothing to do with having a frame at all. I wanted something closer to one of those old Chesterfield sofas. Now those things were really hard, *extremely* hard with very tight leather upholstery and button welting. I added a small turned arm, which I had never used before, but generally, most of the details were extensions of the Twenty-Eight lounge *(pages 65-69)*. ■ In the years after the Thirty-Three chair, I began trying to use the component thinking that had led to my first wood lounge chair, the Saronis in 1963, and the molded Synergistic series in 1970. The result of that thinking, the first modular lounge, was the Twenty series in 1971. It was a very simple wood box into which I dropped the softest cushions I had ever made *(pages 132-133)*. ■ Long ago, Le Corbusier designed a chair he called the Le Grand Confort Petit. With a few pieces of welded metal tubing, he built an open cage to hold big blocks of plush cushions on the inside. It's actually quite comfortable, even though it's straight-sided, closed-in, and kind of boxy. ■ Keeping that sort of thing in mind, using a few component parts, I wanted the Twenty lounge to escape the whole idea of old-fashioned upholstery— you know, the nails and tacks and leather straps and all that nonsense. Again, I wanted a simple thing that could be easily disassembled, just a bunch of soft cushions that fitted inside a box to make a single seat or a sofa. Also, I wanted a lot more comfort and I wanted a better sitting angle than the upright cushion blocks had given in the Corbusier chair. But even more, I wanted a very *wrinkly* affair. You know, very soft leather filled with Dacron, down, or whatever, so the cushions would look really thick and friendly after you sat on them for a while. ■ Then, after the Twenty series, I designed a lounge chair with big, thick cushions that were supported by notched sections of over-large and shiny hollow tubes. But the whole thing was a big failure. I hated the large tubes, the brightness of the metal, and all the unnecessary details, I just *hated* them. I knew the design of the chair worked against everything I believed furniture should be. It's like all those times I tried to do postmodern furniture years later. I didn't design a single one that I carried to fruition or even to model form. I mean, some of that stuff has been a raving success for the last few years, but when I tried to do something like it, I just couldn't. I don't believe in those designs or designers, it's that simple. I really shouldn't have tried it. I've given all that up and I'm glad. It's like asking those guys with their beliefs to design things like mine. They can't work against their grain either."

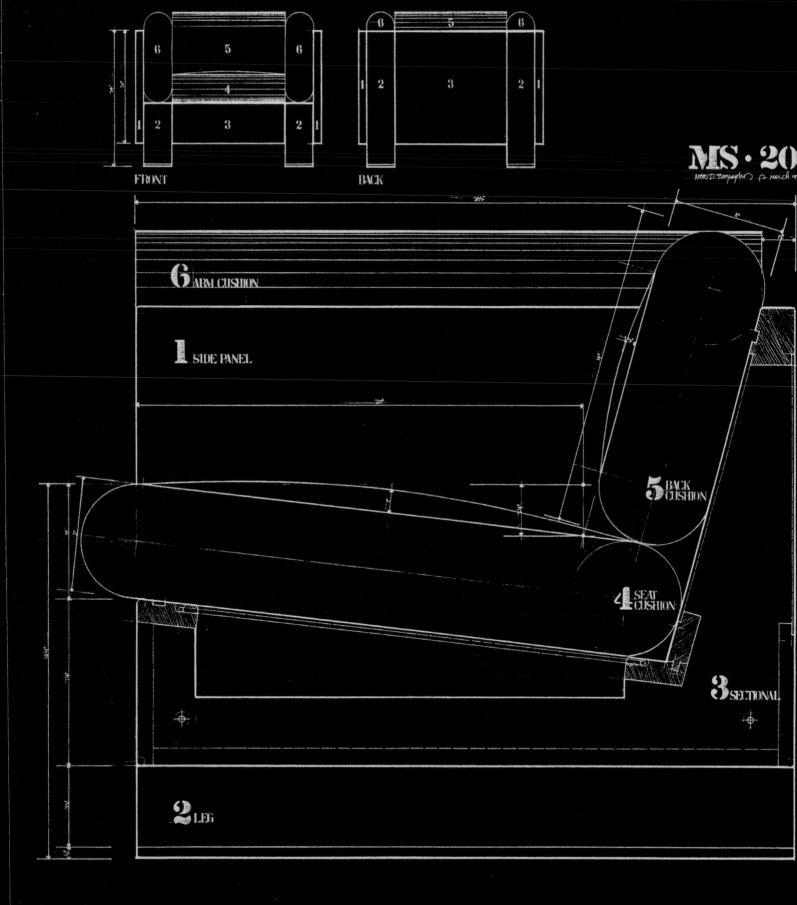

FRONT

BACK

MS · 20

Miles D. Zoographer 12 march 19

6 ARM CUSHION

1 SIDE PANEL

5 BACK CUSHION

4 SEAT CUSHION

3 SECTIONAL

2 LEG

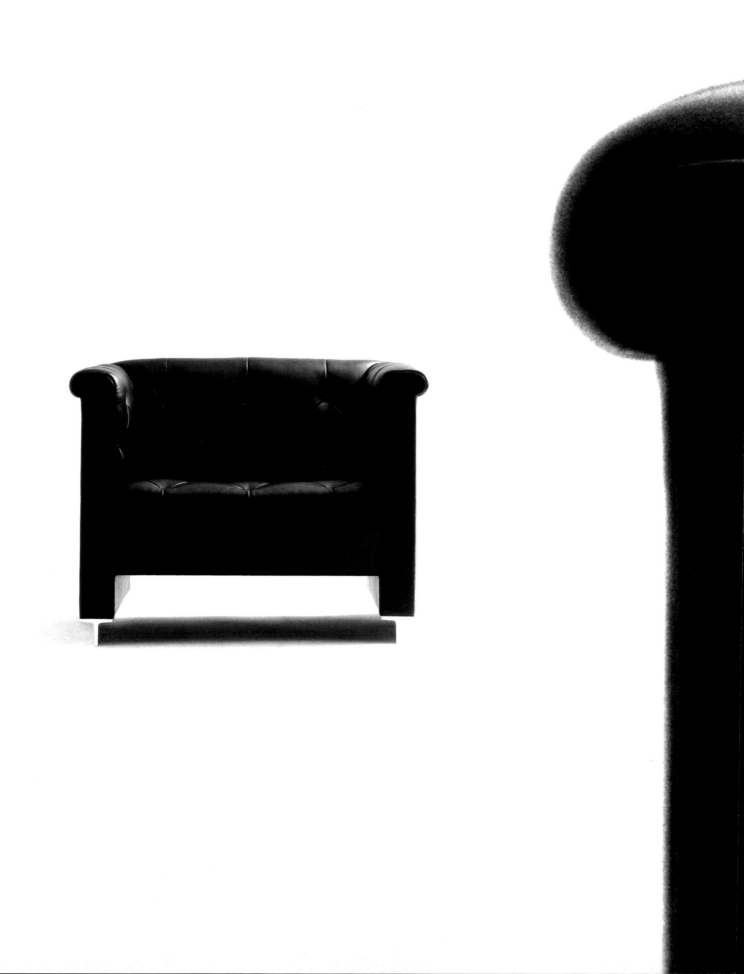

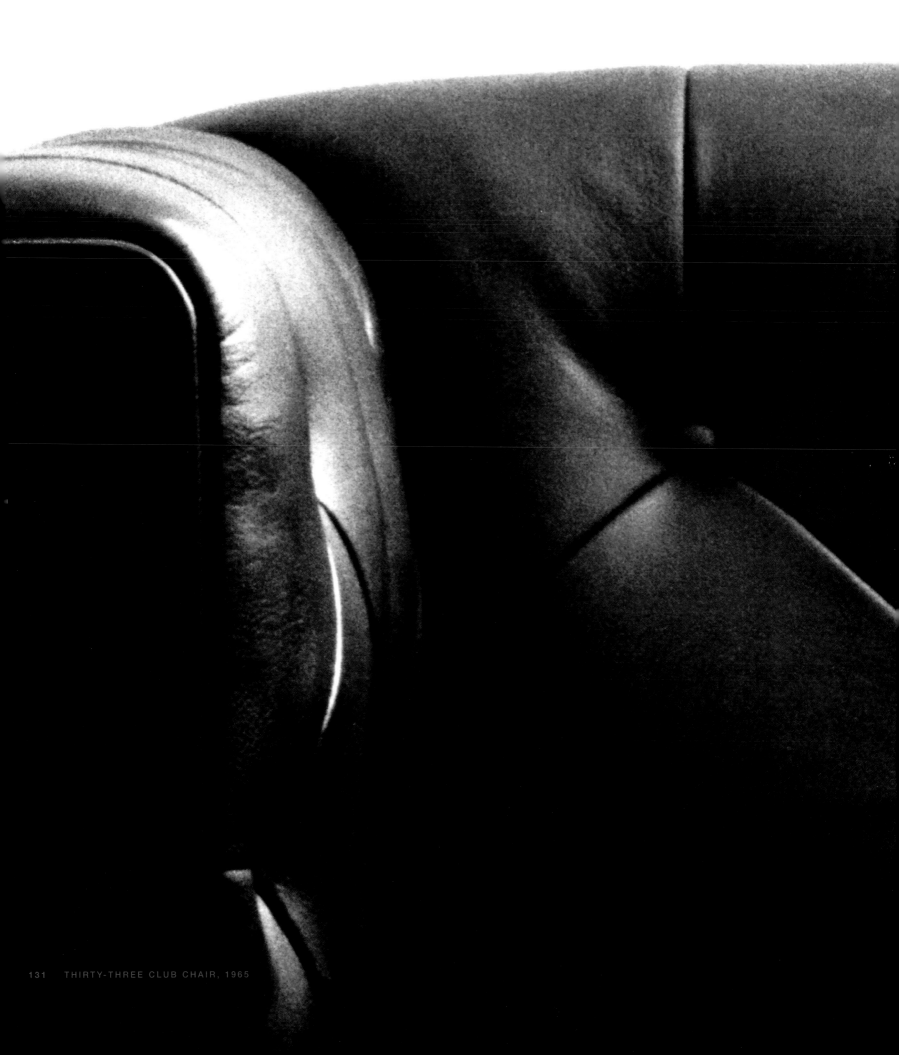

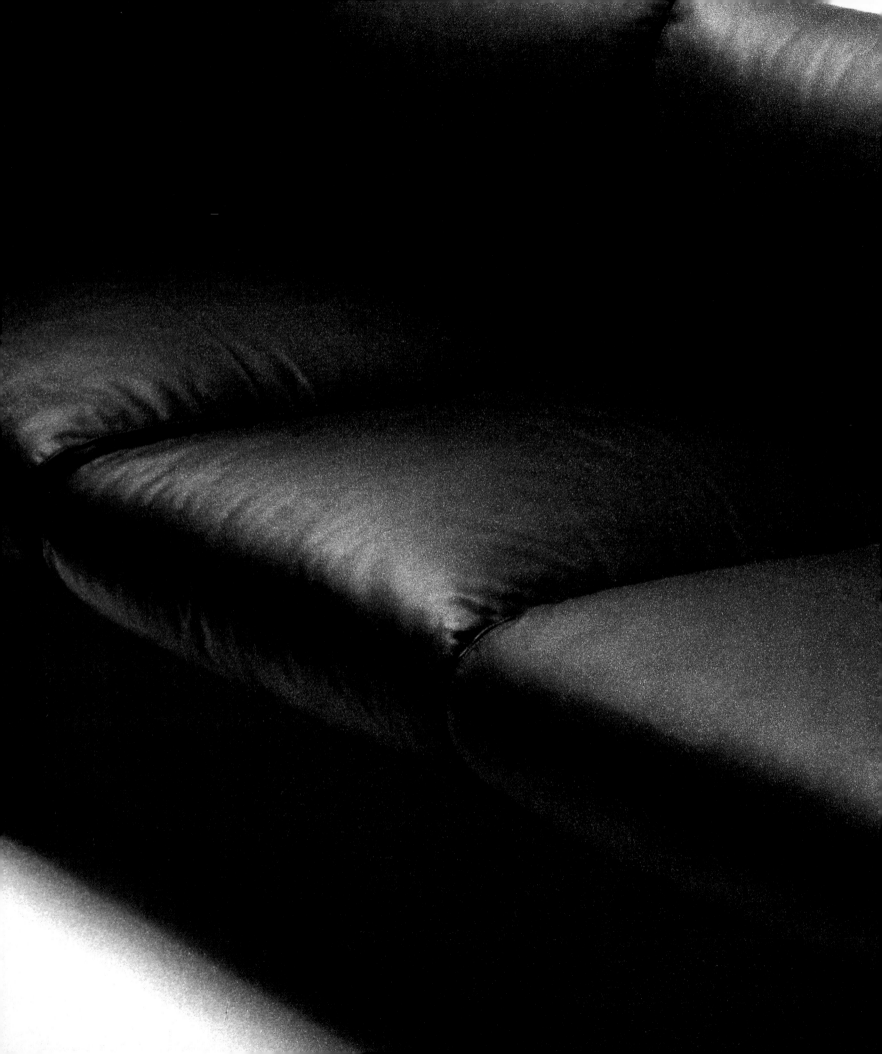

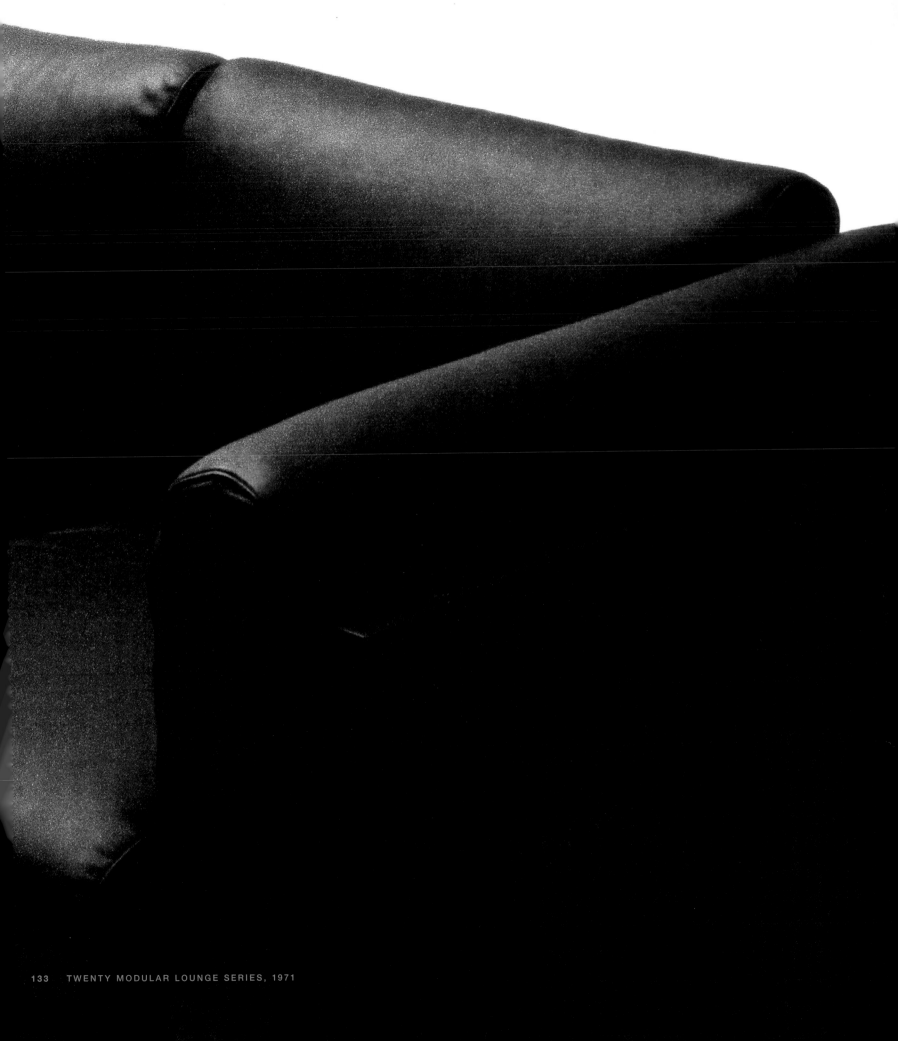

133 TWENTY MODULAR LOUNGE SERIES, 1971

■ THE THIRTY LOUNGE SERIES

"After the Twenty series, which was the most straightforward design of box and cushion components I ever did, I produced a new modular chair that was much more elaborately detailed. That was in 1977, when the architect Harry Wolf asked for special multiple seating to use in large public waiting areas. He wanted a chair designed so that when it was connected to other chairs like it, the series would form long curving lines. In order to do that, I had to make the arms like wedges, wide at the back and narrow at the front. These arms joined the seat units—the wedge shapes forced the line of seats into the curves he wanted, while the seat units remained constant. To reverse the curve of the seats, I just turned the wedges around. ■ The sides of the seat were carried down to the floor to create the looks of one unit, very much like what I tried with the molded units in the Synergistic series. There were no legs, so the thing seemed to sit on the floor like one big volume. ■ Later on, I gave this lounge chair straight arms instead of wedges so I could include the design in my company's collection. But in a way, the idea of connected seats lasted longer than the Thirty did. In plan, the wedges can be seen as prototypes for the spine-supported, semicircular steel benches I later did for multiple seating in the Pittsburgh airport for Tasso Katselas *(below)*."

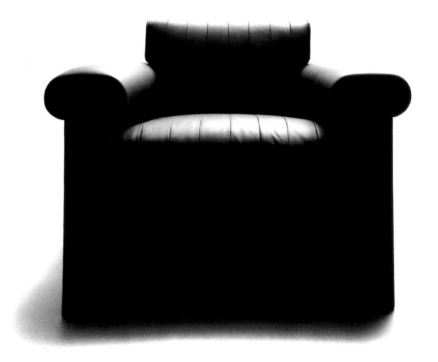

THE IRELAND CHAIR In 1962, right after I left SOM, Lydia dePolo asked me to design a wood chair for the interiors of a hotel in Ireland. This was the first carved wood chair I did. From one piece of material, I carved a sympathetic surface for the sitter's body on one side and an architectonic shape I liked on the other side. This was no great revolutionary concept, but the solution was very hard to find. ■ Combining the inside and outside surfaces of a chair is difficult, but all my bucket chairs had to solve this same problem. Their outsides are almost cylindrical shapes, but the insides are much more complex. You really have to do this with *any* kind of chair. No matter what the outside form is like, the inside has to be carefully shaped to fit the back, arm, seat, and legs of the sitter comfortably. ■ In the Ireland, it was also hard to find the right way to separate the more sculptured upper part of the chair and the dowels of its leg structure. I decided to use a shaped reveal. You know, you can find many kinds of reveals in every building and piece of furniture that SOM ever did. SOM was *always* using reveals to separate materials. I guess they had their own reasons for that, and those reasons have certainly influenced my thinking, but in this chair it was a matter of necessity. I could not join the round dowel leg to the flat, curving arm without some kind of very deliberate separation. ■ In one version of the chair I added a padded back insert, but it never worked out. I didn't want the insert, I was forced to add it. As I have said, people always want, *always* want something other than the thing you offer them. I imagine they feel more involved if they change things. They hardly ever take what you think is the final product, no matter what it is. They want the thing to be made higher, lower, thicker, thinner, fatter, skinnier, more comfortable, less comfortable, more padded, less padded, God knows what, and the Ireland chair is a very good case in point. I always fought against the insert, to me it ruined the whole chair and I don't think the pad made it any more comfortable than it already was. ■ Why do people do this? I had a nice wood chair. Why was it so hard for people to accept it the way it was? If it's comfortable, it's comfortable the way it is. If it isn't comfortable, then don't buy it. If you make a designer add something that *you* think he should, it really is an intrusion, you know. ■ The same sort of thing happened with the arm of the Sixty-Six chair. It was meant to be an armless chair, *period*. Take it or leave it. At least it turned out I was happier with that arm than I thought I'd be, but I still prefer the chair without it. It's much more *basic*. ■ Take Corbu's chaise longue. Now *that's* a chair that could use arms. It's very narrow, and when you sit down in it you don't know what to do with your arms. They hang down, or you have to put them on your lap, or you have to tie them to your body like they're dead or something, so they won't drop. I'm sure that people wanted to have arms on it and he realized it, but he wouldn't add them. I have one at home in Athens and I think it's the most comfortable chair on earth. And it has no arms. If it did the beauty of the lounge would be ruined, and who needs that? ■ The original Ireland was made of teak. The wood was unfinished, or some oil was added for protection. Almost all my wood chairs are like that, I like the looks of natural wood, that's why I use it in the first place. If I wanted teak to be like cherry or walnut, why not use those woods to begin with?

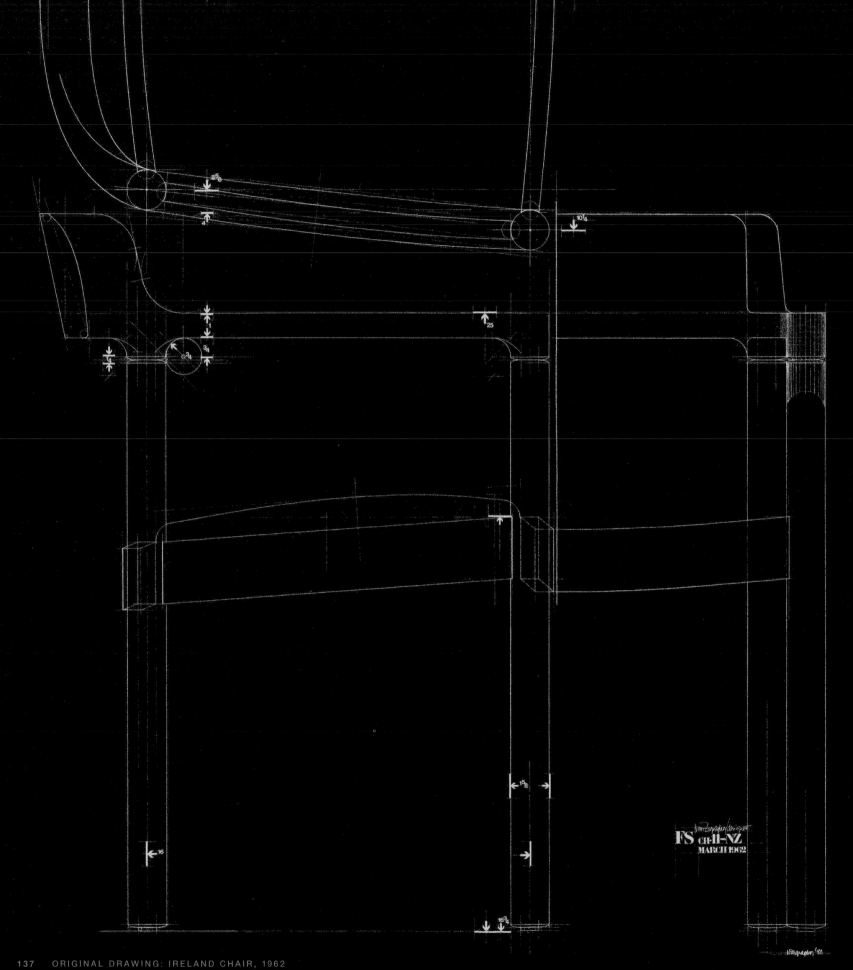

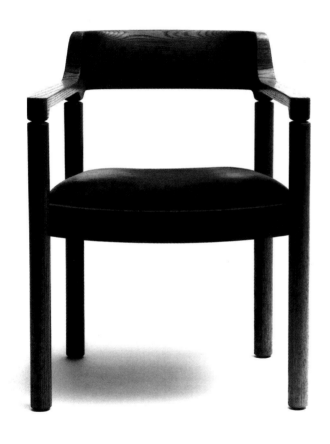

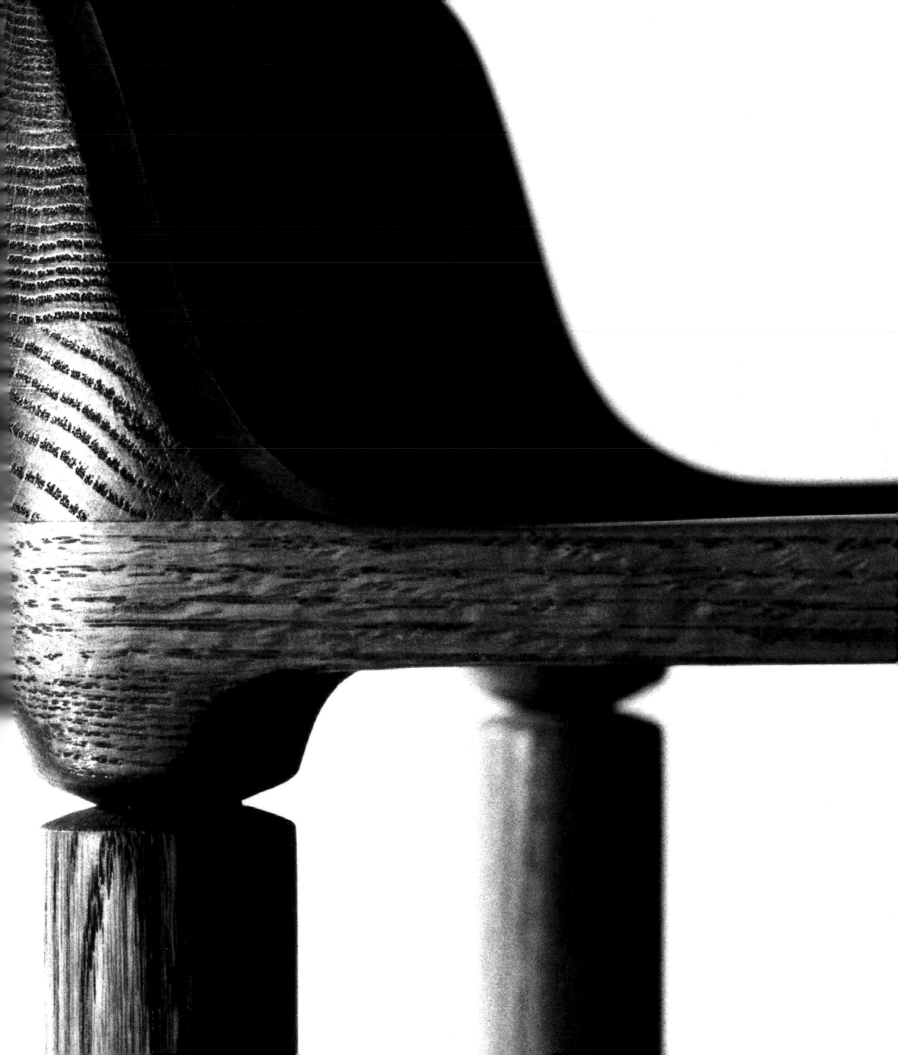

■ **THE WHITE CHAIR** "This chair was supposed to be a less costly version of the Ireland chair. I wanted to make the arms and the back out of a single piece of steam-bent wood. That would have made sense, it really would've been cheaper. But as usual, it didn't work out that way. I had to make an assembly of three pieces of solid carved wood. At least it didn't have the turned legs the Ireland chair has, and it didn't need the shaped reveal, so the new chair was less expensive to build. Instead of the leg reveal, there is a very narrow notch where the flat surfaces of the legs meet the upper part of the chair, but the notch is minimal and it's necessary. If there wasn't a separation there would be cracks where the different grain directions in the wood meet. The real reason for reveals and notches is to hide or prevent flaws that happen naturally, even when a thing is built properly. Like the moldings and baseboards in rooms are necessary to hide the joints between ceilings, walls, and floors. ■ Maple was used to further reduce the cost of the White chair. But I thought that made the chair look like really cheap school furniture, so I decided to lacquer it. The first versions of the chair were produced by Albano, then two other manufacturers tried it and the results were absolute disasters. The chairs looked terrible, they were not made precisely, they broke, they fell apart, big disasters. Then Karl Meyer at Sidler Brothers in New York began making them and they were perfect. Sidler was the best shop I have ever worked with, the best ever. They did things in wood that were more precise than things made with metal, which is just amazing. ■ I had *terrible* fights with other wood shops before Sidler and Karl showed up. I couldn't do much about it because I had a partner who always cared a lot more about costs and profits than satisfying customers with well-made products. That was a big problem. I remember a time when we sold two hundred of another wood chair and they all fell apart. Obviously, whenever that happened, we had to take the chairs back and remake them. But manufacturers like Sidler were hard to find, and they didn't always have the practical things we wanted, like enough storage to maintain inventories. Still, we needed them a lot more than they needed us. Being too practical about manufacturing economies always seemed to do us much more harm than good. ■ Bad manufacturing also meant huge arguments. I usually had to handle the manufacturers to get the best out of them, often spending a lot more time to rescue things in their shops than I should have. So places like Sidler for wood frames, or Treitel-Gratz for all our metal frames and bases, were absolute godsends for me. They are the opposite of bad manufacturers, they *can't* do something bad, they only know how to make things right. ■ Ten years after the White design, I made the Black chair for a library in San Francisco *(pages 142-143)*. But the project didn't happen and only one of the chairs was ever built. When I look at it now, I see that it's wrong, the back of the seat is far too low. I never had the chance I needed to work that out, the dimensions of the chair are off, and the whole thing looks too stiff. Still, I think this could be a really good chair. I made it at a time when I was beginning to combine the different design approaches I'd been using for twenty years. So the Black chair is partly carved, and with the mechanically connected parts I used to hold the seat, it is partly component-built."

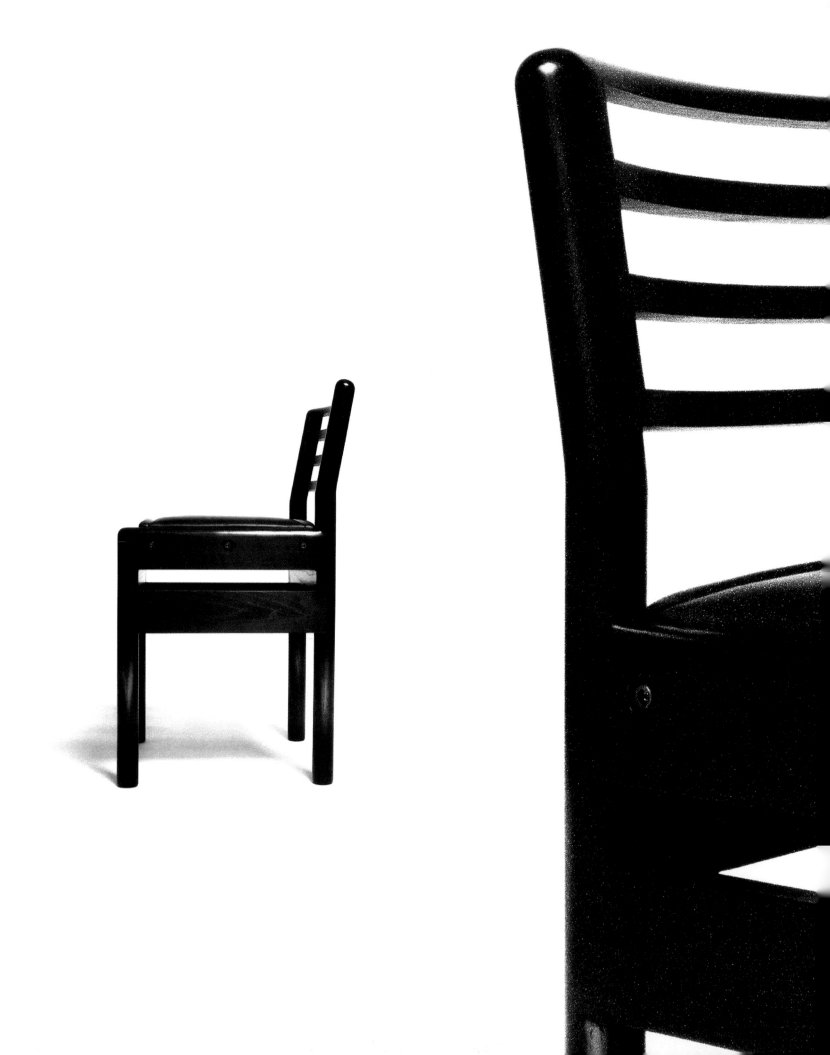

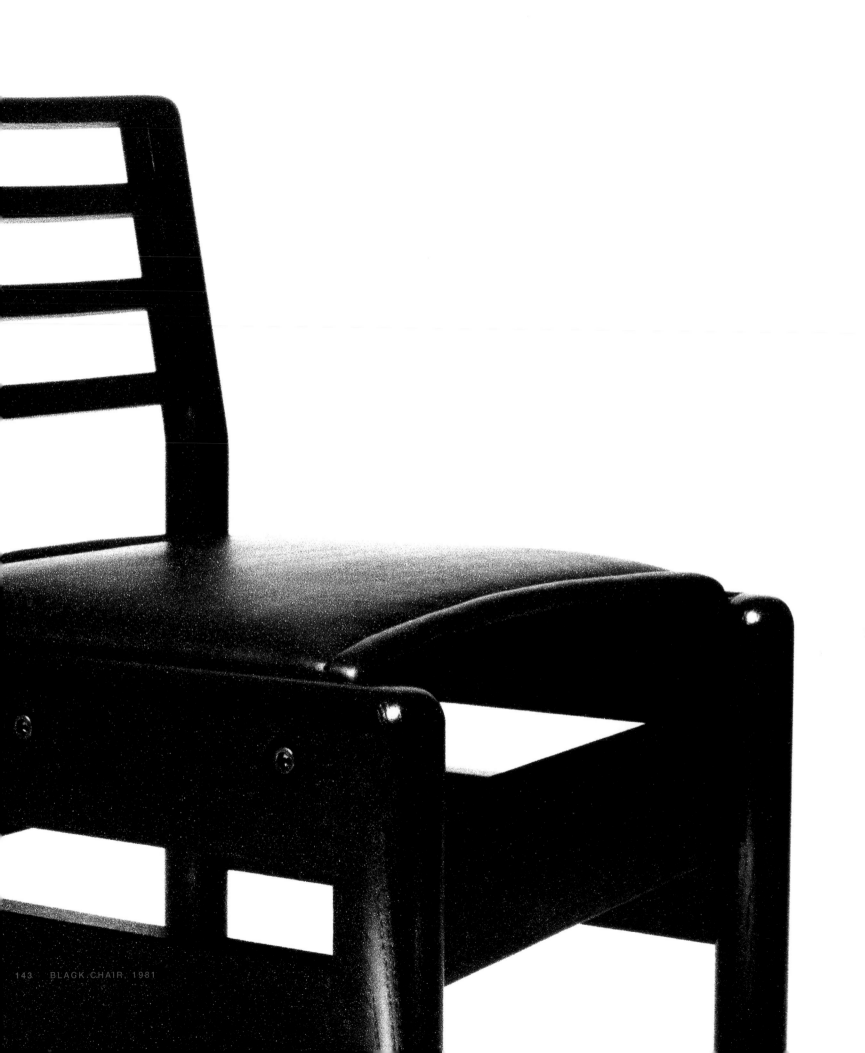

143 BLACK CHAIR, 1981

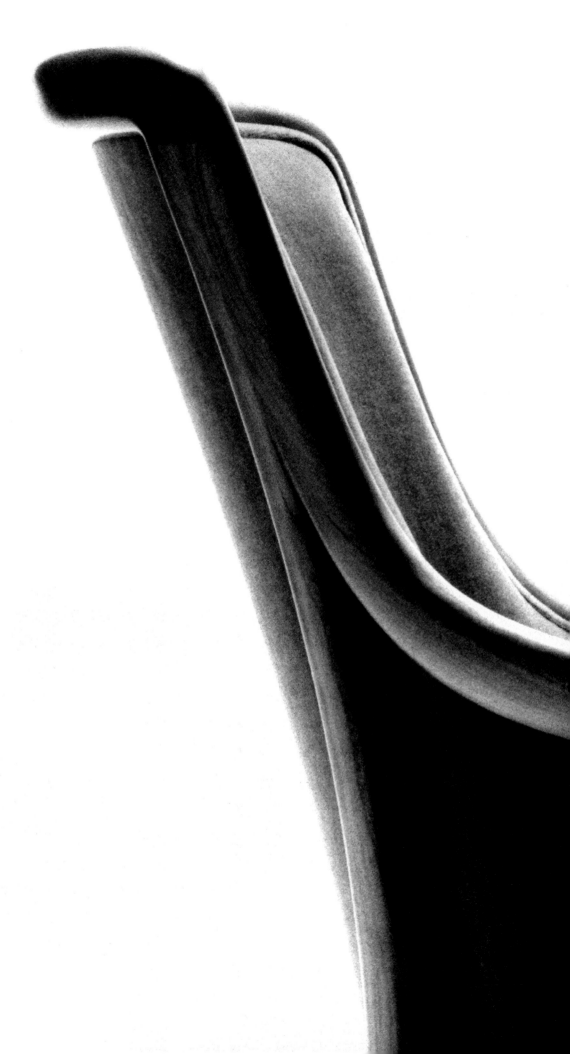

■ **THE CINNAMON CHAIR** "While Phil George was designing interiors for a new restaurant in Rockefeller Center, he brought me a photograph of a Scandinavian tub chair with four legs. It wasn't very elegant, but Phil said it was quite comfortable. I said I'd much rather do my own version of the chair and I did. Well, the difference between the two was night and day, and the chair turned out to be, I think, elegant *and* comfortable. ■ This is the one wood-carved chair I shaped by hand instead of drawing the form first. I described what I wanted to Karl at the Sidler shop, he made a very rough wood frame, and then I went to work with a rasp. Gradually, we worked out the right curves, the right wood to be used, the height of the back and arms, the pitch of the seat, and all that. After the first prototype, I don't think we changed a single detail, that was it. Which was *amazing*. That usually doesn't happen, it just doesn't happen. ■ The first versions of the chair were covered with a patterned fabric chosen by Phil, which I did again for him when he placed the chair in the sponsors dining room at the Metropolitan Museum of Art. I don't think much about colors or fabrics when making a chair, I never choose patterns, patterns are very painful to me. When adding this chair to my own collection, I chose a plain mohair close to the color of the cherry wood. So I called the chair the Cinnamon. It looked monochromatic, but still, it was more colorful than any other chair I have done. ■ While making this chair and its open-arm version called the Saffron, I worked a careful transition where the round rim meets the square stretcher and leg. I thought the blend of geometries would be interesting, as I think it was in the Alpha pedestal base."

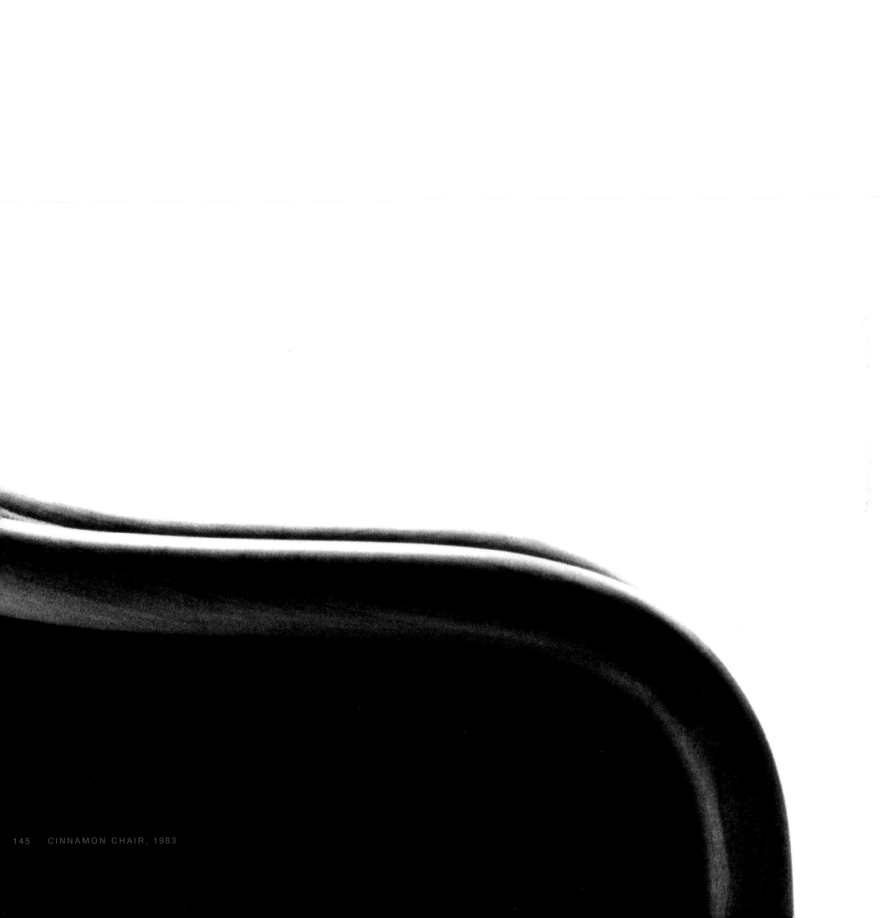

145 CINNAMON CHAIR, 1983

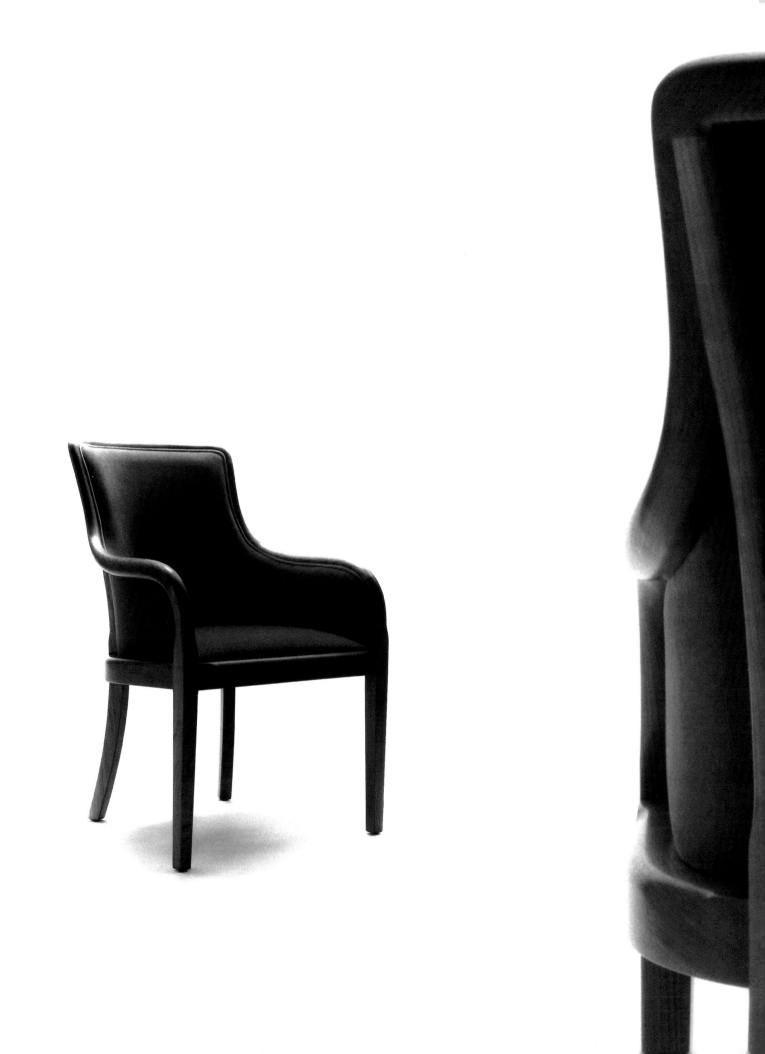

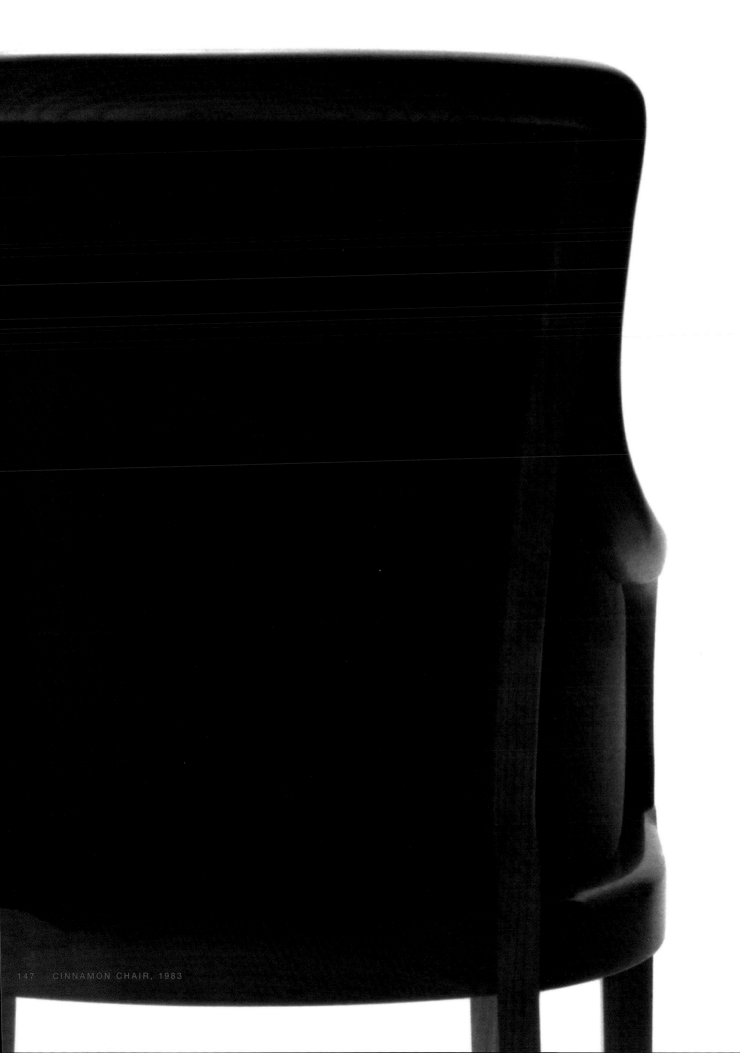

■ **THE SARONIS CHAIR SERIES** "A year after leaving SOM in 1963, I made my second wood chair using a simple cage of dowels *(opposite)*. There were slings suspending the seat and leather-wrapped arms to make them soft to touch. The chair was named the Saronis series when I used it seven years later in a house I did for my family in Greece. I made a side chair and then a lounge version *(pages 150-151)*, and both were much simpler constructions than the altered ones produced later. ■ In the beginning, every dowel in the cage was exactly the same diameter because I wanted to make these chairs with one element used over and over again. But there was a lot of weight in the contraption and the factory couldn't handle it using the dowels I asked for. So I had to compromise the design by doubling up the dowels or elongating them to ovals for greater strength. I remember thinking I might have been much better off making these chairs out of metal, but I wanted that *warm* tubular look and I think I got it. ■ Both the lounge and side versions were drawn two-dimensionally, in profiles on paper. I spent a great deal of time working out the right seat-back angle in both chairs; it was a long process of trial and error. At first I developed their angles to fit my own body. Now I am not a typical shape, but you've got to start someplace, you know, and you can always adjust what you do if people find it hard to live with. In the end, I was very happy with the way these chairs turned out. They were the right accommodations for both kinds of sitting, I think, so their seat angles became constant standards. I think working with long legs like mine is better anyway; just think of what this furniture would look like if I were a short little guy *(laughs)*."

■ **THE SUSPENSION SERIES** "In 1966, I designed the sofa version for the Saronis series. For the first time, I perceived a chair design as though it extended *into* my elevation drawing, deep into the paper. That depth was infinite because the seat could be built with a succession of identical components. Also for the first time, I carried what I thought was a proper sitting angle to a new product: the angle of the Saronis lounge became the angle of the sofa. Then I carried the sitting angle of the side chair in the same way and produced a sequence of completely new designs called the Suspension chairs. ■ At first, they were supposed to be cheap, so I tried to use inexpensive, knock-down parts to build them. But they got out of hand and ended up costing more than they should have. To be sturdy and durable, the Saronis chairs had to be glued and the Suspension chairs had to be put together at the factory. The Sixteen chair *(page 153)* came closest to a knock-down chair, but it's very hard to put together. I tried it and it took me forever, *forever*. ■ The original suspension design, the Saronis, has two soft loose cushions sitting on flexible and springy leather straps. The rest of the Suspension chairs, the Fifteen, Sixteen, and Seventeen, all have fixed seat-angle assemblies suspended within different frames. The evolution of the frames reflects my own transition to component design, which started when I first used metal tubes in 1966. ■ Some details reflect fashions at the time they were done, like the big tubes in the Seventeen *(pages 154-157)*. No one can really work in a vacuum, you know; some designs can be prompted by things happening around you. I still like the Seventeen, but its Disneyland look got tiring, so I got rid of it."

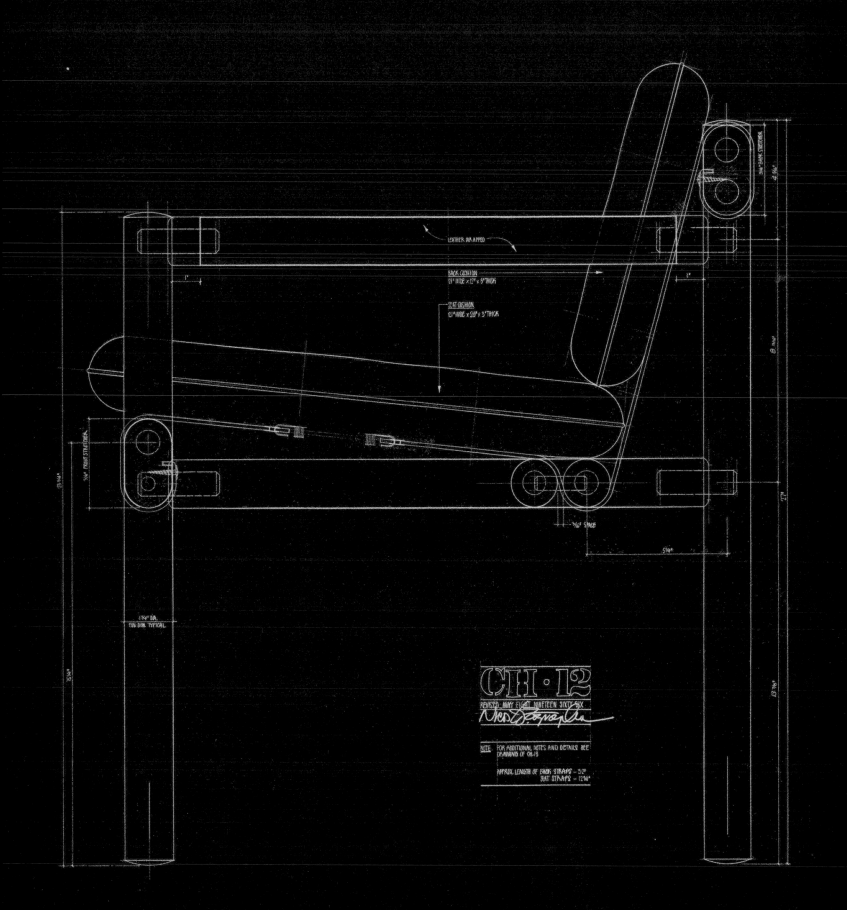

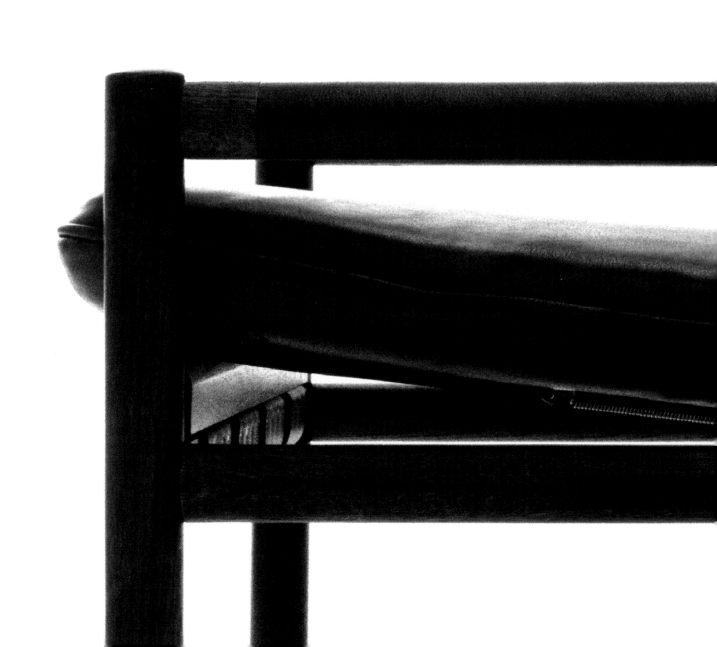

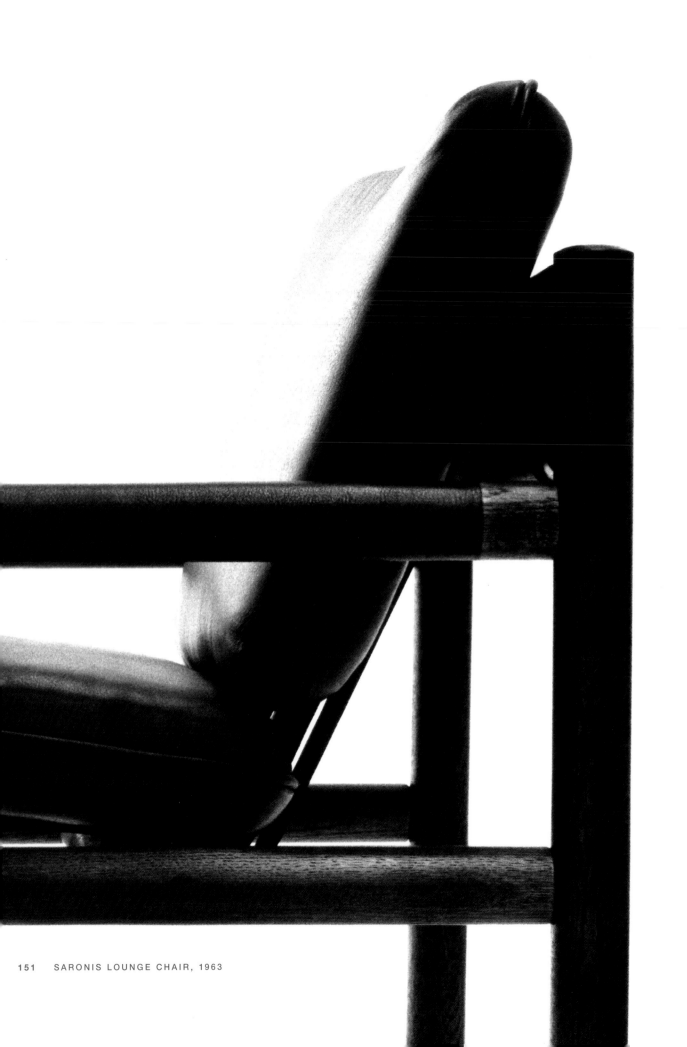

151 SARONIS LOUNGE CHAIR, 1963

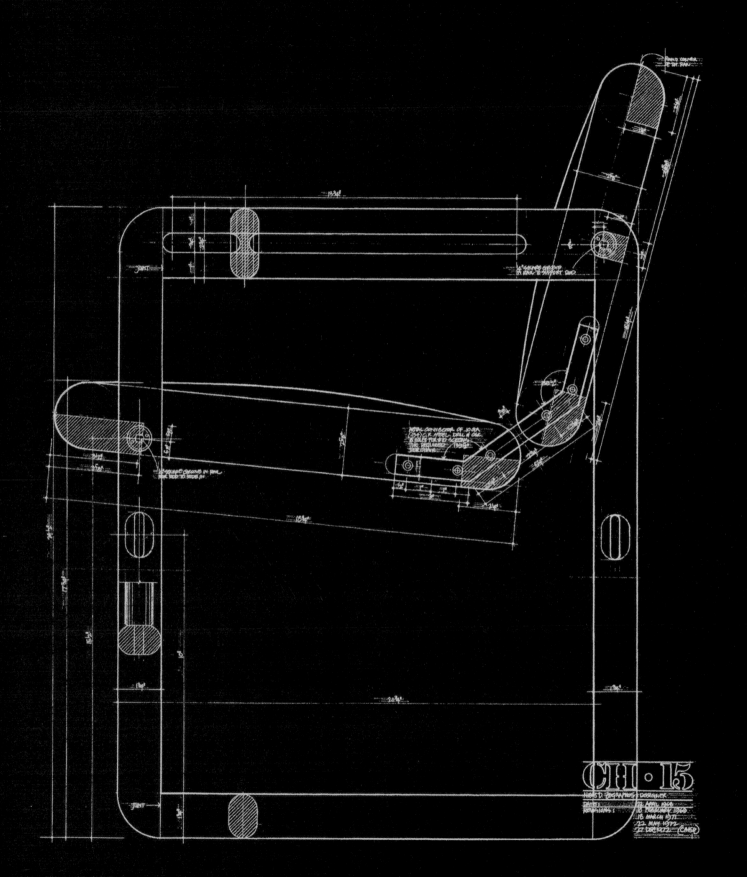

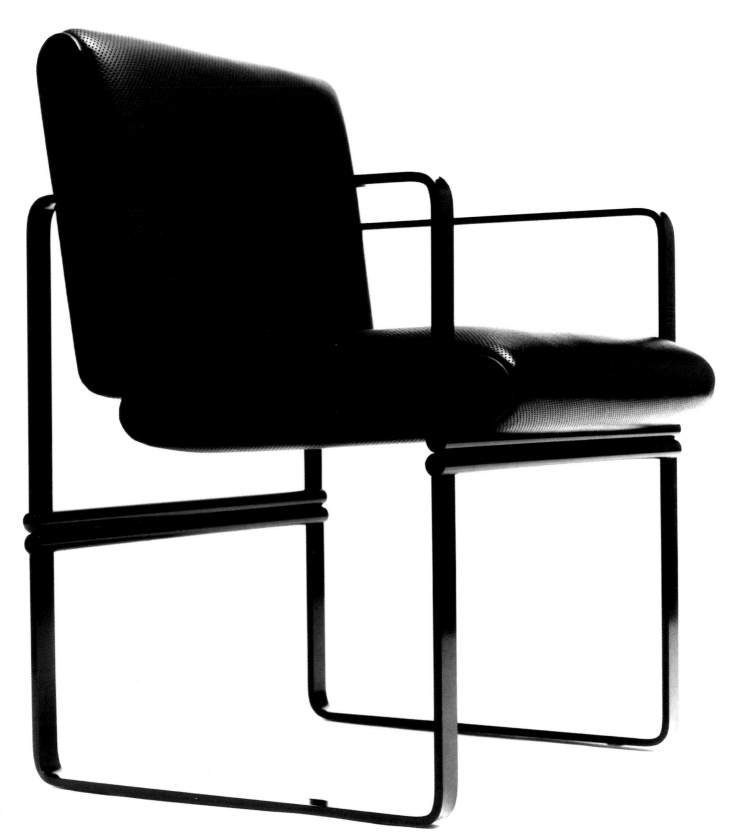

153 SIXTEEN CHAIR, 1970

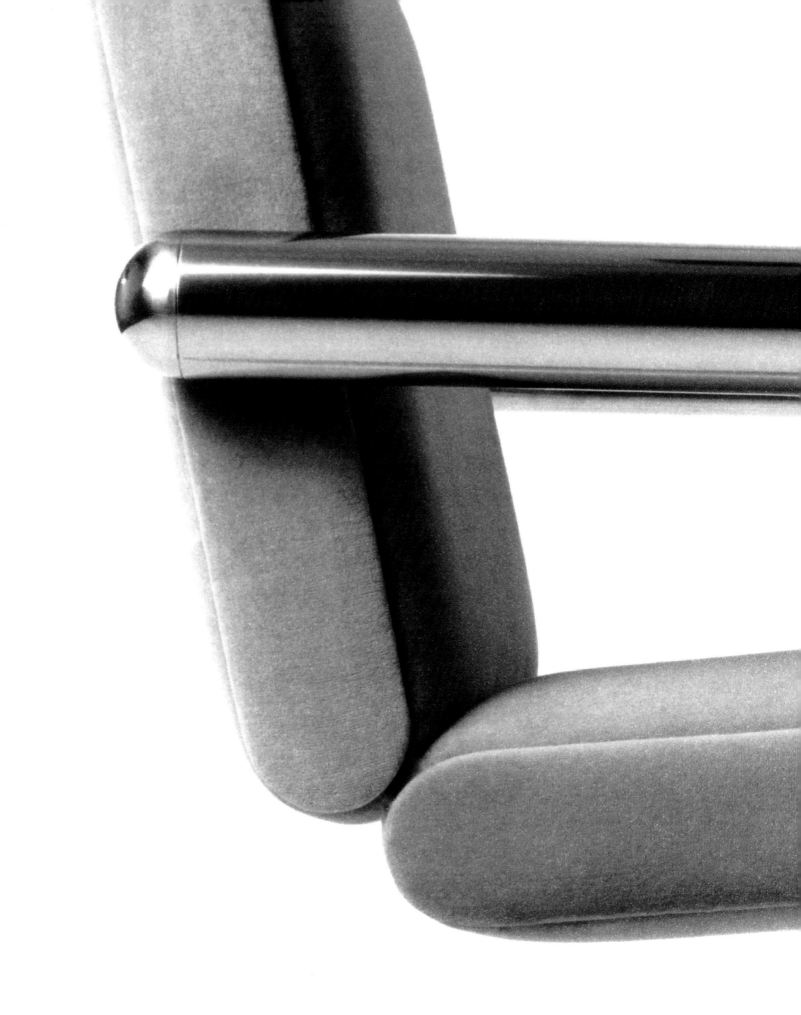

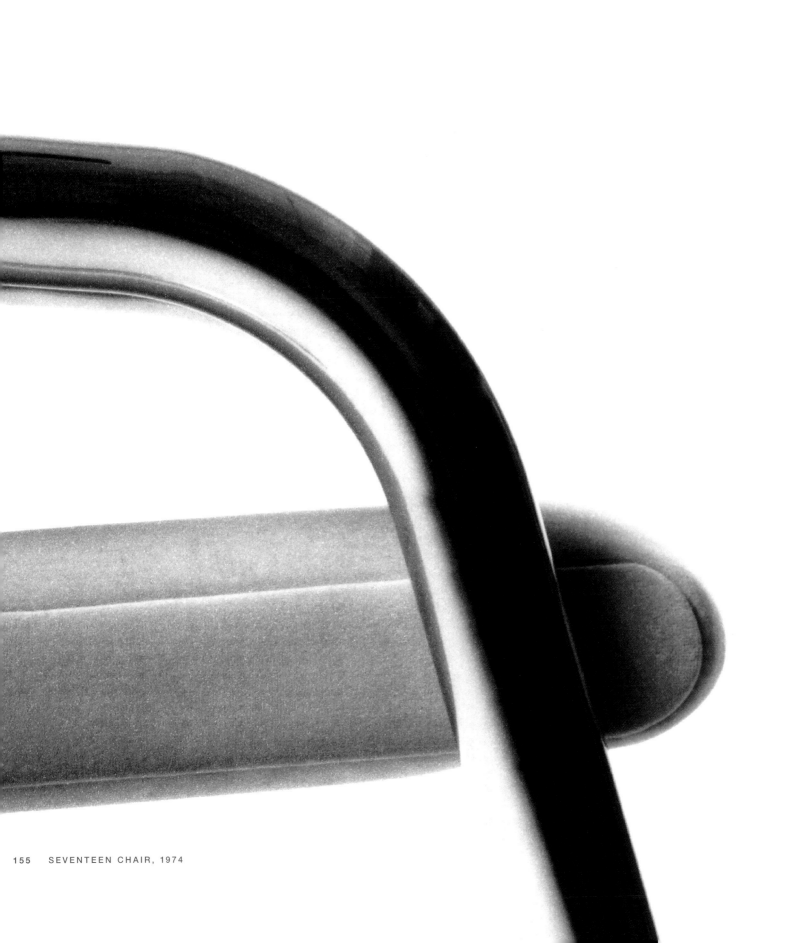

155 SEVENTEEN CHAIR, 1974

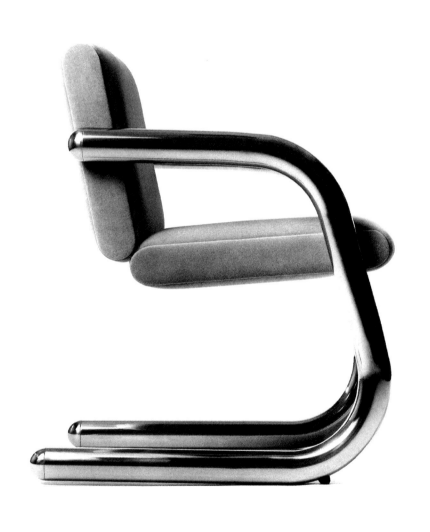

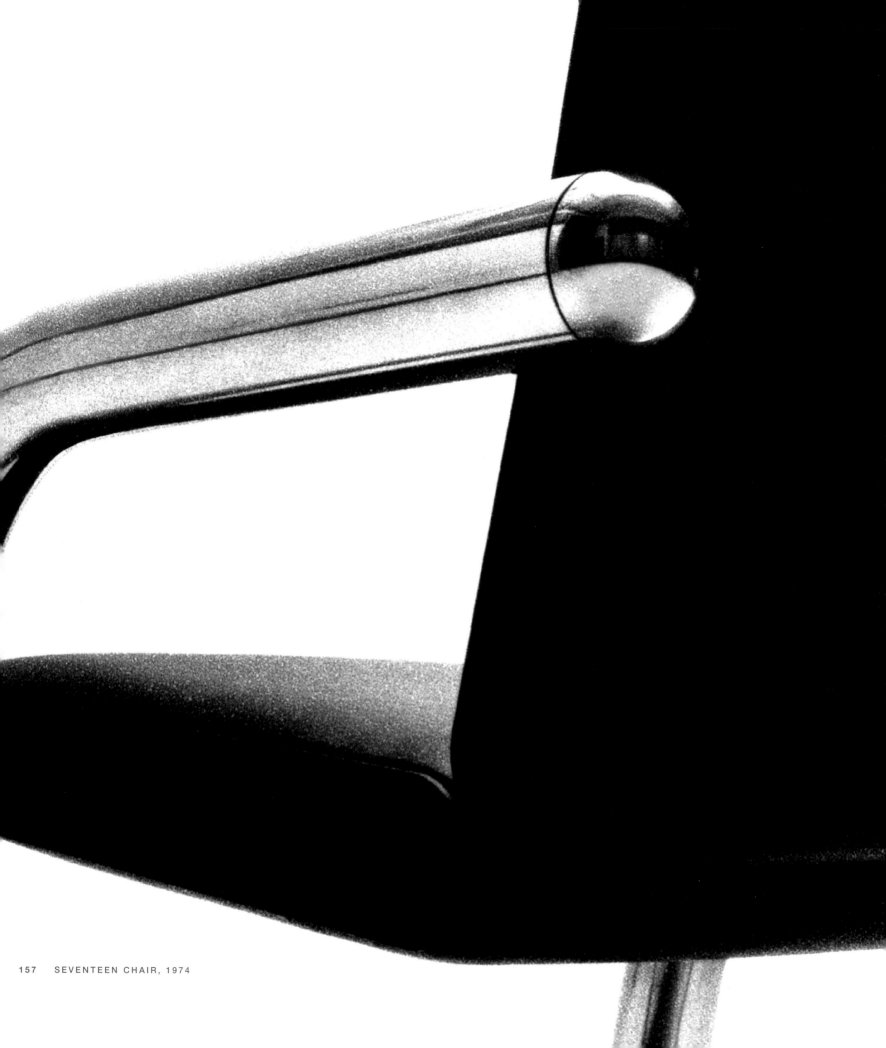

157 SEVENTEEN CHAIR, 1974

■ **THE SARONIS TABLE** "When I designed this table *(opposite)* for the Saronis house in Athens, I wanted it to be monumental because the room it would occupy was large and open. The table had to be very bold, it had to overpower the large number of simple cane chairs that would be placed around it. But when you try to make a thing bold, you know, it should still have a delicate sensitivity to it. Bulk should always have elegance. That's why those big legs have round ends—to meet the floor with a slight, almost delicate touch. I didn't want to bring the whole leg to the floor, that would have looked clunky. Also, the round leg ends are more practical since they are much less likely to be damaged. ■ The first version of the top on this table had a half-round bull-nose edge with the same radius as the legs. Later, when I made the table for the company's collection, I changed the half-round to a quarter-round and squared off the bottom. I prefer the second version, but everybody else seems to prefer the first. ■ The top surface of the table is veneered; the bull-nose edges and legs are solid wood. It's a bit of a puzzle where the round leg joins the quarter-round corners, but that's like the Cinnamon chair. I think that blending different shapes like this provides the interesting touches of character you want. ■ Despite everybody disagreeing, I insisted on and got the *exact* same dimensions when I designed the tiny little tables as I made in the big one. Everybody said I had to scale the thickness of the leg down, but I made it the same size. I think I was right; the best table is the smallest one. In fact, that small table led directly to things that depend entirely on that scale, like the Museum bench *(pages 160-161)* and then the CTD table *(pages 162-165)*."

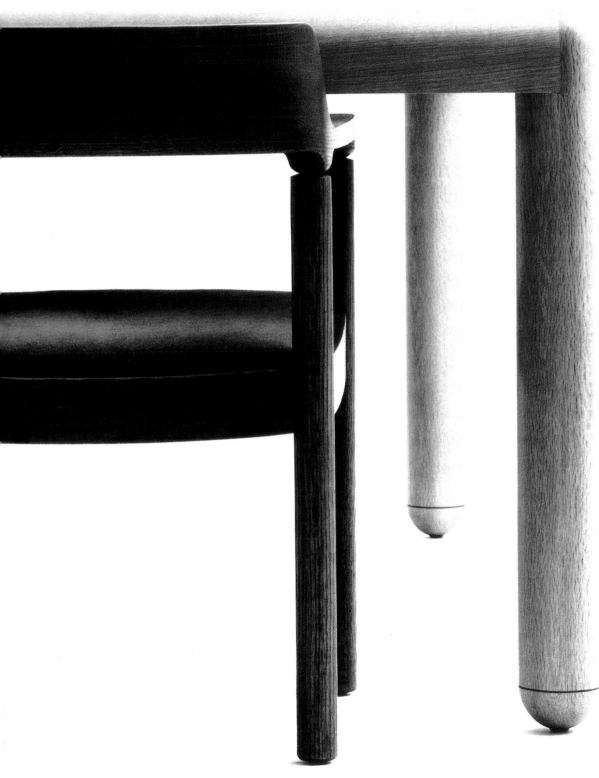

159 SARONIS TABLE, 1970

■ **THE MUSEUM BENCH** "First done in 1974 for an art museum that wanted seats for visitors, this bench has since been used in galleries and large public spaces. Obviously, the design owes a lot to the details of the Saronis table—it has the same thick legs with rounded ends, and it has the same puzzle of complexity where each leg joins the top. Fitting the leg into the top that way had to be so exact it drove everybody absolutely crazy. ■ The bench is white oak and the top is concave, at least minutely concave. But the slight depression is still enough to make the bench top surprisingly comfortable to sit on. The big mass looks like one thick thing sitting in space. It has the feeling of an integral unit, like it was poured right there in place. I like that a lot, it looks really *solid*. My impulse to make things out of one material popped up again, and so did the old SOM rule: *Keep things simple no matter how complex the details get*. It would be terrific if the bench were marble or chipped from a big block of stone. Or maybe one huge solid piece of stainless steel. That would be very nice *(laughs)*. Hell of a problem to make though. ■ This is the

same bench that was included in the show of twentieth-century products at the Whitney Museum of American Art. Later, when I extended the design to small tables, they did well too, even though they cost a lot because of that tricky puzzle corner."

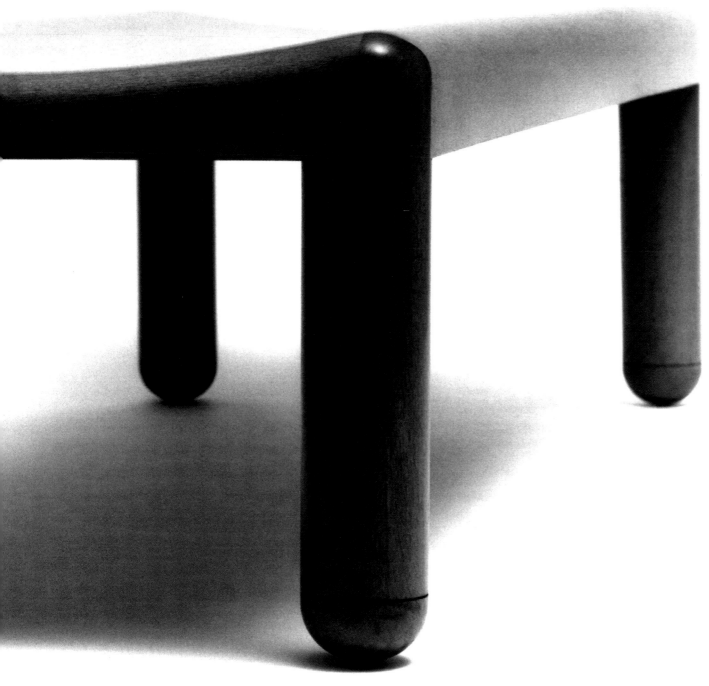

161 MUSEUM BENCH, 1974

■ **THE CTD TABLE** "It seems I am always playing with the most basic geometric shapes, always working with square and round, square and round. That's all I do I guess, that's my whole palette, square and round *(laughs)*. I really don't remember ever working with triangles, I don't like what comes from triangular shapes, even though I have designed a few houses and corporate interiors with walls set at forty-five-degree angles. ■ I honestly do not know where the geometries of the CTD table came from, but I do remember drawing the thing on a paper napkin while flying from Athens to New York. I had a lot of time on my hands, I didn't know what to do with it, so I stuck with my drawing and worked out the plans, sections, and little three-dimensional details, the whole table on that one flight. When I got home, I drew a formal drawing *(opposite)* and added a whole line of desks and cabinets that were based on the same idea. ■ At first, I wanted to sell the series to another furniture company that was capable of promoting it to much larger markets than my usual ones. But after long negotiations we just couldn't agree on the terms of a contract, so I decided I had to make the table myself. A small section of the top was produced, then a full-size prototype *(pages 164-165)*. ■ Obviously, this table is not like anything I have ever done before. It looks kind of strange and that's just what I like about it. At the time I wanted some kind of departure; that was important, there was a real need for me to look at everything in a totally different way. I don't mean the *ergonomic* way; I don't fit into that category of design. Ergonomics isn't related to my furniture, I never tried to make anything that was ergonomically based. I don't even like the word. To

me, the ergonomic movement has made and is still making *machines*, not furniture in the way I think of it at all. When I think of ergonomic design, I think of the mechanisms that lift seats up or move them down, like a barber's chair. What has been produced by the movement, what came from its beautiful purpose and logic, is some really ugly furniture. ■ Years back, I remember seeing a bunch of German chairs, really horrible things made for secretaries I think, things that were meant to make their lives a lot easier. But they definitely were not the kind of chairs I have done or ever will do. I want to be really clear on this; I am much more concerned with the *appearance* of things that surround us. That was my only motive in the CTD table; that's where it came from. It's so simple, it's really nothing but pure geometric shapes arranged together in a pleasing way. ■ To me, every design I do is about the eye and nothing more. Don't try to find any practical reasons for this. I would not have rounded the edges of this top at all if I wasn't concerned with the way it looked—I would have cut the edges square. But I like seeing that edge in section, I like to see the bull-nose because it's a beautiful shape. I didn't want to hide it, so I cut the end and left it open. And if I wanted to have a slanted surface along the sides of the table just for the sake of function, I wouldn't have made it so obvious, I would've carried it all the way around. ■ The table began as a design for a desk, just as you see it here. There was a slanted surface for the arms of the user and the same kind of surface for visitors. I could've stopped there and left the top rectangular, but I decided to add the racetrack end and the other details so the desk would appear to be much *more* than a desk."

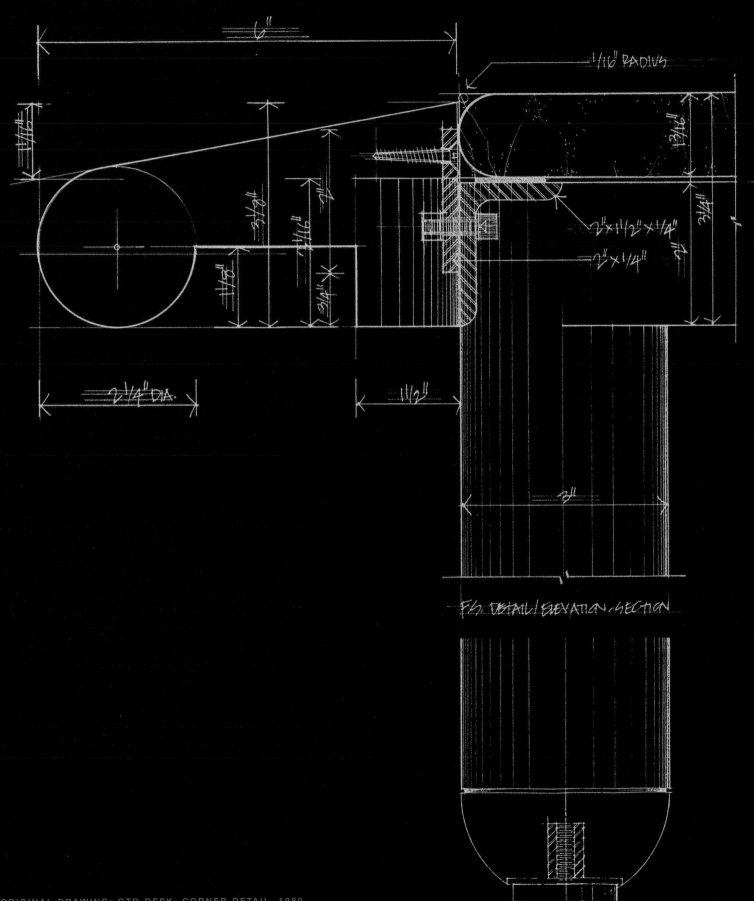

6"

1/16" RADIUS

1/16"

2"×1 1/2"×1/4"

2"×1/4"

2 1/4" DIA.

1 1/2"

3"

F.S. DETAIL / ELEVATION - SECTION

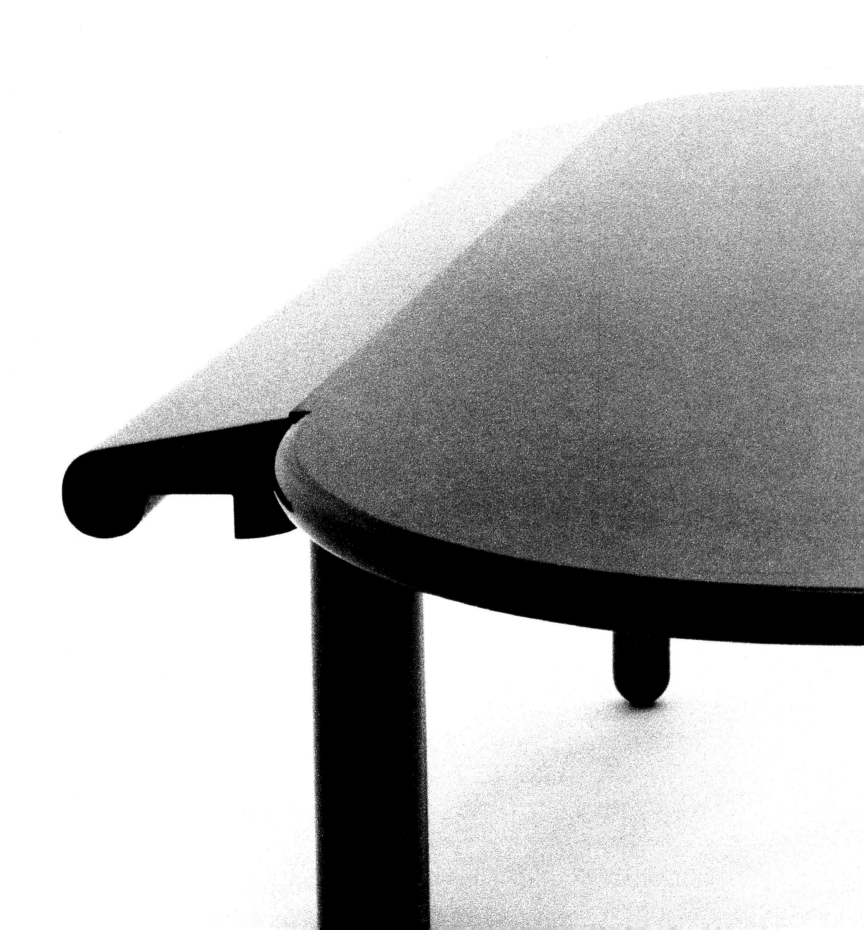

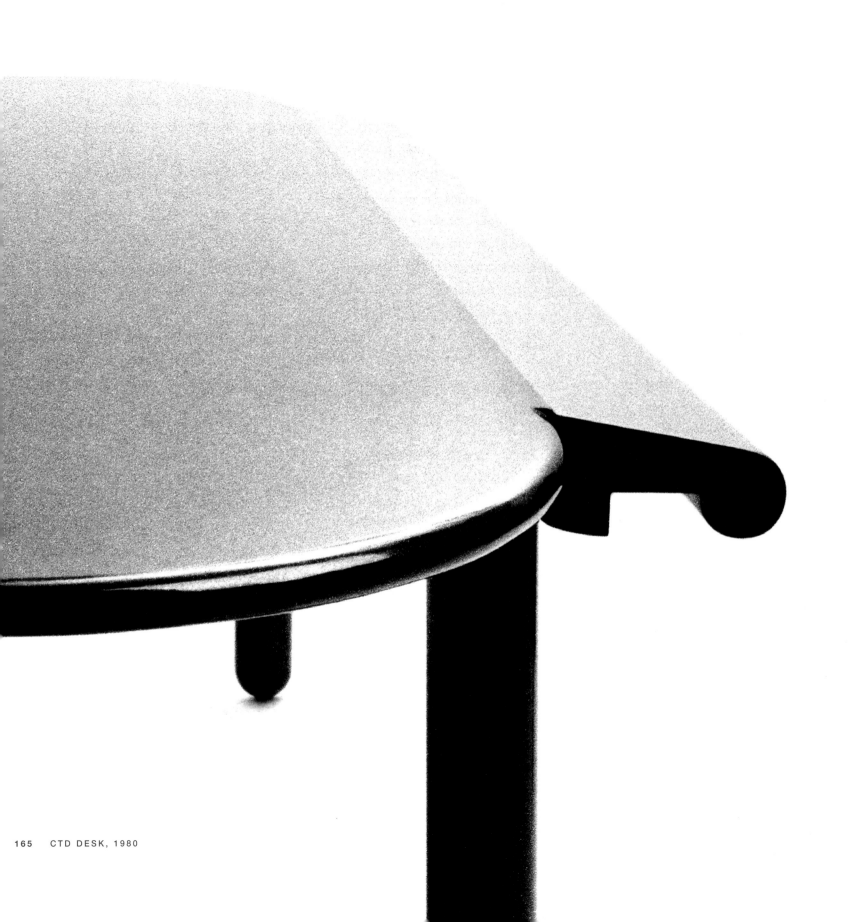

165 CTD DESK, 1980

THE EXECUTIVE CHAIR "About a year before the CTD table, in 1979, I designed an executive chair that had a similar emphasis on bull-nose edges. In fact, there are many forms that are similar in the two products. The Executive chair also recalls the Twenty-Eight or Ribbon chair I designed over twenty years ago: it has the same bent plywood frame and tight leather upholstery. ■ The chair sold well, but not too well because it was another one of those expensive productions. But as always, the cost was not my first concern. There are details in this chair that I think are intrinsically necessary, so I used them no matter what they cost. This chair could be bought for much less money if it were made in large quantities, but you know, I can't do much about limited production, and I can't do anything about my design standards. Sometimes I think that SOM ruined me for life. In that place, there was only one way to do things and it was never the cheap way. Because of that experience, I've always tried to escape the need to cheapen a design; I've always found reasons, not always valid reasons, for avoiding a change. ■ Sometimes I really do try to find more practical ways to build a thing, like using molded urethane to produce the arms of this chair, instead of making them by hand. But the molding technique wouldn't give me the shape of the arm I wanted. So I just couldn't use it, even though it would have cost two-thirds less. Instead, the arms are hand-shaped plywood wrapped in leather. ■ Big Allen-head screws fasten caps along the sides of the chair to hide the gory construction inside. The big padded rolls were just a way to end the seat. The upper roll on the high-back chair supports the neck; on the low chair it falls behind the shoulder blades."

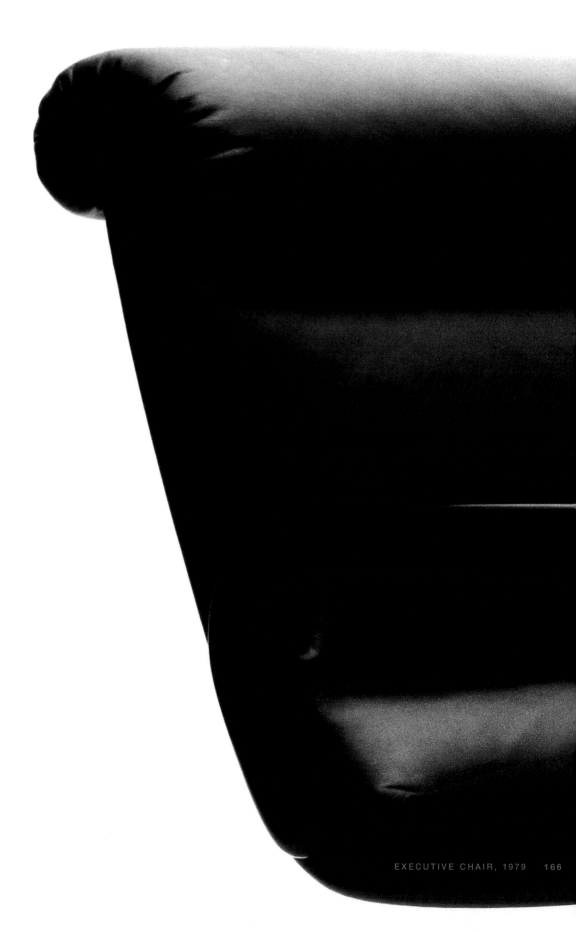

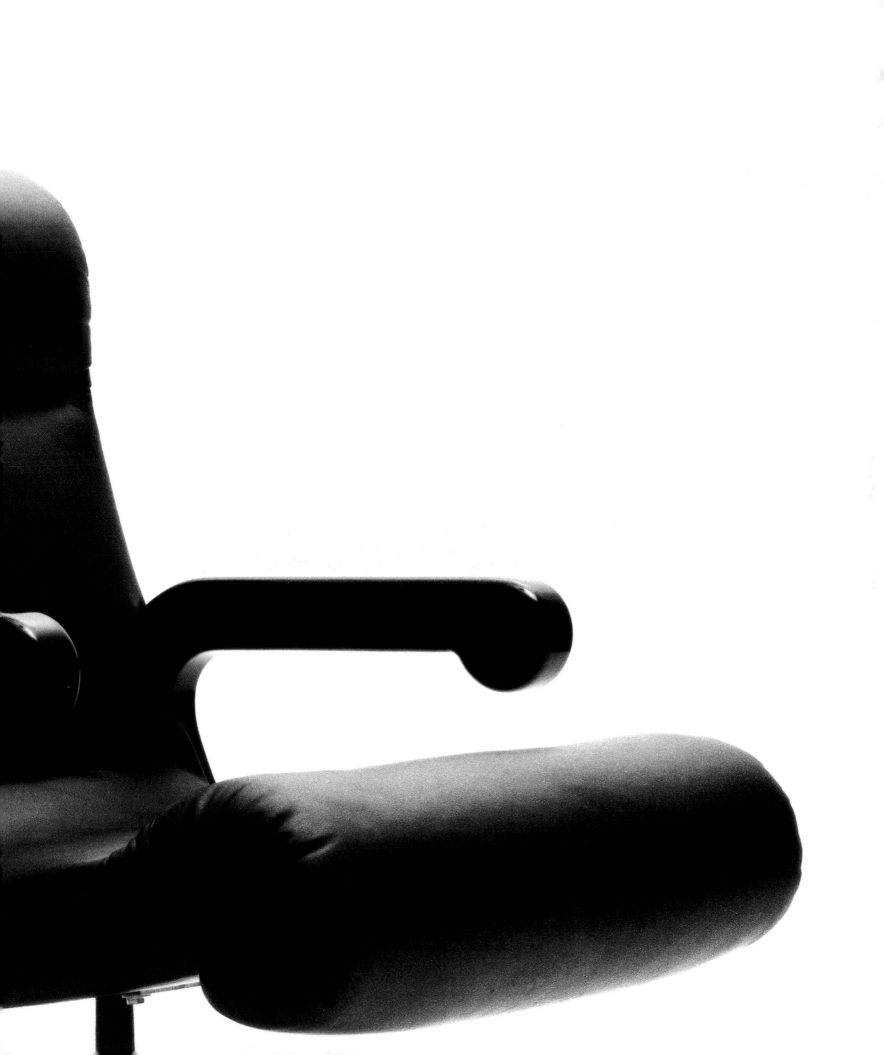

"Most of all, I wanted a sofa that had a high enough back to support your head when you sat down in it. When I designed it in 1981, most sofas had cushions that were ridiculously low, like the sofas that were designed by SOM. Many sofas are still like that, they make you feel like you're on a bench. They give you almost no support and you can't relax unless you lie down on them. I suppose some sofas in the past have had the comfort I wanted, but all the high-back ones I have ever seen are really hard and rigid. I wanted much softer comfort, and I wanted to hold the sitter's neck with a padded roll like the one used on the Executive chair *(pages 166-169)*. ■ The Alpha sofa was designed for use in reception areas or corporate executive offices, where people should have as much comfort as possible. I was thinking of a personal kind of sofa. But you know, in all the designing I do, I don't think of where a chair or sofa might go, whether in an office or a residence. It never becomes a factor. Furniture is really just furniture to me. In fact, I'm against the idea that residential furniture makers seem to have, that they're some kind of Detroit that must produce something new every year. Furniture should not be called residential or contract, it's just good or it's bad. So I've never seriously looked into the residential market. Gordon Bunshaft, an architect who looked at furniture the way I do, used a lot of my stuff in his own home. If architects like a design, they just buy it no matter who makes it. ■ The sofa was made before I began designing for the Alpha Credit Bank in Athens. It was the third of my modular lounges, and like the Twenty and Thirty series, it is one terrifically expensive sofa as they go nowadays."

ALPHA CREDIT BANK SERIES

"When I was asked to design new furniture for the Alpha Credit Bank in Athens by the chairman, Yannis Costopoulos, I was given areas with empty partitioned spaces. We needed lounge seating, so I suggested we use the Alpha series. He liked it and that's where the project began. ■ The Alpha bank was founded in the late 1800s by the Costopoulos family in a provincial town in Greece. It moved to Athens in the 1920s. My father worked for the bank all his life and became the managing director. When Yannis Costopoulos arrived in New York to work, we got to know each other well. He's a very creative fellow, he has built a big collection of Greek art for the bank, and he has donated large amounts of money to art museums in New York City and Athens. He has also helped the bank gather a very extensive and important collection of coins. He's a man with expanded horizons, to say the very least. ■ My work in furnishing the bank and its branches has become the largest concentrated job of design I've done *(pages 177-192)*. And it is the only job that won't mix my furniture with designs by others. There won't be a Barcelona chair, or a Brno chair, or anything else. That's very rare for me. The interiors I have designed in the past have often had a Corbu chair or Mies chair, or something else I chose to combine with my own work. But in this project, it seems to be important that Yannis Costopoulos can say, *In this place, all the furniture is designed by Nicos Zographos. Period.* ■ In the beginning, I wasn't sure about the idea, it was almost a burden. But now I think he was wise to give me that burden. I feel responsible in a way I've never felt before and I think I'm doing better things because of it. And it's a

continuing thing. It's not done once and over with. Now I'm replacing the furniture in the other branches of the bank. We're throwing out the cheap ordinary things and replacing it with much better stuff. The nice thing is it's all *my* stuff. ■ The bank's main offices are in a building that's new while some branches are housed in old restored buildings. These places have painted ceilings and some fabulous details, but generally, most of the spaces are pretty small. So the furniture I produce has to be flexible and adaptable enough to work in any size space. ■ When I started I thought I needed an overall theme for all the furniture, a design theme that went well beyond the first Alpha sofa. So I began to develop a curve detail to characterize everything, a very long and sweeping curve to be used in secretarial desks, vitrines, credenzas, and a new lounge series called the Tuxedo *(pages 184-185)*. ■ On the whole, I have come to think of the work I have done in the Alpha Credit Bank job as an abstract, intellectual exercise. While it may look form-conscious, it isn't meant to be sculptural at all, it is meant to feel constructed. In that sense, the work is closer to the architectonic design of my table structures than my cushioned furniture. Still, all those curves go back to the modular components of that Alpha sofa—my attempt to construct a bunch of big rounds that looked terrific from all sides. ■ These constructions really began before the sofa with the Executive chair and the CTD table. That's when I started drawing simple circles on paper. Circles have intrigued me always. The more I work with them, the more they appear in my design. The work I have done for the Alpha Bank is full of big circles. When I look at it now I see it has become pure geometry.

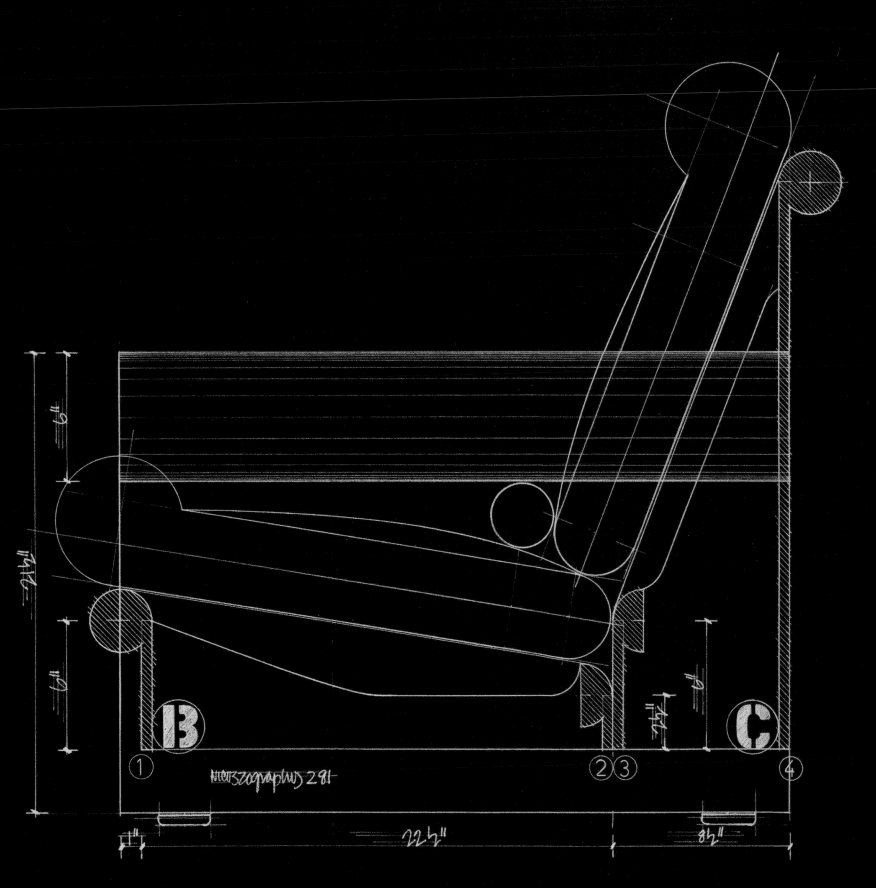

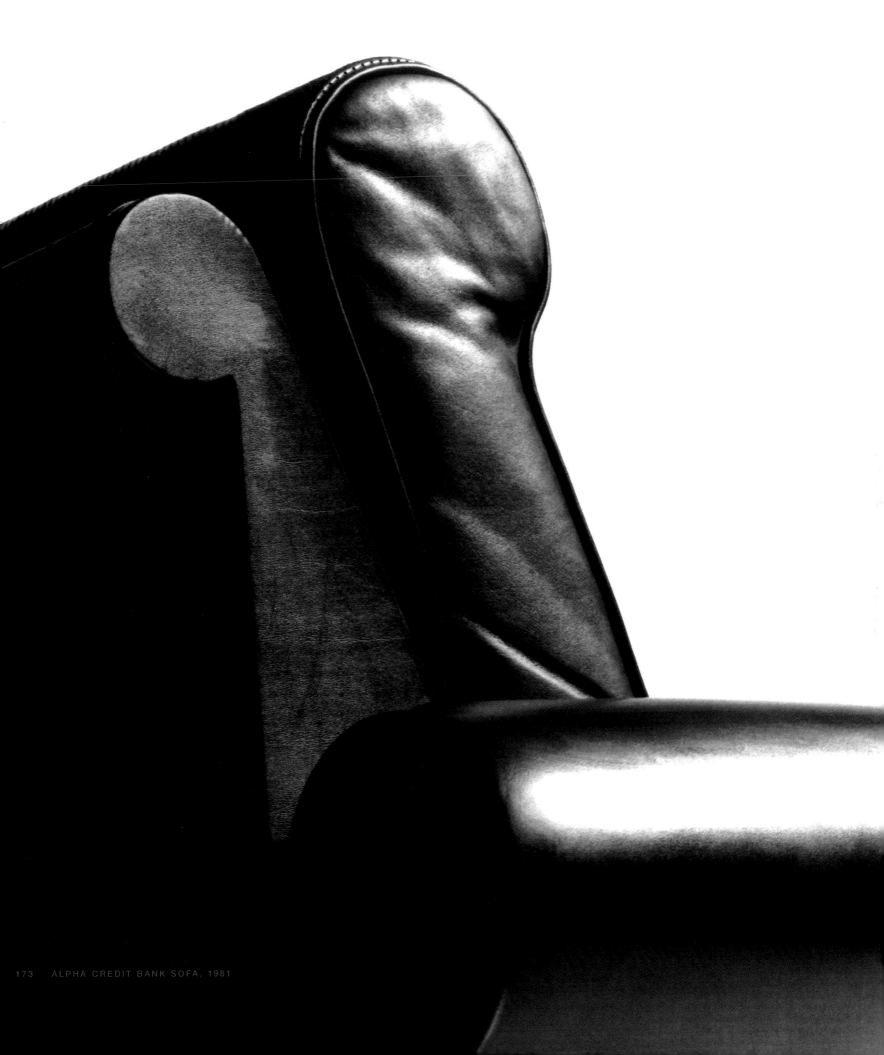

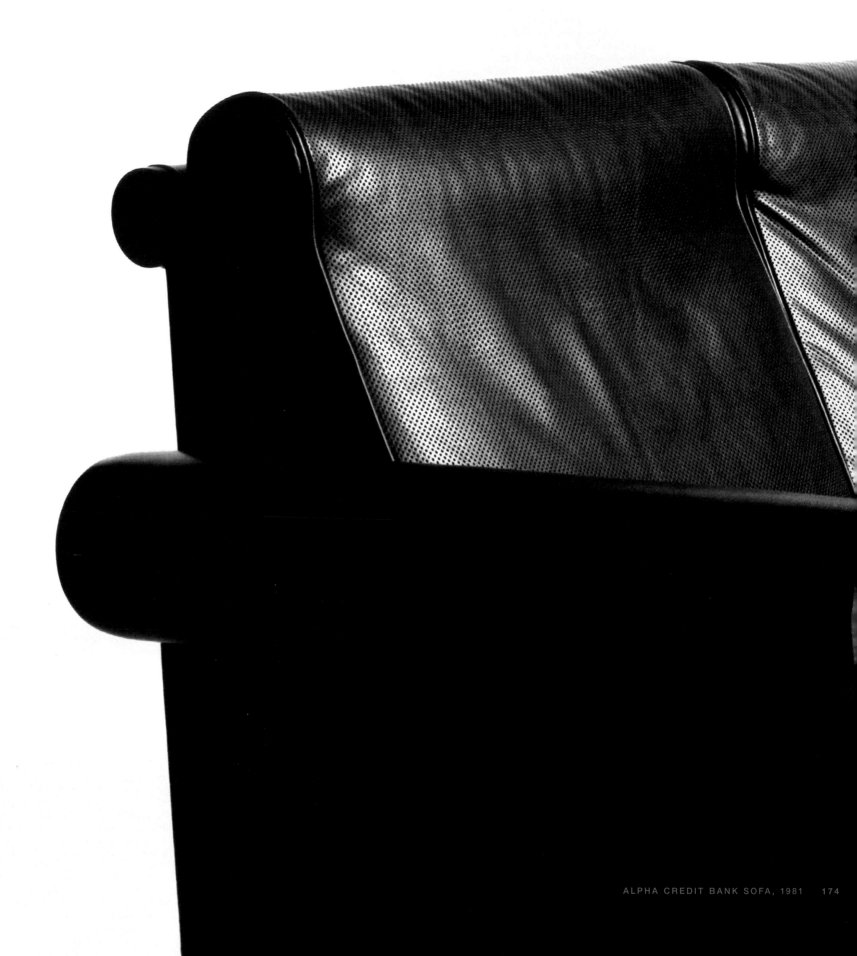

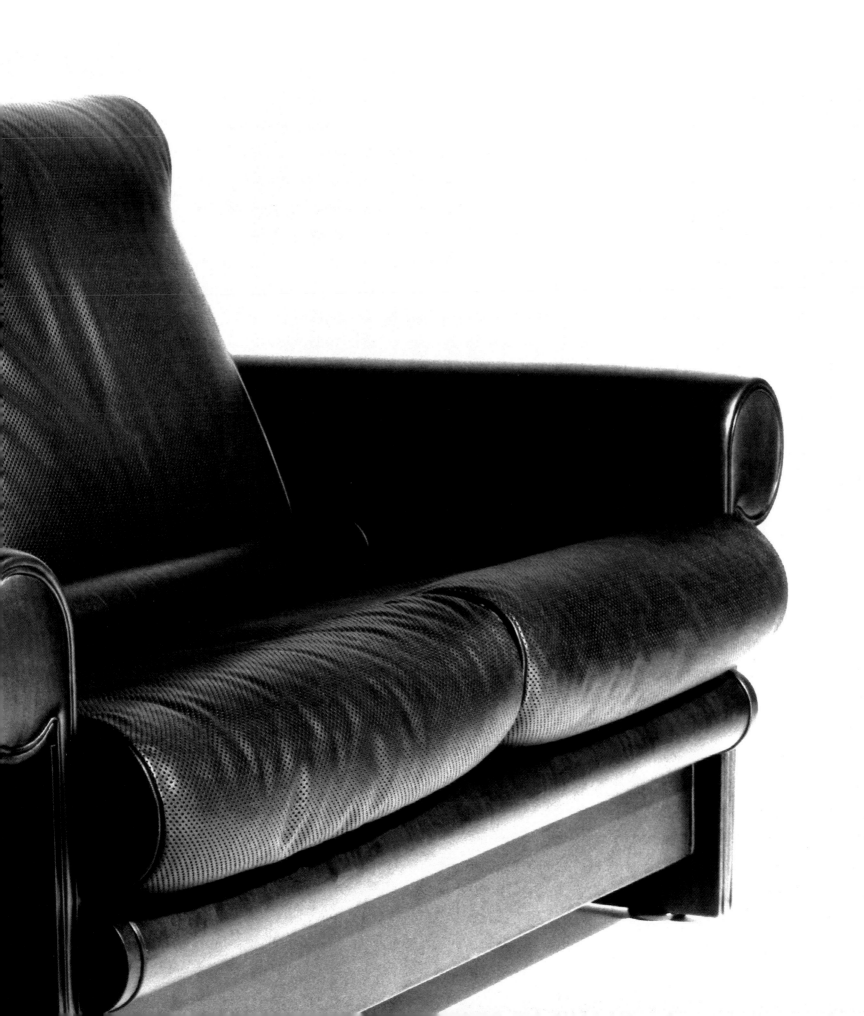

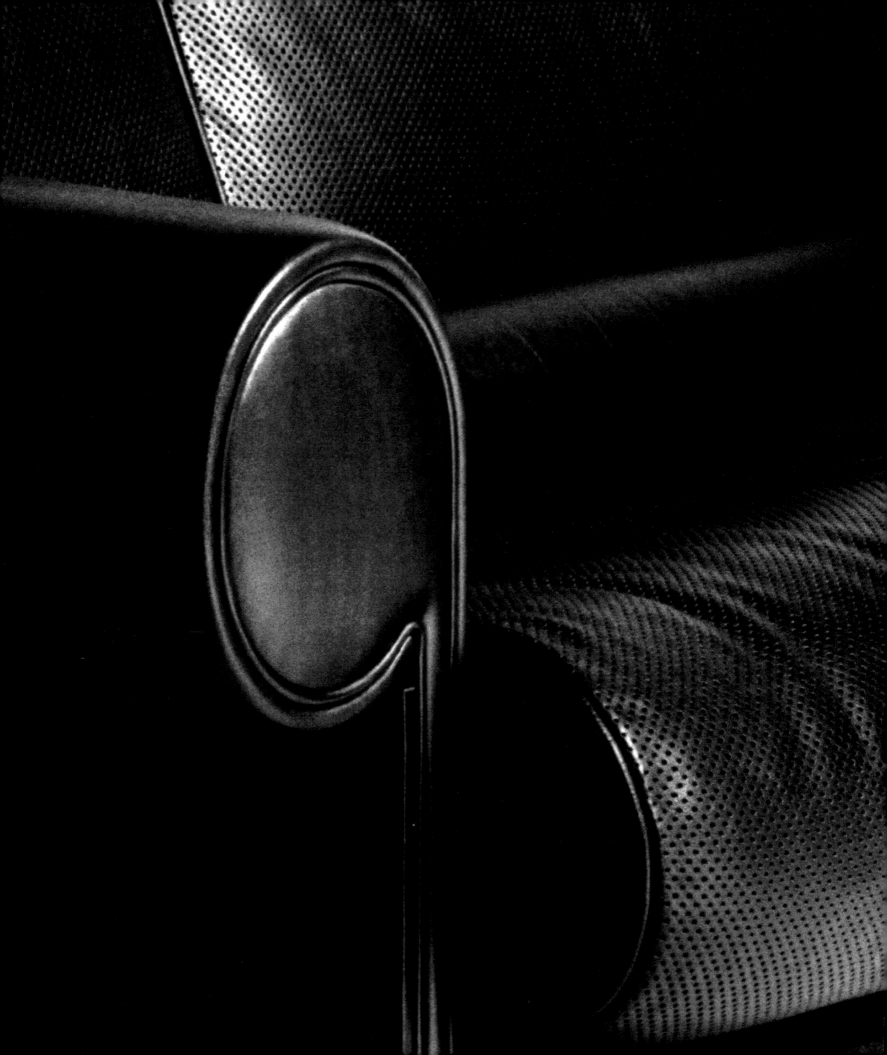

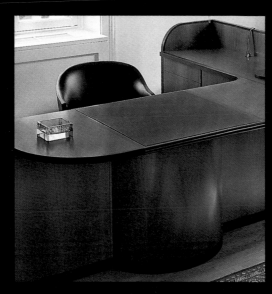

ABOVE

PRIVATE BANKING DESK

FOLLOWING PAGES

SECRETARIAL AREA

VICE PRESIDENT'S OFFICE

CHAIRMAN'S OFFICE

LOUNGE AREA

DINING ROOM BUFFET

VICE PRESIDENT'S SITTING AREA

BOARD ROOM

LOUNGE AREA VITRINE

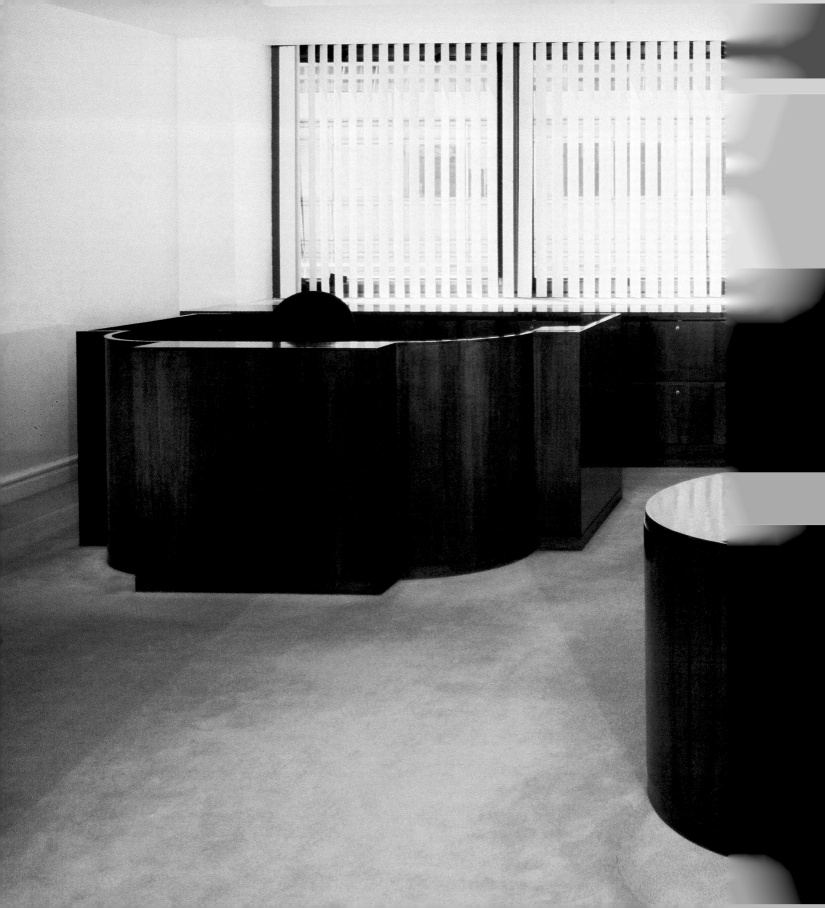

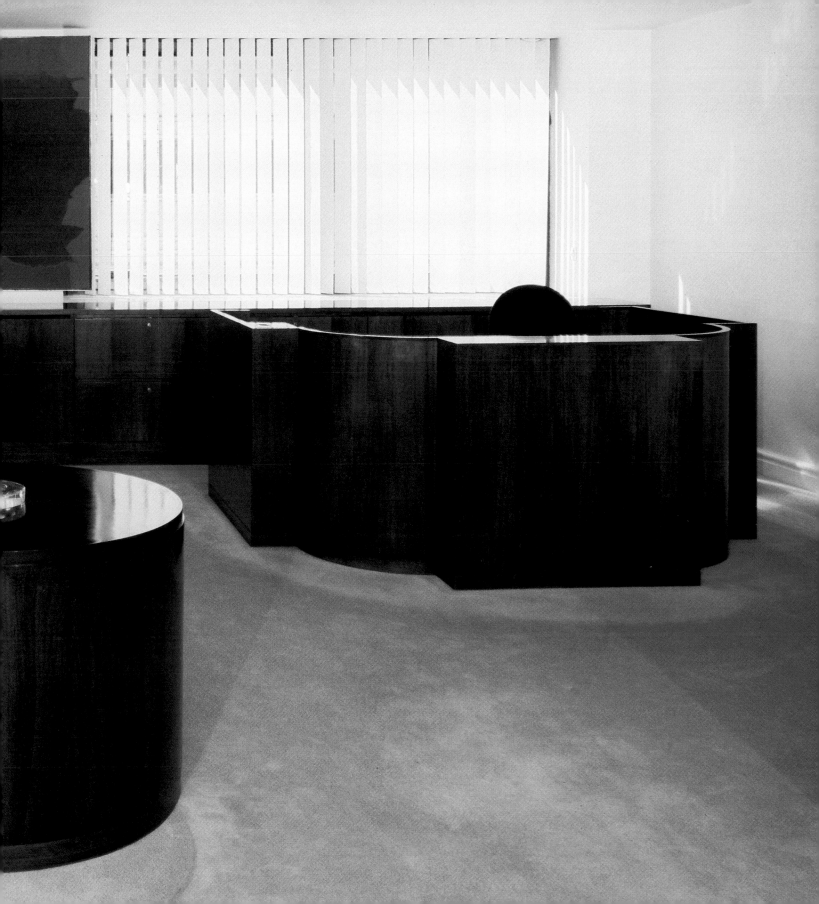

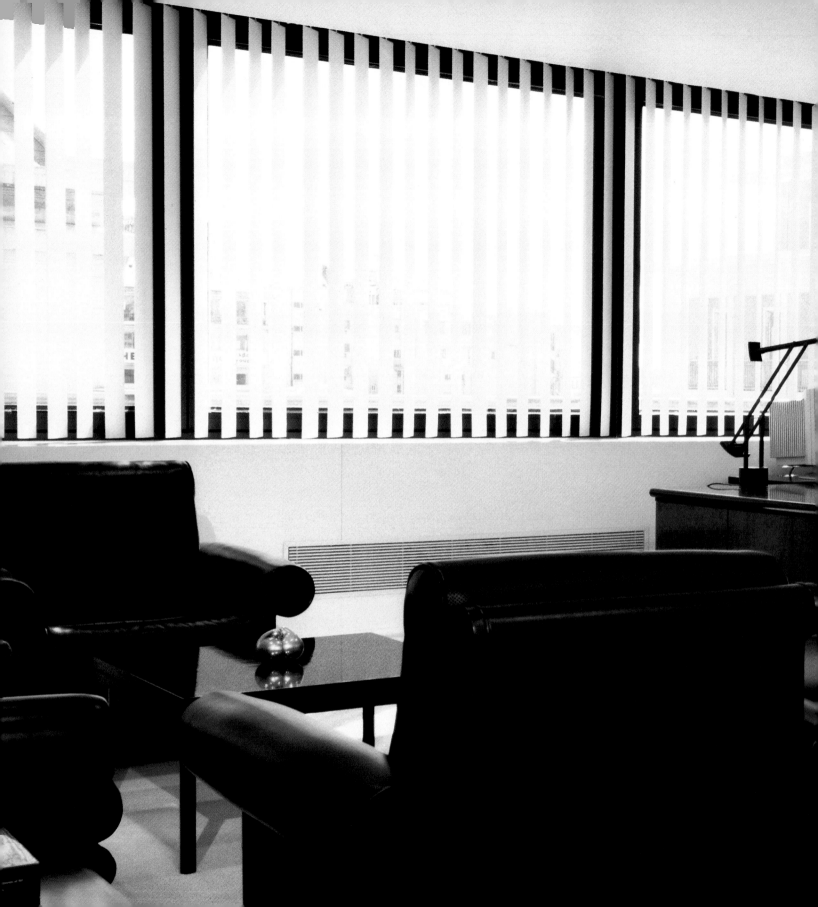

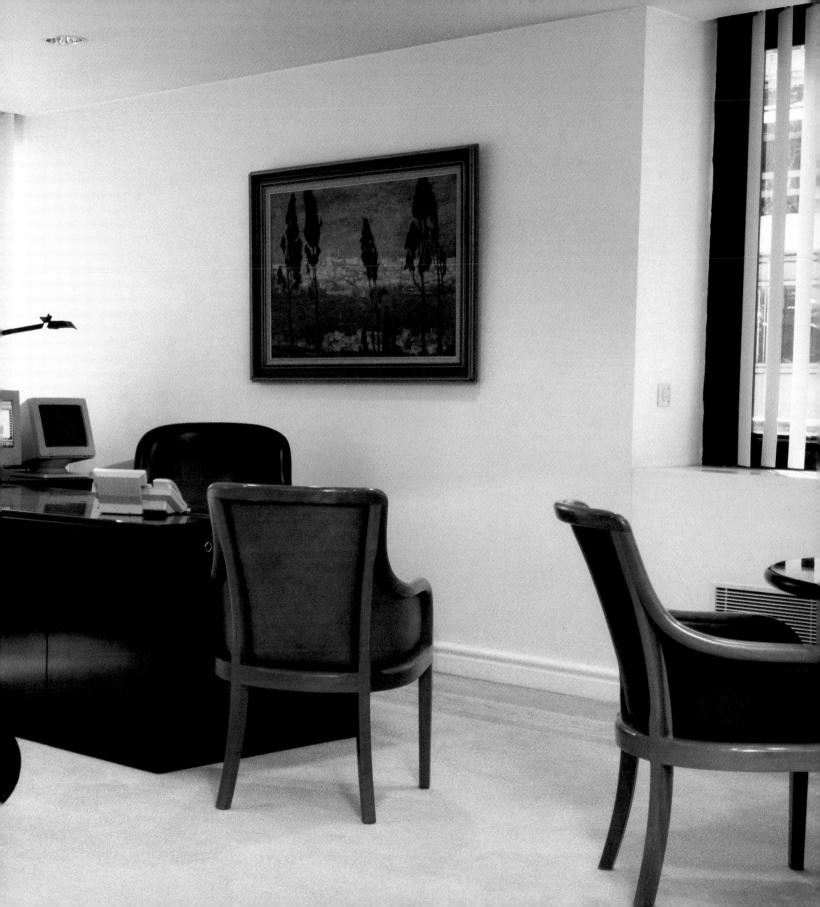

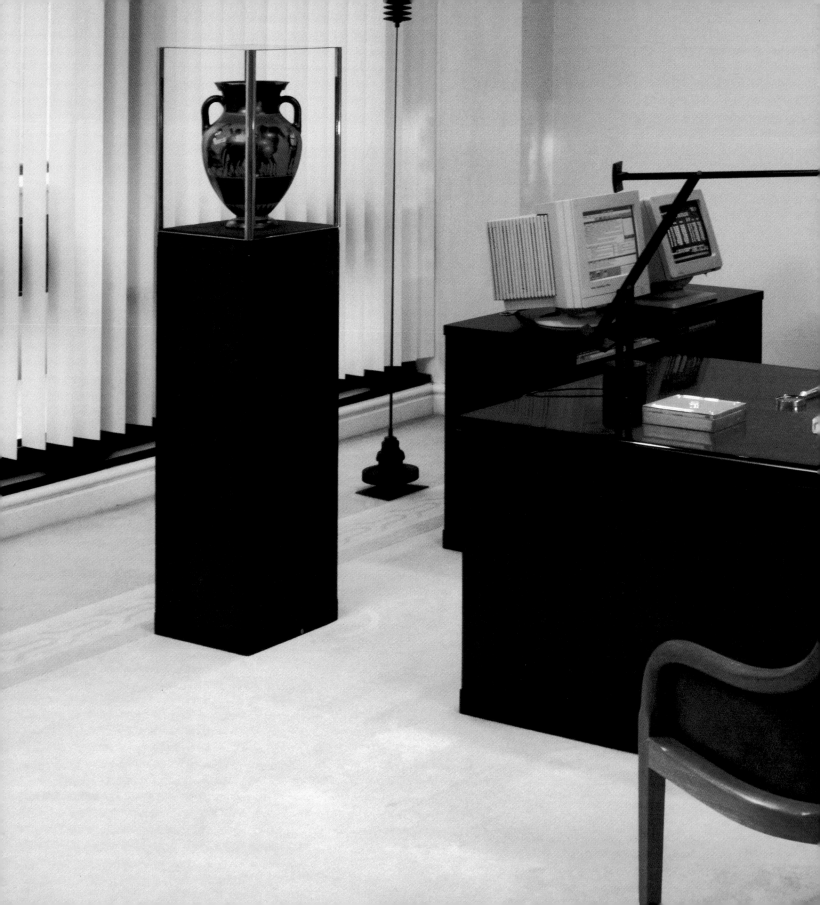

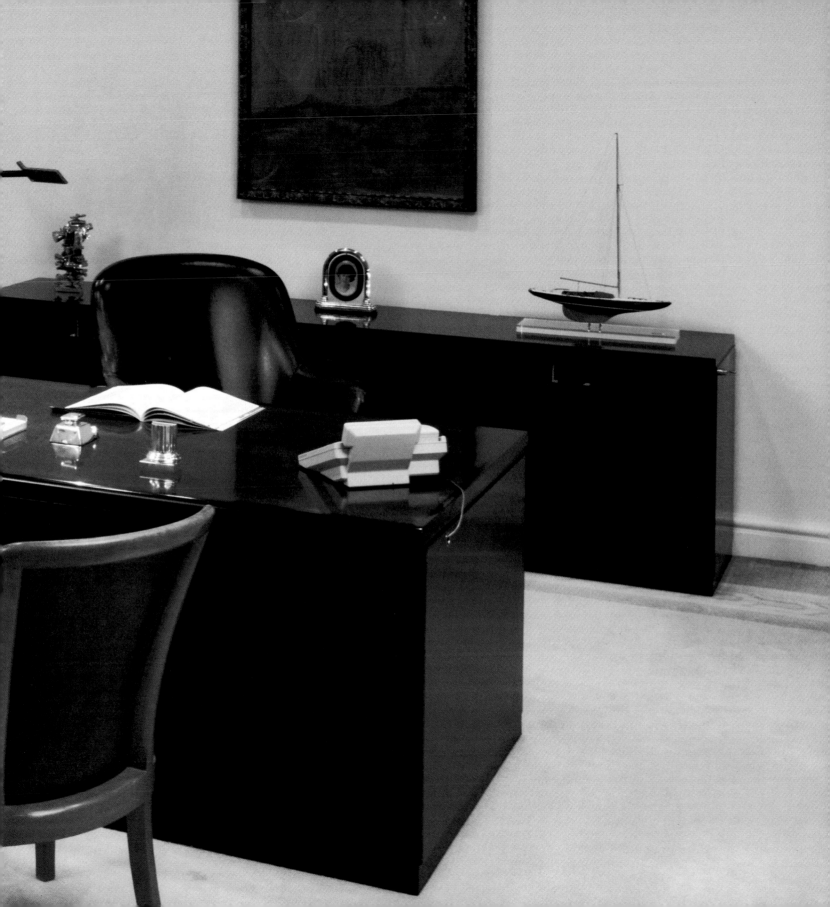

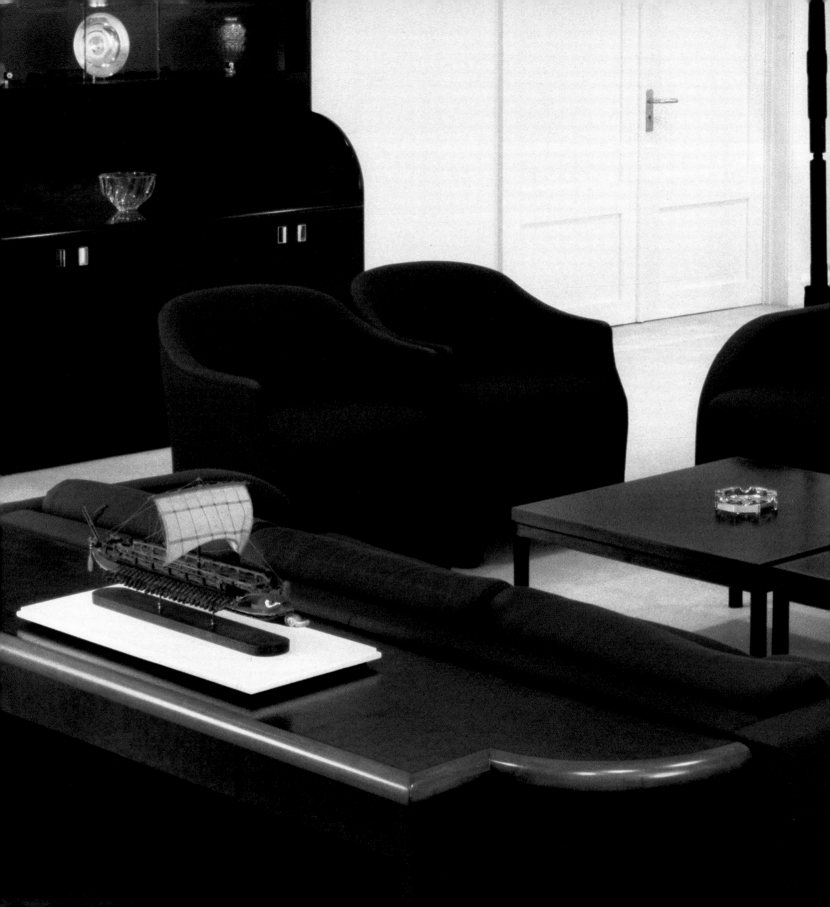

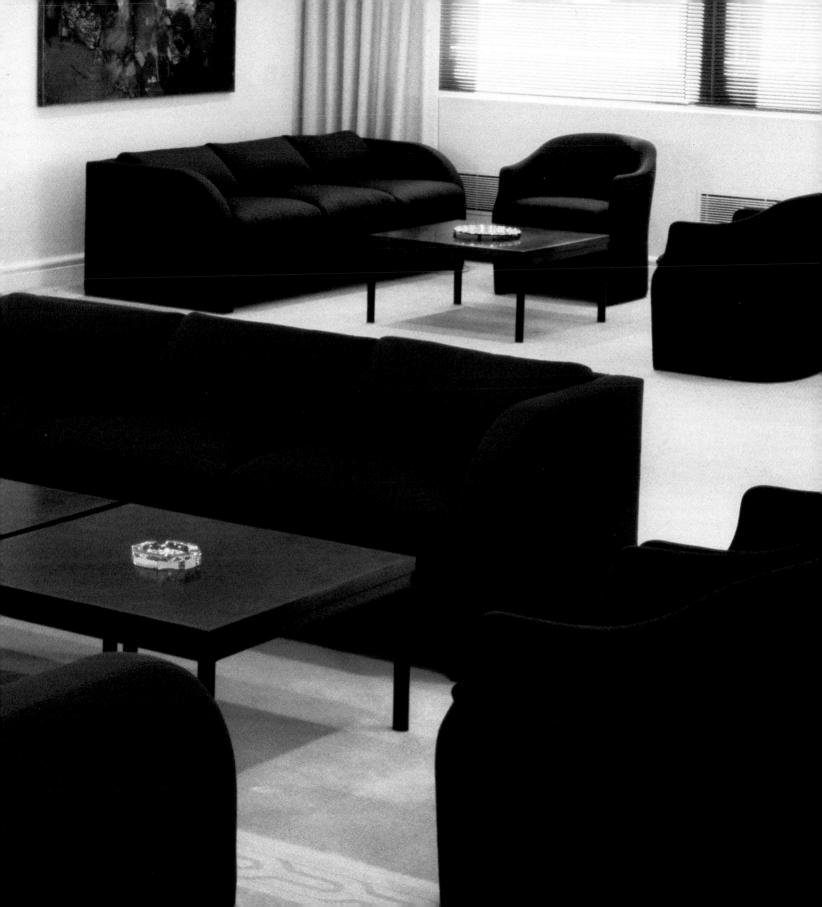

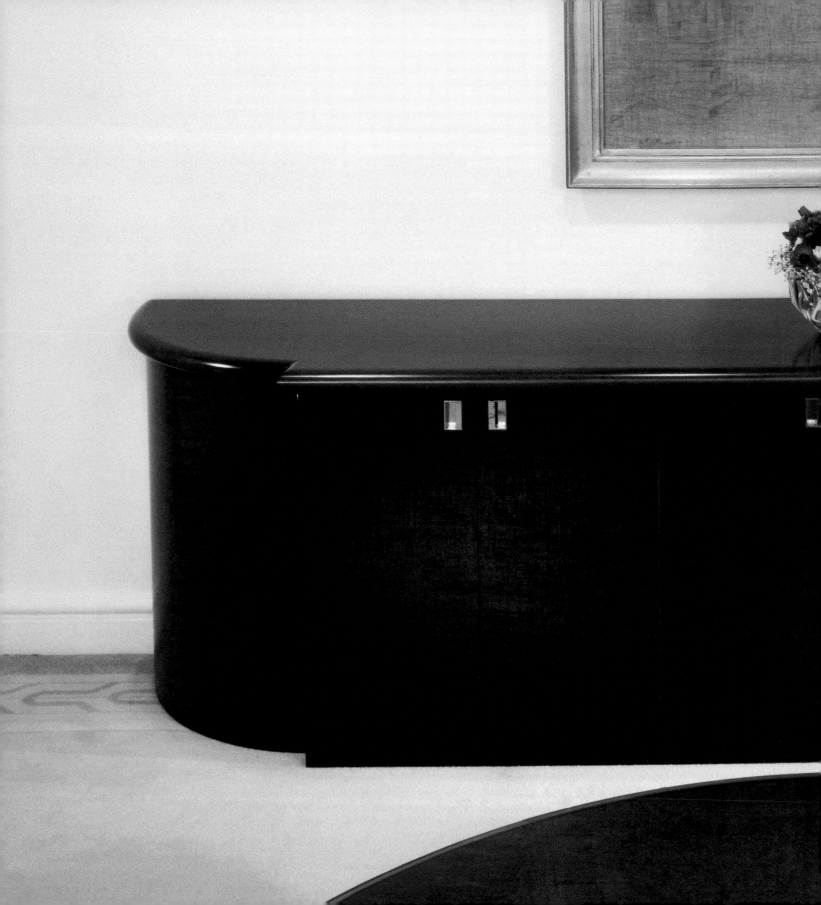

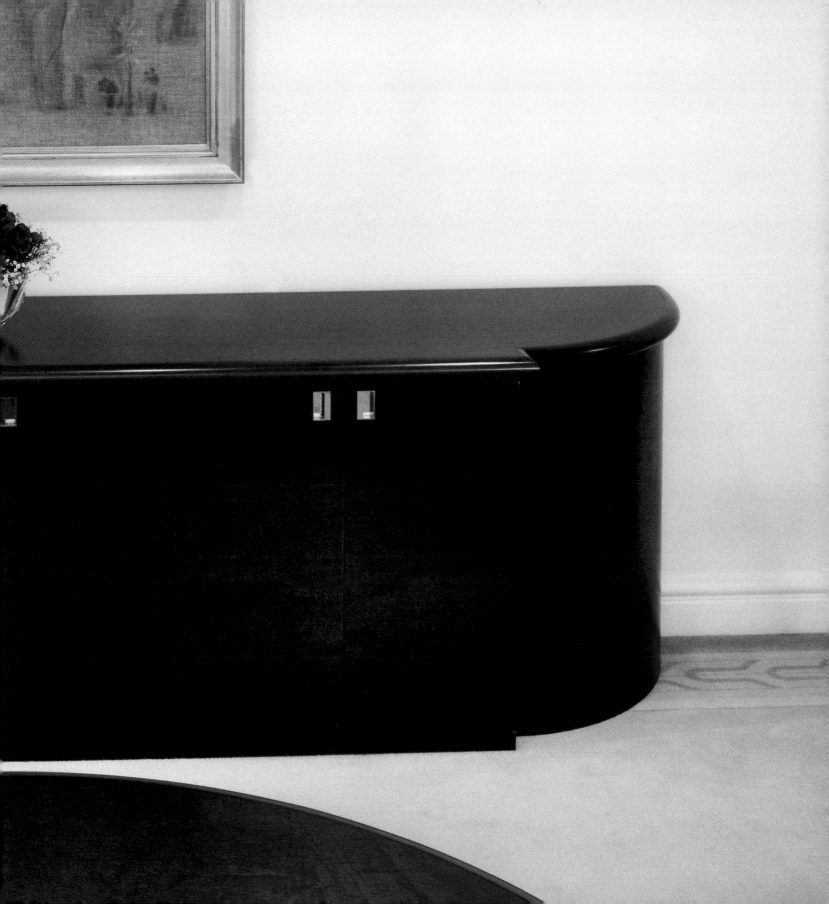

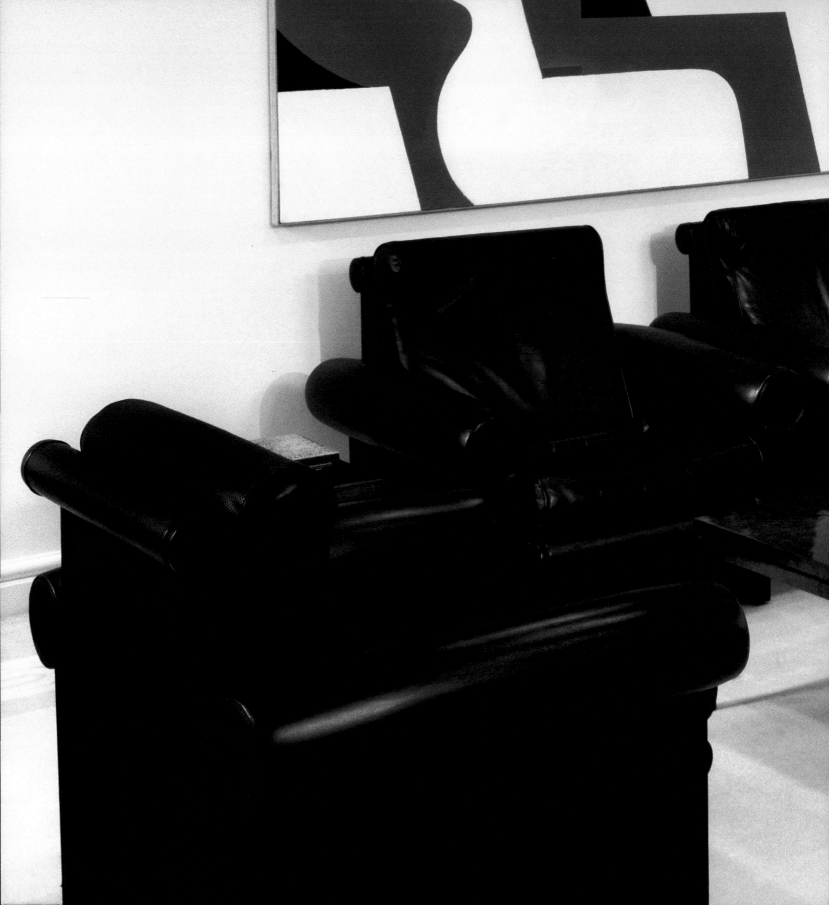